How To Create
PHOTOGRAPH
SPECIAL EFFECTS

Allan Horvath

Publisher: Bill Fisher
Editor-in-Chief: Carl Shipman; Editor: Theodore DiSante
Art Director: Don Burton; Book Design: Kathy Olson
Typography: Connie Brown, Cindy Coatsworth, Kris Spitler

ISBN 0-912656-98-0
Library of Congress Catalog Card: 79-84518
©1979, Fisher Publishing, Inc. P.O. Box 5367, Tucson, AZ 85703 602/888-2150
Printed in U.S.A.

ABOUT THE AUTHOR

Allan Horvath has been a photographer for more than 35 years. After nine years as a military and civilian photographer with the United States Air Force, he obtained a Ph.D. in geology from Ohio State University, worked as a geologist, and taught geology for ten years at the University of Dayton. During this time his writings and photographs were published in such magazines as *Popular Photography, Camera Magazine, Camera 35, Photography Annual,* and the *Journal of the Photographic Society of America.* More recently, he has published photos in Kodak publications and also written an article on crystal patterns for *The 10th Here's How.* He currently teaches photography at Sinclair Community College in Dayton, Ohio.

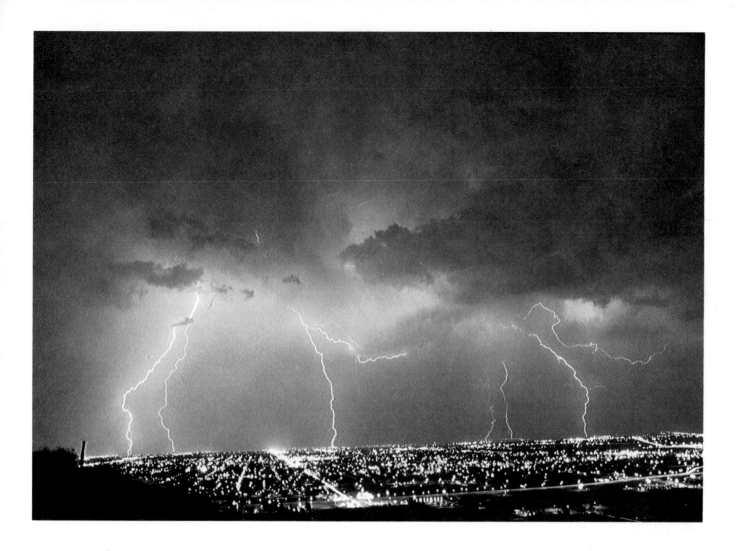

Some pictures command your attention because something is *different!* The visual impact of the image is often derived by altering one or more parts of the standard photographic process. My book discusses photographic alterations and explains how each can be used for special effects.

This is my definition of the standard process: It involves being able to properly focus, expose and shoot subjects to make conventional photographs. I assume you know how to use your equipment and can use photography as a recording medium. These are the minimal skills you'll need.

Special effects is more than just *recording*. It tends to say or imply something about the subject, the photographer or both. It is a visual statement with its own grammar, syntax and conventions. Essentially the subject is the story and you, the photographer, are the author communicating the story visually. This involves interpretation, experimentation, patience and a willingness to learn, so you can use technical expertise *to support the esthetic demands of the subject.* The key is seeing the subject and being able to translate your sight and interpretation into an interesting photo. This is done before, during or after the actual shooting of the subject, and I deal with all three possibilities.

I've written this book to show what is possible and how other photographers utilize different techniques to create special-effect photos. The technical and artistic potential of photography is nearly limitless, and the guidelines here should be used as a starting point for your personal photographic style. These ideas work, but you may find different ways to achieve the same end—creative imagery.

Once equipped with an interesting idea, you can make a visual statement with an appropriate method. Ideally, the visual statement is made first. Photos that are all technique without an interesting image are often ineffective and dull, but they may be necessary for practice. Record the technical information such as the film, lens, attachments, filters, aperture and shutter speed you are using. This allows you to evaluate or repeat what you have done. And you develop more control of the medium and become better equipped to deal with a variety of photographic situations. Then you can apply the best method to any situation and get the strongest possible image. I hope you find real enjoyment making special-effect photos.

3

TIME, MOTION AND CAMERA

The camera is the basic creative tool of photography. This book deals mainly with the modern 35mm SLR camera, but even a simple 35mm rangefinder or twin-lens-reflex camera can be used to create most special effects relating to time and motion because extra gadgets are not essential. All you really need is a camera, film and imagination.

Experimenting does not always produce intended results. Sometimes, it produces total failure, sometimes success, and other times it gives results that are both unintended and successful. You will learn something from each of these cases, so don't hesitate to experiment and create.

TIME AND MOTION

Time is a factor in every photograph, and controlling the medium includes controlling the time it takes to make an exposure. Some special effects use unusual exposure times—both short and long.

For an arbitrary dividing line, consider long exposure times as those requiring a tripod or other firm support for the camera. With 50mm lenses this is any time longer than 1/30 second. A general rule gives the slowest hand-held shutter speed as the reciprocal of the lens focal length. A 135mm lens implies the slowest speed for hand-holding should be about 1/135 second, but 1/125 second is usually close enough.

Motion is recorded by film as a continuous flow, a blur or a sharp and frozen image—depending on shutter speed and subject motion. Long exposure times blur the moving subject, and you can include a nonmoving subject in the scene as a reference point for the blurred motion.

Consider the feeling or impact of the motion. Is it real action, implied action or only action for an abstract effect stressing patterns and flows?

As the photographer, you choose the visual statement to exploit the medium. The relationships between scene elements determine the photograph's impact, and you must decide what they will be.

Bustling city scenes during night and day, waterfalls or rivers, active people and windswept foliage are all subjects worth shooting with long exposure times. Find a moving subject, such as a person or a waterfall, and photograph it with different shutter speeds. Record the exposure data. Analyze the subsequent images and see the effect created by the various speeds. This will help you choose appropriate shutter speeds for other subjects. **Shift the Reference**—Panning the camera with the subject blurs a

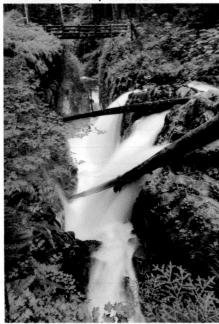

Long exposure times, such as one second, make waterfalls appear as soft, moving blankets of white water. Photo by Ted DiSante.

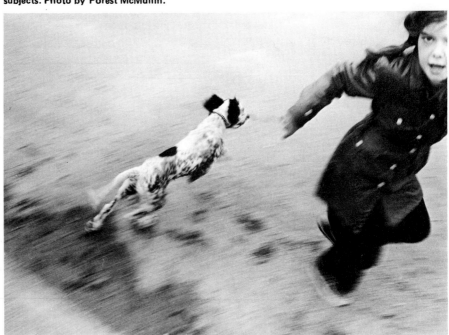

A 1/30 second shutter speed allows some motion to be recorded without totally obscuring the subjects. Photo by Forest McMullin.

1/15 second **1/8 second**

 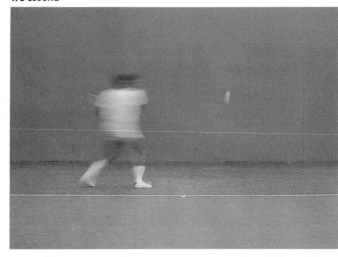

1/4 second **1/2 second**

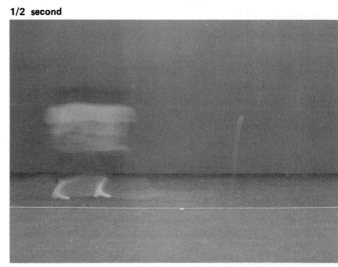

Each shutter speed will make a moving subject look different. This can be tough to predict, so I recommend you bracket speeds.

Panning often gives the illusion of motion yet retains a sharp image of moving subjects. I used a 1/30 second shutter speed and a 135mm lens for this scene.

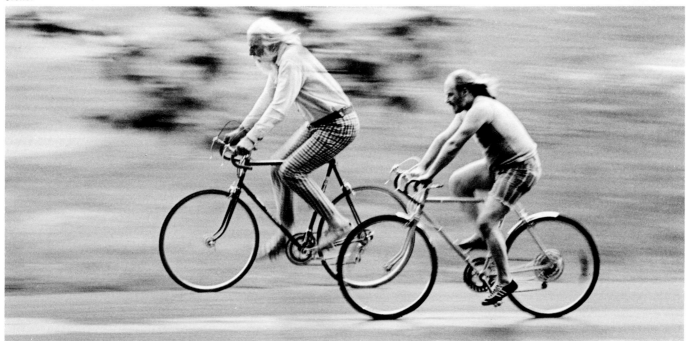

fixed background, and a moving subject becomes apparently stationary. This shifts the reference point of motion. For movement perpendicular to your line of sight, simply plant your feet and swing your body from the hips as you follow the subject in the viewfinder. Continue panning while you depress the shutter-release button. A shutter speed of 1/15 or 1/30 second works well for initial tests with a 50mm lens. You can use a different shutter speed depending on the motion, the speed of the subject and your desire to freeze it or let it partially blur. If the subject is moving toward or away from you, you can't totally stop motion by panning.

Induced Motion—An alternative to stationary long exposures and panning is camera jiggling. An induced tremor in the camera during exposure blurs the subject and creates the effect of motion. Exposure times around 1/15 or 1/30 second are fast enough to record some motion without totally obscuring the subject by blur. Practice, experimentation and bracketing are necessary for different lenses, subjects and exposure situations. Generally, the subject is fixed and well separated from the background, which may be out of focus anyway. Small sparkles or highlights on the subject make little light trails when you jiggle the camera, and these help make the effect work.

If your camera allows it, film may be moved instead of the camera, creating a streaking effect. Shoot a subject with the camera set on B. For good exposure, a slow film, small aperture, dim light or a combination of these may be necessary. Shoot the scene with the camera on a tripod. Open the shutter, then wind the film with the shutter open. Complete the exposure of the scene on the next frame with the shutter still open, and print the two frames as one. Try using an exposure time of one second instead of the B setting.

Eliminate Moving Subjects—Long exposure times can be used to exclude motion from a scene. With very long times, such as 30 to 60 seconds, a moving subject in the field of view may not be in one spot long enough to register on the film. This usually requires using *Neutral Density* (ND) filters, which are gray and don't change the colors of light. They are available with light-stopping ability from 1 to 13 exposure steps in either glass or gel.

If you need to photograph the interior of a busy museum for instance, shooting with ND filters and long exposure times can photographically eliminate people traffic from the scene. Chapter 2 includes

Reflections on a river become abstract light trails due to camera motion and a shutter speed of 1/8 second. Photo by Kevin Marks.

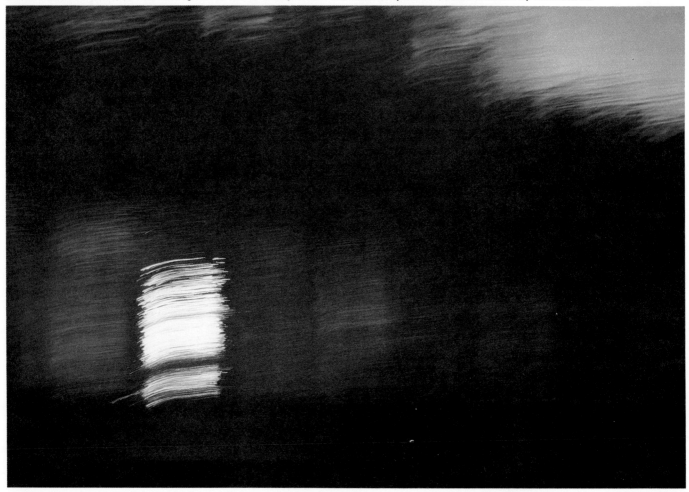

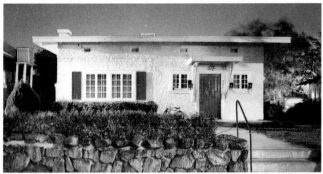

A 15 minute exposure time under the light of a full moon created a cyan cast in the image.

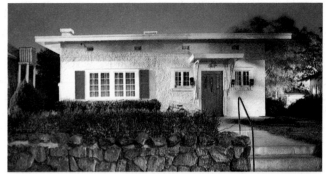

Color correction with a CC20R filter and increasing the exposure time to 24 minutes solved both problems caused by long-exposure reciprocity failure in Kodachrome 64. Because of the extremely long exposure time, people who walked past the camera were not recorded.

LONG-EXPOSURE RECIPROCITY FAILURE

Exposure times longer than 1/10 second may create problems if some adjustment is not made. The film will appear under-exposed and, with color film, also improperly color balanced. Called *reciprocity failure,* this inconsistency occurs with all standard films. Reciprocity adjustments for some popular films are in the table. Try to avoid giving more exposure time when adjusting for reciprocity failure because it only compounds the problem; use a larger aperture when possible.

Scenes with long exposures can be photographed realistically or not with color film by exercising the option of color correction. The table also gives recommended filtration for color films, and the indicated exposure increase includes the effect of the filters.

The color cast the film would have without correction can be inferred from the color of the recommended *color-compensating* (CC) filter. These are available as gel filters made by Eastman Kodak and glass filters made by other manufacturers. To correct a green cast, a magenta filter is used; for yellow use a blue filter; for red use cyan. Try intensifying the color cast with a color filter of the same color and see what happens.

TYPICAL EXPOSURE AND FILTER CORRECTIONS FOR RECIPROCITY FAILURE

| FILM | EXPOSURE TIME | | |
	1 sec.	10 sec.	100 sec.
Kodacolor II	+1/2 step none	+1-1/2 step CC10C	+2-1/2 step CC10C + 10G
Kodacolor 400	+1/2 step none	+1 step none	+2 step none
Ektachrome 64	+1 step CC15B	+1-1/2 step CC20B	not recommended
Ektachrome 50	none none	+1 step CC20B	not recommended
Ektachrome 200	+1/2 step CC10R	not recommended	not recommended
Ektachrome 400	+1 step none	+1-1/2 step CC10C	+2-1/2 step CC10C
Ektachrome 160	+1/2 step CC10R	+1 step CC15R	not recommended
Kodachrome 64	+1 step CC10R	not recommended	not recommended
Kodachrome 25	+1 step CC10M	+1-1/2 step CC10M	+2-1/2 step CC10M
Fujicolor F-II 400	+1 step none	+2 step none	+3 step none
Fujichrome 100	+1/3 step CC05C	+2/3 step CC10C	+2 step CC20C
Agfachrome 64	+1/2 step CC05B	+1 step CC10B	+3 step CC15B
Agfachrome 100	+1/2 step CC05B	+1 step CC10B	+3 step CC15B
Photomicrography 2483	+1/2 step CC10Y	+1-1/2 step CC10Y	+3-1/2 step CC10Y
Pan b&w films	+1 step 10% less development	+2 step 20% less development	+3 step 30% less development

NOTE: Table shows recommended exposure increase and color-compensating filter that are needed for color film. For b&w films, the table shows exposure increase and recommended change in development time. This information is recommended as a guide only. Bracketing is suggested. Data may be changed by film manufacturer.

ND filters and their light-absorbing properties.

Stopping Movement—Motion can be frozen by using fast shutter speeds. A time of 1/500 or 1/1000 second tends to stop motion, sometimes showing us things we do not ordinarily see. Segments of action are extracted from the flow of motion for us to observe. Most human and animal motion can be stopped with these speeds, but fast film and quick reflexes are necessary to do it.

Electronic Flash Stops Action—Electronic flash units have flash times around 1/20,000 second—some even shorter. The flash from properly placed units can stop action in sports, machines, wildlife and many other things that move.

Try to shoot at peak moments of action for the most interesting effect. With a jumping subject this is the fraction of a second in which it is moving neither up or down—it is in between the two directions of travel. Full extension or contraction of an arm or leg are also peak times, and they imply tension or a transition phase. This helps define the frozen motion and makes the visual statement stronger.

Some new cameras with motor drives or power winders have special flashes which synchronize with the frame rate and allow continuous shooting for short periods of time. This feature can help you capture peak action and the before-and-after scenes, but it is no substitute for anticipation of the action.

We are all interested in photos that show us something we don't normally observe, and stopping the unseeable can give a special effect worth noticing. Chapter 3 gives more detail about flash lighting and how to use it.

Panning does not always freeze motion, but sometimes the blur makes a more interesting effect. Shutter speed 1/4 second. Photo by Ted DiSante.

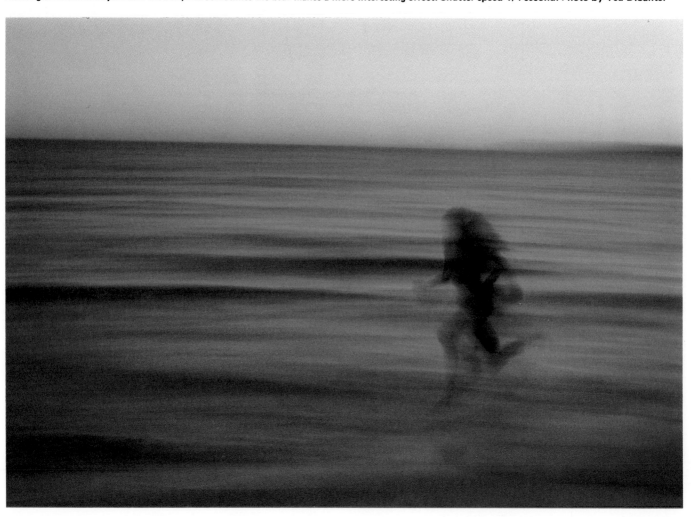

The girl seems to hang in mid-air because I used a flash to stop motion.

A strobe light, such as the *Blue Box* available from Edmund Scientific Co., produces a series of flashes.

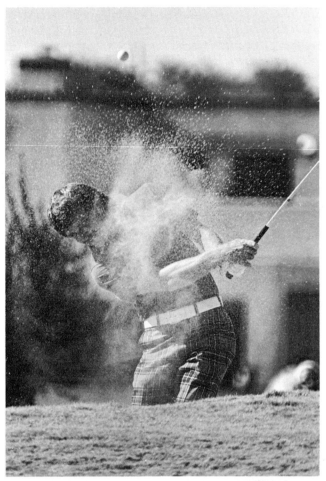

The spray of sand and the rising golf ball were moving very fast, but photographer Dennis Makes anticipated the action and used a 1/1000 second shutter speed to capture it.

Discrete parts of the motion were stopped by the flashes of the *Blue Box* strobe light.

Combining Long and Short—Long and short exposure times can be combined on one frame by using a flash with shutter speeds longer than the camera's flash sync speed. For example, if a camera's sync speed is 1/60 second, the flash will also synchronize with shutter speeds of 1/30, 1/15, 1/8 second and longer. The B setting of the shutter can also be used. The flash can be fired at the beginning, during or at the end of the long exposure, but must be triggered manually for the last two cases. Scenes at twilight, night or with dark backgrounds work well with this technique.

Usually the long exposure time is calculated for the background or ambient light, and the flash is effective on a foreground subject. A combination of different kinds of light and frozen or flowing motion creates a photo with an unnatural feeling. See Chapter 3 for recommendations on calculating exposure.

MULTIPLE EXPOSURE

Modern cameras are now designed to prevent accidental multiple exposure, and subversion of the mechanism is necessary to do it deliberately. Some cameras have a control that prevents the film from moving as you cock the shutter for the next exposure. Others are not as simple, and a trickier technique must be used, such as cocking the shutter with the rewind button depressed. Check the instruction book for your camera.

At the end of the multiple exposure, advance the film normally. With some cameras, not all of the next frame may be moved into position. If there is any doubt, be safe and waste the frame after a multiple exposure by tripping the shutter with the lens cap on.

Some misalignment of critically located objects may occur during multiple exposures. You can check your camera's registration by attaching it to a tripod and shooting some fixed subject, such as a line drawing or a printed page, with multiple exposures. Some multiple-exposure subjects don't need to be precisely aligned, but you should know the capabilities of your camera.

Black-Card Multiple Exposures—If your camera does not give good registration with multiple exposures, you can still make them by controlling the "shutter" externally instead of internally. Set the camera to the B setting. Hold the shutter open with a locking cable release while holding a black piece

Because of the dark background, no exposure compensation was necessary for this double exposure.

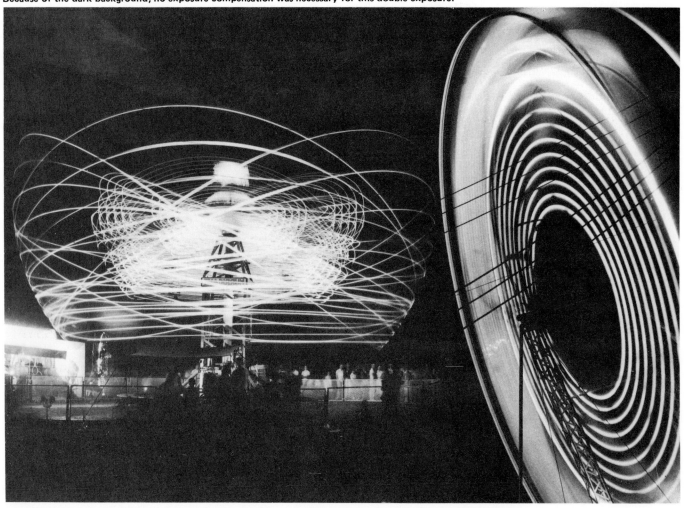

10

of cardboard over the lens. Remove the black card to expose the film and replace it after the exposure is made. Do this for each exposure.

The lighting and aperture for this method should be arranged so you can use long exposure times such as 1/2 second. The method is simplified if a flash exposure is made in an otherwise darkened room or at night. Flash exposures may be combined with exposures lit by moving lights, and the card or lens cap is merely replaced between exposures. Aperture or camera position can be changed between exposures if you carefully hold the card over the lens.

Exposure Considerations—Exposure for in-camera multiple imagery depends on image overlap. If the subjects of interest do not overlap, give full exposure for each shot. For overlapping images, each individual exposure should receive a fraction of its normal exposure. The fraction is determined by the number of overlapping images. For a triple exposure, each shot receives 1/3 the normal exposure; for a double exposure each shot gets 1/2 the norm. These guidelines work for most situations. Chapter 2 contains information about using filters with multiple exposures during daylight.

When making multiple exposures, a plain dark background is preferred—particularly when you are making more than two or three

Photographer Rick Gayle used the black-card technique to make this photo. The subject and a white background were lit with different lights. He made the first exposure with both lights on and then covered the lens. The person left the scene, and the foreground light was turned off for the second exposure, which grossly overexposed the area not blocked by the dress form.

In this double exposure, the subject becomes almost transparent because photographer Kevin Marks used normal exposure for each shot.

The first exposure for each frame was of the litho negative, and the second exposure was of the colored filters. No blank-frame exposure was made between the two frames and some image overlap resulted. Red and green added photographically to make yellow.

exposures. The background becomes lighter in the final image as more exposures are made, and it is possible to give so much background exposure that the subjects of interest are not recorded on the film at all.

When shooting at night or against a black background, many combinations of images are possible. Combine a flash with light trails; change lens and perspective for each shot; create a montage of city lights or multiple-expose the moon.

Making unusual title slides for slide shows is another way to use the double-exposure method. White plastic or transfer letters can be obtained from camera or art-supply stores to make your title. Photograph them against a black background. The second exposure can be a sunset, foliage, a painted design, another photograph or whatever is appropriate. The ideal background complements rather than competes with the lettering. Overexpose the lettering 1/2 step to get bright and legible words. Then expose for background normally. Distinctive titles can be made by using slightly out-of-focus backgrounds, other slides or special photos created by methods discussed in this book. More information on title slides is in Chapter 8.

MAKE LONG PICTURES

You've probably seen photos made with special panoramic cameras which photograph an unusually wide scene on one piece of film. If you need this kind of photo, you'll just have to rent or buy one of those cameras as there's no way to do it with an ordinary camera.

For any particular scene and camera location, the width of the scene you can photograph is limited by the width of the film frame in the camera. The trick used by some special panoramic cameras is to move the scene past the camera while simultaneously moving the film inside the camera at the same

This Widelux F-7 camera has a 26mm scanning lens that records a horizontal angle of about 160° onto a 24mm x 59mm frame of 35mm film.

With the Nikon Panorama Head you can rotate and lock the camera precisely in position for each frame of a multi-frame panorama.

The Widelux F-7 creates a photo with minimal wide-angle distortion because it uses a curved film plane. Photo by Ken Berard.

speed as the image. Others have a rotating lens which "wipes" the image onto a long curved film plane.

Multi-Frame Shooting—Another way to make long photos is to shoot multiple frames. By using the camera conventionally and merely changing position, a fragmented panorama can be made. The result will be a string of frames that show the total landscape when printed or viewed together.

Find an outdoor landscape you want to record. Focus and compose the left section of the scene. After the shot, keep the camera to your eye, cock the shutter and revolve your body clockwise until the right-hand side of the first frame is the left-hand side of the second frame. Try not to duplicate parts of the scene if smooth continuity of the landscape is your intent. Continue this method until you photograph the desired section of the landscape.

The technique can be used in different ways. You can stay in the same shooting location and revolve around that point to get a 360° panorama, or you can move in a straight line parallel to the scene.

Laterally moving the camera is best for flat, nearby subjects you don't want distorted by the pan method. Careful viewing and camera positioning is necessary for accurate image placement. Consecutive frames will have some common elements if you don't move the camera far enough. Or, the black spacing between frames will seem to cover the scene between frames if you move the camera a little past the common border between sections of the scene.

For precise circular movements of the camera, use a tripod with a pan head. This allows you to rotate the camera smoothly. The camera stays at the same height if the head is horizontal. Use a level to check. If you know the angle of view of the lens you are using, you can rotate the camera that angle for proper spacing with no image duplication. The accompanying table gives angles of view for different focal length lenses.

Special panoramic attachments which attach to a tripod are available. Nikon is one brand. The tripod head is locked so the camera revolves with the panoramic head.

It has a built-in level and click stops which let you make precise rotations of the camera. Click stops correspond to the angle of view of the lens you are using, but some overlap of image area is built-in to the click-stop mode of the head. If you don't want image overlap, there is also a setting that allows you to rotate the camera freely.

Process the exposed film, but do not have it cut. If you shoot slides, you can mount the strip in a window mat so it can be viewed by back light. If your enlarger is too small for the strip, have full-frame prints made from either the negatives or slides. But when shooting for this kind of assembly, have some common image area between frames. Then you can trim the prints and have the borders match-fit together in the composite scene.

ANGLES OF VIEW FOR SOME LENSES

Focal Length	Angle Of View
24mm	84°
28mm	75°
35mm	63°
50mm	46°
85mm	28.5°
100mm	24°
135mm	18°
200mm	12°

In this long landscape made with the camera on a tripod, the frame lines seem to cover parts of the scene.

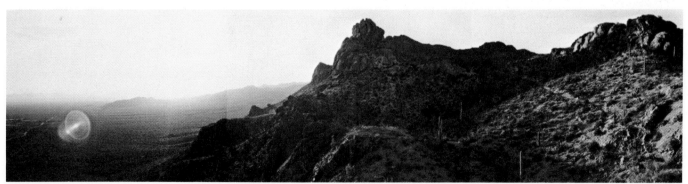

The Nikon Panorama Head was used for this photo to get precise camera positioning. Prints made from each slide were trimmed so they fit together as one continuous scene.

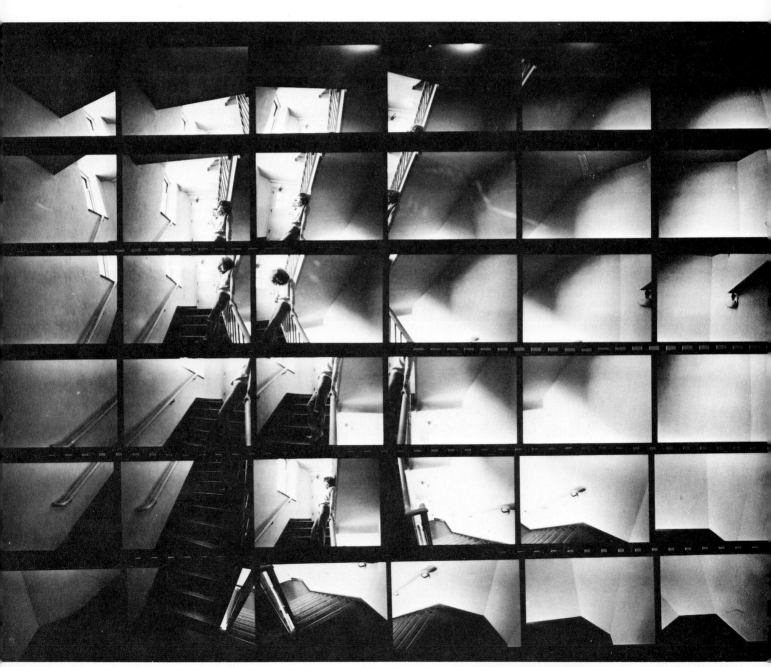

Another way to use the panoramic technique is to combine panoramas in the form of a contact sheet. Photo by Hassan Dajani.

2

LENSES, FILTERS AND LENS ATTACHMENTS

Most lenses and filters have two kinds of applications. One is the intended use of the lens or filter, which usually gives a photo without any visible special effect because you are using the equipment in the normal way. The other application is to use the lens or filter in an unusual way to create a special effect.

In this book, *filter* means a device for changing the color or amount of light entering the lens, but not causing any other visible effect on the image. Lens *attachments* change the image in some optical way, such as multiple-imaging a single subject or converting small light sources into star patterns. Obviously, the purpose of a lens attachment is to produce a special effect or you wouldn't be using it.

USING YOUR LENSES

Except for fisheye, zoom and macro lenses, using available lenses for ordinary photography is basically a juggling act involving angle of view, perspective and depth of field. Angle of view increases as focal length decreases. And if the camera position is not changed, the foreground/background relationship, or *perspective*, remains the same with all focal lengths. If you enlarge part of the 21mm photo to the size of the 200mm photo, they will appear the same.

Changing focal length *and* camera position adjusts perspective. The apparent distance between foreground and background is al-

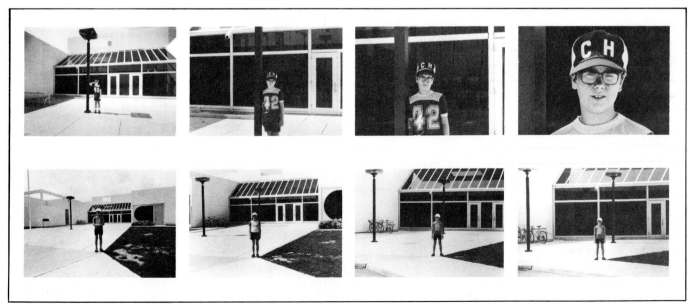

In the top series of photos, perspective is constant because camera position stays the same and only focal length changes. In the bottom series, perspective shifts because camera position and focal length change to keep the model the same size in each photo. Focal lengths from left to right: 21mm, 50mm, 100mm, 200mm.

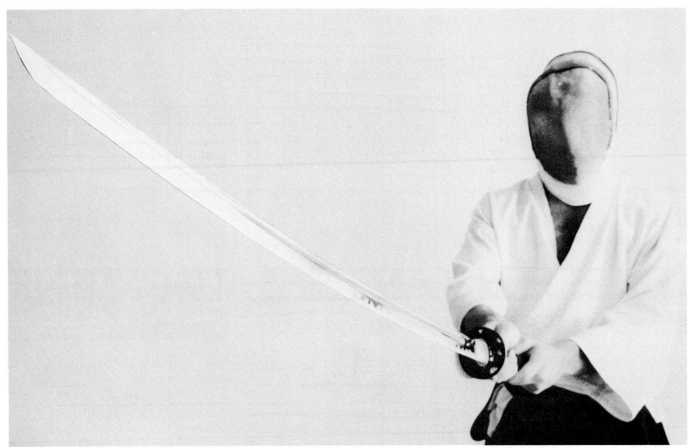

The sword is not really as long as it appears in this photo. The nearness of the tip to the 24mm lens distorted the true length.

tered as focal length and camera location are changed. Factors affecting perspective include lens focal length, camera position, final image magnification and viewing distance.

Depth of field is dependent on subject distance, *f*-stop and focal length. Generally, long focal length lenses have larger minimum apertures and less depth of field than a wide-angle lens.

Exploiting Short Focal Lengths— Lenses with short focal lengths can focus with very short distances between lens and subject; a typical 20mm lens can focus on a subject less than one foot away. This allows you to get so close that the resulting photo of a person looks more like a caricature than a portrait. This is the way to get large noses receding into a small head, a huge hand reaching out to the viewer or a comically large foot connected to the subject's body tapering off into the distance.

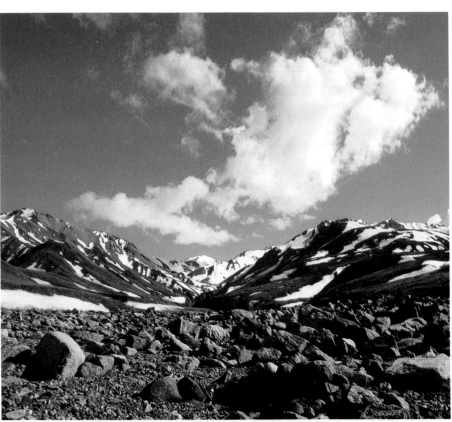

With an aperture setting of *f*-16 on a 24mm lens, you can make very realistic landscape shots because the depth of field is from .75m to infinity. Photo by Ted DiSante.

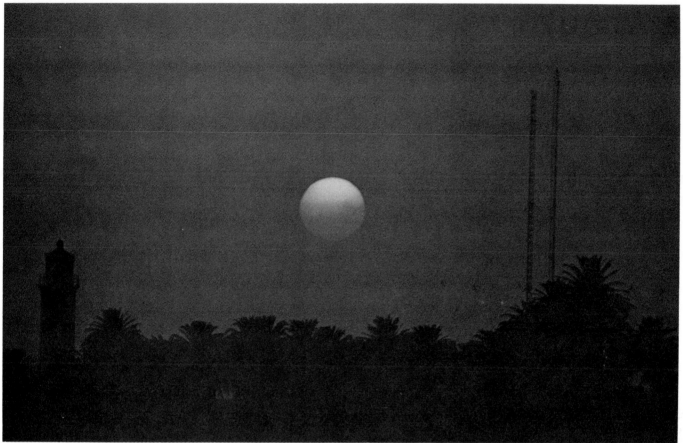
A 400mm lens increased the drama of this sunset by making the sun look closer and larger than real life. Photo by Dennis Scalpone.

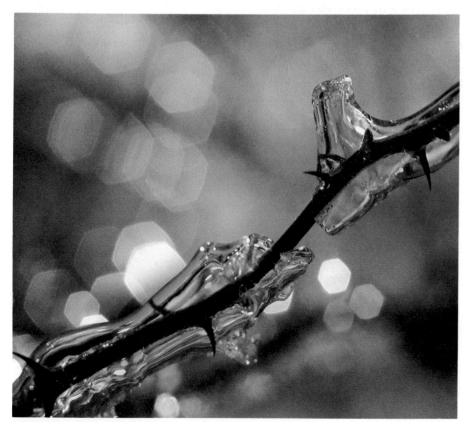
Out-of-focus highlights are important elements of this macro shot.

The effect occurs because the viewer of the image doesn't recognize what he is seeing. Put your eye close to the picture, and it looks the same as if your eye were close to the subject. We seldom look at somebody's foot from a few inches away, so it looks funny in the photo.

Another effect you can create is a feeling of intimacy in a landscape photo. Put a short-focal-length lens close to a flower or even down in the grass and adjust it so nearby objects are in focus. With medium or small aperture settings, distant objects will also be in focus, and the result is a landscape view we seldom see.

Foreshortening—Long focal lengths such as 200mm or 300mm seem to compress the distance between foreground and distant objects in a photograph. This effect is often used to make things look closer together than they really are. You can make ordinary traffic seem as if it were a hopeless traffic jam or

you can make a setting sun the same size as a foreground building.

Depth of Field—In an ordinary picture you try to adjust depth of field so it suits the mood or feeling you are trying to convey. When depth-of-field effects are exaggerated, the results can be considered a special effect. Usually, extreme depth of field is not noticed by the viewer unless it is done with a wide-angle lens so something close to the lens is also in focus.

Use small depth of field—sometimes called *selective focus*—to call attention to one part of the scene by having the part sharply focused and everything else blurred. This is particularly effective when everything between lens and subject is blurred, and the subject stands out because it is in focus. Long lenses with wide aperture work well for this—a 200mm, *f*-2 for example. Use the lens wide open and control focus to put limited depth of field where you want it for the desired effect.

Point of View—Another simple but effective trick without using any special eqiupment is to put the camera in some unusual location to take a picture. For example, put your camera down at the ankles of a crowd or stand on a balcony and shoot straight down. Photos such as these command attention because of the unusual point of view and thereby have a special effect.

Fisheye Lenses—These lenses have very wide angles of view—typically 170° to 220°, depending on focal length. Because of their short focal lengths, ranging from about 6mm to 17mm, some of these lenses have so much depth of field that there is no focusing control. Everything from a few inches to infinity is in good focus.

There are two basic kinds of fisheyes. A standard-format fisheye makes a circular image larger than the film frame, so you see a rectangular photo that is part of the complete circular image made by the lens.

A circular-image fisheye makes a circular image fitting inside the film frame—typically a 20mm diameter circle.

Look for unusual viewpoints to turn an ordinary subject into an interesting composition. Photo by Dennis Scalpone.

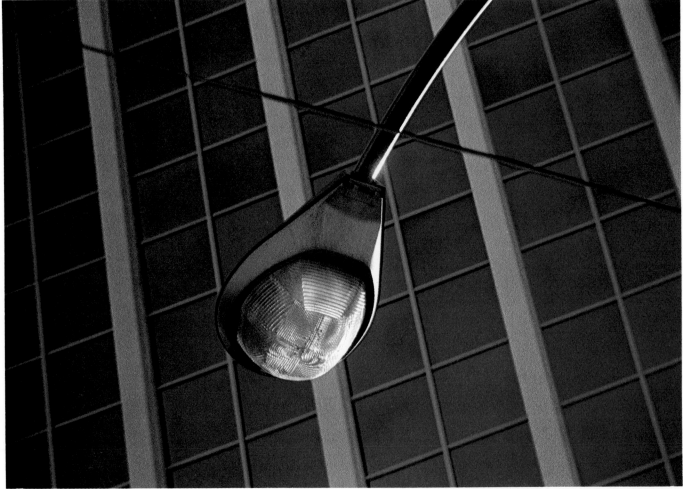

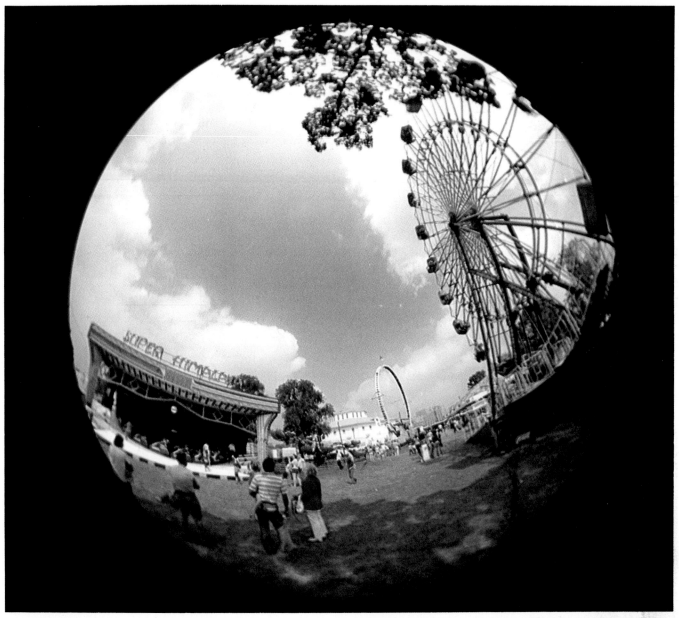

I used the Kalt fisheye converter on a 50mm lens to make this picture.

Both kinds cause *barrel distortion* of the image; any straight line not through the center of the lens bows outward. Using the distortion creatively is the basis of many special effects with a fisheye lens. By pointing the lens up or down from horizontal, you cause the horizon to become a hill or valley. If the horizon is water with boats on it, the effect is startling.

High-quality fisheyes are expensive. If you can sacrifice some image quality, consider a fisheye-conversion attachment. These mount on the front of an ordinary lens, reducing its focal length to about 15% of normal. A 50mm lens is converted to a 7.5mm lens with one of these adapters, and a 24mm wide-angle lens becomes a 3.6mm lens. A high-quality lens without any attachments should be used for best image quality, but for special results try what you have.

Fisheye conversion lenses have special adjustments to couple with the prime lens. A through-the-lens metering system can be trusted if used properly. You may include the sky in the scene and should compensate for it being in the meter's field of view. Bracketing exposures is a good idea.

This Kalt fisheye converter changes a 50mm lens into a 7.5mm fisheye lens.

19

Zooming—Zoom lenses have capabilities to create in-camera special effects. You can create exploded views of a subject in the center of the frame by zooming during a long exposure. A tripod and slow film allowing a shutter speed of about 1/8 or 1/4 second serve as starting points for this effect. Frame the subject in the center of the frame and use the smallest focal length setting. Begin the zoom and press the shutter-release button after the zoom has started. If properly done, the image shows a sharp outline of the subject and an expanding blur surrounding it.

Try zooming at different rates, directions and shutter speeds. Multiple-exposure photography also benefits from zooms because it allows you to use only one lens for a variety of focal lengths to create exposures with different perspectives and magnifications. Try zooming at night and combining exposures for wild montage effects. Create light trails by zooming during exposure. Let your imagination take charge.

High Magnification—Macrophotography makes a photo with special appeal when you record a scene that isn't normally observed, and so change the scale of life or see the unseeable. Special exposure and lighting techniques are not covered here, but a brief introduction to the equipment is in Chapter 5.

Whatever equipment you'll be using to make small subjects larger, remember to observe your subject carefully while planning the shot. Explore the intricacies of a butterfly wing with color film, investigate the subtle shadows or veins in foliage, or go completely abstract and record pure tones or colors. Choose one subject and photograph it extensively with macro equipment. Use different lighting, magnifications, color filters and viewpoints. Explore the subject in detail. Experiment and practice looking beyond the obvious to make an image worth remembering.

FILTERS

Filters should be used to support the subject because it is the most

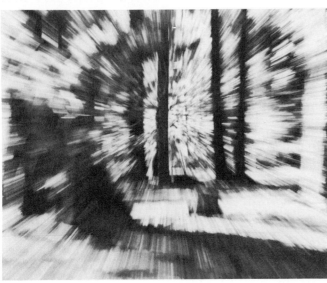

Color filters change the color of light by transmitting some wavelengths and blocking others.

Use color filters with b&w film to create tonal contrasts in objects that would reproduce in nearly the same shade of gray. The filter *lightens* its own color and *darkens* others.

No filter

Yellow filter

Green filter

Red filter

Opposite page, Top left
Iris Landscape by Kevin Marks.

Opposite page, Top right
All the gruesome details of a Cecropia caterpillar are apparent in this close-up view by Peggy Jakobowski.

Opposite page, Bottom left
Sally Cullen-Jorgensen used a 35mm-100mm zoom and 1/15 second exposure time to make this photo. Choose contrasty subjects for this effect so the exploding lines are emphasized.

important element in a successful photograph. A photo displaying dazzling filter technique combined with an uninteresting subject is still a dull image. When learning about a filter and its possibilities, shoot a scene with and without the filter for later evaluation. Decide whether the filter helped the photo or not.

STANDARD B&W FILTERS FOR SPECIAL EFFECT

You will probably recognize the assortment of filters in the table on this page. All have specific applications and yield no obvious effect when used normally. They are correction filters to make the best of less-than-ideal shooting conditions. You probably have some of them because the photographic situations that benefit from them occur so often.

TONAL CHANGES IN B&W

Standard b&w films are *panchromatic*, which means sensitive to all colors. This characteristic can cause different colors in a scene to appear as the same tone in a b&w print. This may make the scene appear

This gel holder screws into the threads of the lens and has a door that opens for placement of the gel.

less real or have less impact, but color filters can be used to create more tonal contrast in a b&w image. The color filter lightens its own color and darkens all others. Different degrees of contrast can be achieved by selecting the filter color and density from an array of colored gels and glass.

Yellow, orange and red filters darken blues and work well for increasing contrast in sky/cloud scenes. Green filters accentuate texture in skin tones and create a more natural rendition of foliage; a light red filter does the opposite.

You can often predict the result of using a color filter with b&w film, but sometimes you will be surprised. This is because film doesn't "see" colors exactly the same as we do.

COLOR CASTS

Extending the application of these standard filters for b&w film helps justify their cost. Try using them with color film to deliberately change or intensify color. The filters add color casts which give a different mood to a scene than if it was not altered. Amber color-correction filters or the warm yellow, orange and red filters are effective with sun, water and back-lit scenes because they intensify the feeling of warmth. Blue color-correction filters work well for wet or gray days to make the scene seem even colder. A deep blue filter used in daylight gives the effect of late night illumination by the moon. CC filters, or *color-compensating* filters, can also be used to create color casts.

FILTERS FOR B&W FILM			
Desired Result	Light	Filter Color	Filter
Sky/cloud contrast	day	light yellow	K2, 8
More sky/cloud contrast	day	deep yellow	9
Outdoor portraits or natural foliage	day	green/yellow	11
Penetrate haze	day	orange	16
Exagerrated sky/cloud contrast	day	red	25

FILTERS FOR COLOR FILM			
Film Type	Light	Filter Color	Filter
Daylight Color	3200K tungsten	blue	80A
Daylight Color	3400K tungsten	blue	80B
Tungsten Type B	day	amber	85B
Tungsten Type A	day	amber	85

SPECIAL-EFFECT FILTERS FOR COLOR FILM

Some special filters create effects only for color film. Advances in filter technology in the past few years have made them more affordable for the amateur photographer. The specific names of the filters vary with manufacturer along with differences in design, patterns and degrees of effect.

Color-Spot filters place the central portion of the picture in a clear circular area surrounded by the slightly diffused color of the filter. The effect is similar to a subject in a spotlight. Color-Spot filters are available in red, green, yellow, blue and neutral gray. They resemble a conventional color filter with the center cut out to give a spot or vignette effect. A similar filter can be made by cutting a circle in a gelatin filter.

The degree of effect depends on the aperture you use. The intensity of the color and the sharpness of the circular vignette decrease as larger lens openings are used. To avoid surprises, use the depth-of-field preview button on your camera to see the effect you'll get with any aperture.

With the filter placed in front of the deeply recessed front element of a macro lens, a soft vignette occurs at large apertures. This is not surprising because the filter is nearly two inches in front of the lens.

A **Dual-Color** filter is composed of two semi-circular pieces of different-color materials combined to make a full circle. They are available in various color combinations including red/green, yellow/purple and red/blue. You can rotate the filter and place the contrasting colors where they will help the picture. Try making multiple exposures of a scene by revolving the filter for each exposure.

Another kind of dual-color filter is made of two circular filters that give you a range of colors. As you revolve the outer ring of the red/blue filter, for instance, the color shifts from red to violet to blue, thus letting you choose exactly the shade you like best. These filters are also available in red/green, yellow/blue and red/yellow combinations.

Graded filters have uses similar to a simple dual-color filter. Cromofilter is one brand. Others are similarly designed. The filter color is in one half of the glass, and the other half is clear. The boundary between the color and clear area consists of a density gradation which prevents a sharp border from being imaged.

A Color-Spot filter.

The Color-Spot filter accentuates the middle of the frame.

Mauve and neutral-gray Cromofilters.

This Dual-Color filter has a *range* of colors between red and blue.

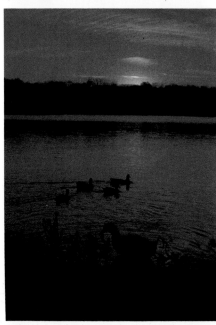

As you rotate the outer rim, the color changes, so you can choose the shade that fits the scene best.

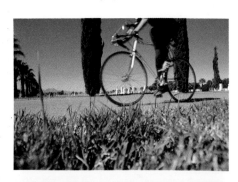

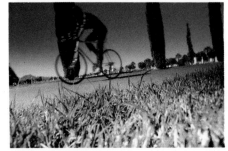

Before and after shots using stacked Cromofilters to dramatically darken the sky.

Use these filters to reduce the brightness range of a scene by adding color and density. They include basic reds, blues, greens, shades in between, and neutral grays of different densities. The filter can be rotated so you can place the color where appropriate for the scene. Or use these filters to darken sky or foreground in landscapes and for enhanced or artificial color. Try combining two filters for even more color shadings. Accentuate a portion of the scene by selectively darkening or lightening it. Using the filters may fool your meter, so bracket a half step in each direction for best results.

Color-Separation filters can give fascinating results in day or night photos when you make two or three exposures on the same frame and use a different filter for each exposure. Recommended red, blue and green filter sets are **25, 58** and **47B** or **25, 99** and **98**. Satisfactory results are obtained with **25, 13** and **80B**.

Fast-moving clouds, cascades and masses of water, and rustling foliage are popular subjects. The idea is to use a moving subject and wait a little between exposures so the subjects moves. The result shows some highlight areas as a single color and some a blend of two filters. Most areas have an overlap of the three filters which combine to show things in approximately normal colors.

Multiple exposures of moving vehicles through two or more filters at night will produce interesting patterns where trails overlap. These are ordinarily made without moving the tripod and camera between exposures, but the desired effect dictates technique. Motion can be added to static scenes by moving the camera between exposures. A scene with a black background allows all kinds of manipulations between exposures including perspective shifts and using filtered flash. See Chapter 3 for more information about flash.

Multiply the film-speed setting by the number of exposures you want to make. Meter the scene with the filter in for each exposure. For example, if you are using ASA 200 film for three exposures on the same frame, set the film speed on the camera to ASA 600; ASA 640 is a standard setting and is close enough. This gives each exposure shot 1/3 the total exposure and compensates for the added density of each filter.

Change an ordinary sky into splashes of colors by triple-exposing through color filters.

SPECIAL-EFFECT FILTERS FOR EITHER B&W OR COLOR FILM

Categorizing filters according to their normal use results in some being classified for b&w and others for color films. Don't worry about these classifications because you can use any filter with any kind of film, particularly when striving for special effects. This section deals with two filters normally used with color and b&w films.

Polarizing Filters are used by many photographers to control light polarized by reflection from most smooth surfaces. When it is reflected from a horizontal surface, we call it *horizontally polarized;* from a vertical surface it is *vertically polarized.* Light from some parts of a blue sky is also polarized. See the illustration on page 25.

By rotating a polarizing filter, you can control the polarization of light it transmits. If set to transmit horizontally polarized light, it will block vertically polarized light, and vice versa.

These filters are useful to block glare due to reflected light from a surface. When photographing through a glass window, for instance, you may see only the front surface of the glass because of reflected light. A polarizer rotated to the correct position blocks much of the

A polarizer drastically reduces glare and reflections.

By removing some haze and glare, polarizing filters can increase the contrast and color saturation of scenes shot with color film.

reflected light and allows you to see and photograph through the glass pane.

Light is polarized most when reflected at an angle between 30° and 40°, depending on the surface. The effect of a polarizer is much more pronounced when the camera is located so the light it filters has been reflected at about this angle. You can verify this by looking through the polarizing filter while changing your viewing position.

Removing glare has other effects on a photograph. Leaves and foliage reflect blue light from the sky. Eliminate some of this reflection with a polarizer and the color changes because less blue light enters the lens. Water also reflects blue sky. When you use a polarizer to remove a reflection, the color and character of water change dramatically. Landscapes often become less hazy and have better color saturation when photographed through a polarizing filter because glare is removed from the scene.

The part of a blue sky that is polarized is always at a right angle to the sun, as seen from the camera location. If this part of the sky is in view when you take a picture, you can darken the sky dramatically by using a polarizer and rotating it for maximum effect.

Light loss through a polarizing filter is as much as two steps of exposure. The filter is commonly purchased as a screw-in type with an outer ring which turns so you can control the polarizing action and see it in the viewfinder. When satisfied with the effect, meter and shoot.

Caution: Some cameras with semi-spot meters give a false exposure reading when a polarizer is used. Check your camera instruction booklet or make some test shots if you are not sure of your camera's meter.

Neutral-Density filters absorb a specified amount of light and are used when the photographer must increase exposure time or open the aperture for some shooting situations. These filters are gray and do not change the colors of an image. They are commonly available as screw-in glass filters, which absorb one, two or three exposure steps of light.

For more light absorption, buy *ND filters* made by Eastman Kodak. These gel filters have a filter designation of 96. An ND .30 has an optical density of .30; a filter factor of 2X; and reduces exposure by one step. Table 2-1 gives the density, filter factor and exposure change for any ND filter.

Any effect which benefits from shallow depth of field or long exposure time may need ND filters. Brightly lit scenes or large apertures sometimes require a shutter speed faster than the upper limit of your camera. Conversely, a long exposure time may necessitate an aperture much smaller than the capability of the lens. The long-exposure effects

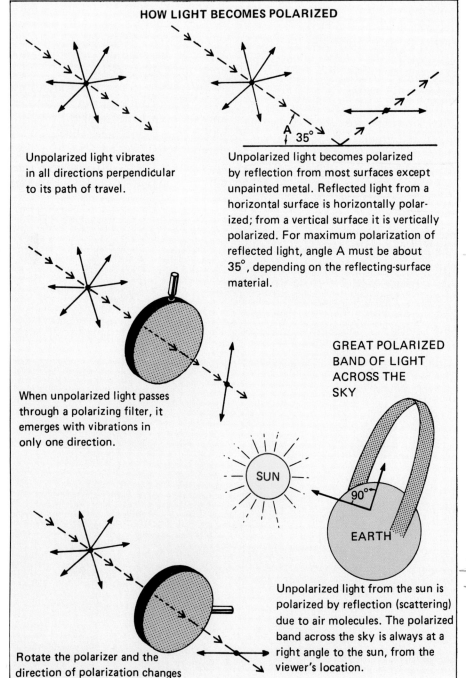

HOW LIGHT BECOMES POLARIZED

Unpolarized light vibrates in all directions perpendicular to its path of travel.

Unpolarized light becomes polarized by reflection from most surfaces except unpainted metal. Reflected light from a horizontal surface is horizontally polarized; from a vertical surface it is vertically polarized. For maximum polarization of reflected light, angle A must be about 35°, depending on the reflecting-surface material.

A 35°

When unpolarized light passes through a polarizing filter, it emerges with vibrations in only one direction.

Rotate the polarizer and the direction of polarization changes

GREAT POLARIZED BAND OF LIGHT ACROSS THE SKY

SUN

90°

EARTH

Unpolarized light from the sun is polarized by reflection (scattering) due to air molecules. The polarized band across the sky is always at a right angle to the sun, from the viewer's location.

mentioned in Chapter 1 sometimes need ND filters for certain light and film combinations.

A polarizer can sometimes be used as an ND filter when two steps or less of absorption are needed. Rotate the outer ring until your meter indicates the needed setting for the shot.

Remember, reciprocity failure may occur. See Chapter 1 for information on reciprocity characteristics of some films.

OPTICAL ATTACHMENTS

These devices look like filters, mount like filters and are often called *filters*. By the earlier definition they are not, even though common usage may not agree with the definition.

Optical attachments produce visible changes in the image by bending light rays and doing optical tricks as they pass through the attachment. The effect is noticeable and obvious to the viewer of the photo because you want it to be.

Diffraction or Rainbow gratings have become popular. These lens accessories look like flat glass or plastic, but actually contain thousands of grooves per inch. These grooves or fine lines break white light into a spectrum with bands of red, orange, yellow, green, blue and violet—the colors of the rainbow. Various patterns are available from several manufacturers. Straight and parallel grooves create a linear-diffraction grating and other designs have the lines radiating outward from a center point or as circles surrounding a center point. The visual pattern of the diffracted light usually shows the line pattern in the grating.

All of these patterns are available in screw-in holders. Some are available as plastic squares which you place in a gel holder in front of the lens.

In my opinion, simple linear-diffraction gratings are most versatile. This category includes the Kalt Multiburst, the Hollo Spectralstar Andromeda, and the Samigon Linear Diffraction Grating.

If you are pleased with the results, you may also want to use the radial or circular-effect variations. These spectral displays overpower most subjects and should be used sparingly unless the effect itself is the goal.

An important consideration with circular-diffraction gratings is the lens focal length. If the light source is in the center, a 50mm lens crowds the circular pattern close to the edges of the frame. A 35mm lens gives more room for the full rainbow design. Imaginative effects are possible using portions of the pattern with a long focal length lens held so the light source is not centered.

With the circular grating you must use the lens at the largest aperture to get a full circle. At night this is no problem, but daylight shooting frequently requires ND filters. A rainbow arc rather than a circle may be best for some subjects. Previewing the image with the depth-of-field preview button or lever helps you decide on the best effect.

The spectral pattern needs a dark background to show well, and full daylight scenes wash out the pattern. Place it in shadows, dark-colored areas or shoot at night.

Soft-Focus attachments are often used for portraits of young women and children because of the dreamy mood they produce. With older people they make wrinkles less apparent. These attachments are colorless and have a wavy, uneven

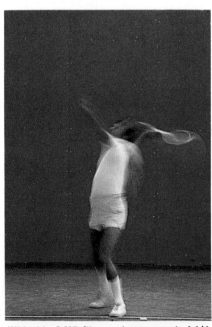

With this .6 ND filter, a shutter speed of 1/4 second could be used on a bright, sunny day.

USING NEUTRAL-DENSITY FILTERS TO INCREASE EXPOSURE TIME OR APERTURE		
FILTER NOMENCLATURE	MULTIPLY EXPOSURE TIME BY:	OPEN LENS APERTURE BY (f-STOPS):
ND .1	1.25	1/3
ND .2	1.6	2/3
ND .3 or 2X	2	1
ND .4	2.5	1-1/3
ND .5	3.1	1-2/3
ND .6 or 4X	4	2
ND .8	6.25	2-2/3
ND .9 or 8X	8	3
ND 1.0	10	3-1/3
ND 2.0	100	6-2/3
ND 3.0	1000	10
ND 4.0	10,000	13-1/3

Table 2-1

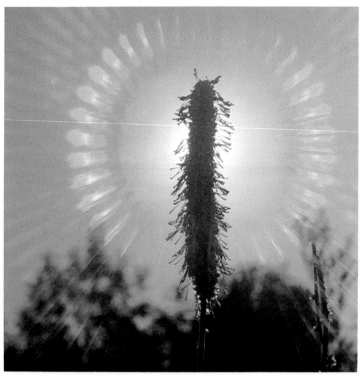

You can use diffraction filters during the day, but be sure to subdue the light source so you don't totally washout the pattern.

For this photo, Mike McGary used a homemade soft-focus filter made by painting a piece of acetate with clear nail polish.

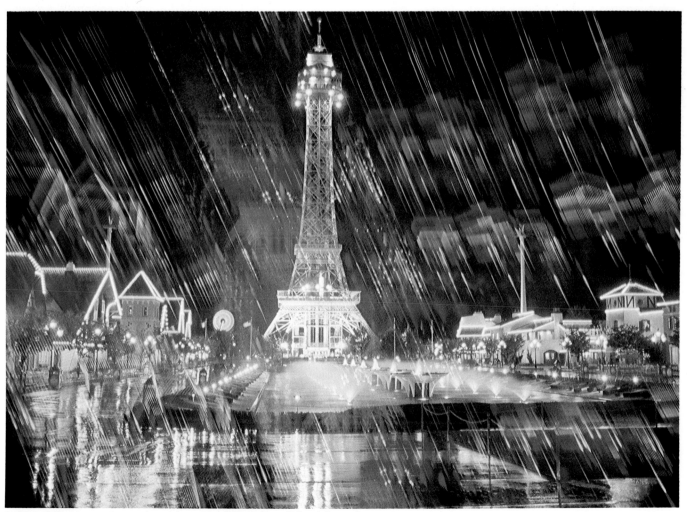

A linear-diffraction grating used at night can produce an incredible rainbow rain.

surface or fine lines engraved in the surface to blur the image slightly, producing a soft effect. Various designs have different degrees of softness and uses. Some have the soft-focus or diffusion effect increasing away from center; others have a clear central area with diffusion surrounding it. The most common type gives equal diffusion throughout the image. A few designed for landscapes are called *fog filters*, and some of these have a blue color to intensify mist, haze and fog.

With a concentric-circle diffuser, use the depth-of-field preview to check image softness at the aperture selected. Opening the lens to maximum aperture produces most diffusion and reduces image contrast. Stopping down the lens increases contrast, but softness diminishes if you stop down too far.

A soft-focus attachment is easy to make. A little experimenting may even produce something better than the commercial products. The messiest way is to spread a thin coating of petroleum jelly on a haze or skylight filter. Be sure it is on the outside of the filter because you don't want the stuff on the camera lens. For portraits, try leaving the center clear. When taking landscapes try a thin coating over the entire filter. Dust clings to the jelly, and this limits the time you can use it before cleaning and re-smearing.

A more-permanent homemade diffuser can be made with clear nail polish and a piece of acetate or glass. You can use a UV filter of course, but lacquer remover must then be used to clean it when it is needed for normal use. Practice on

a spare piece of glass or acetate by making radial swipes with the nail polish towards the sides or corners. Place the dry filter over the lens to see the effect. If the results aren't quite right, try again with a different technique.

Soft-focus attachments can be quickly made for those situations that catch you without one. The quickest and handiest diffuser is no farther than your nose. Use your finger to smear oil from the side of your nose on the glass filter of your choice, but DO NOT smear it on the front element of your lens. The filter can later be cleaned with lens-cleaning fluid. Or cellophane can be crumpled, straightened and placed in front of the lens to create a soft-focus effect. If the glass, acetate or cellophane is a 3-inch or larger square, it can be made to fit a gel

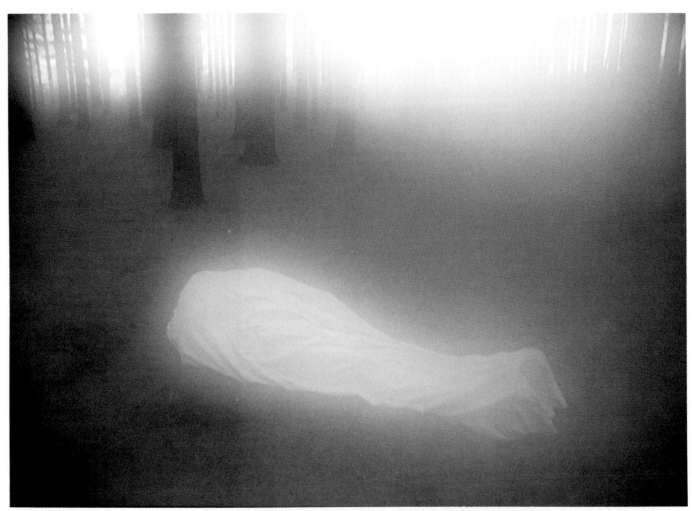

To create this eerie photo, John Cooper breathed on the front element of the lens to make a diffusing layer of condensation.

holder, or the material can be cut into circles to fit an adapter ring which screws into the lens.

Cross-Screen lens attachments add a sparkle or starburst pattern to highlights on a photo. Several types are available to create four-, six- or eight-pointed stars. A variable-star type allows you to vary the effect from a cross shape to an X shape. Cross screens bear a rough resemblance to rainbow filters. Fine lines etched in grid patterns diffract rays from small, bright light sources and intense reflections. Small brilliant highlights from water, metal, glassware and jewelry are appropriate subject matter for star sparkles. Most cross screens also give some soft-focus effect to the subject because of the etched lines on the glass. The filters work best at apertures between *f*-4 and *f*-8. Smaller apertures reduce the effect and make highlights look slightly out of focus.

Before buying a cross screen, try making and experimenting with your own. Fine window-screen mesh can be trimmed to fit an adapter ring or placed in a gel holder. A single screen gives four-pointed stars. A sandwich of two screens angled at 45° gives eight-point stars. If the mesh is metal, you may want to carefully spray paint it a dull color to help reduce reflections and glare. A thin piece of glass can be converted into a star-maker by lightly sanding lines into the glass with fine sandpaper. You can angle the lines and put them where you want for the scene.

Prism accessories are also known as Mirage, Multi-Vision or Multi-Image attachments and come in various forms to produce three, four, five or six duplicate images on one frame. Most come in a mount with a handle so you can rotate the element and change the orientation of the images. They are threaded to fit a camera lens or an adapter ring. Some are also front-threaded so you can screw in a second attachment, but vignetting may occur when using two accessories with a wide-angle lens.

Arrangement of the images varies with the device. They can be oriented horizontally, vertically, triangularly, pentagonally or hexagonally around the center of the frame. Essentially, the center is surrounded by less sharp images but this can be improved by stopping down the lens. Effective use of these accessories requires an SLR camera which lets you see the image location change as you rotate the attachment, change camera position or stop down for sharper duplicate images. The prisms work best on 50mm or moderate telephoto lenses. With longer focal lengths, not all of the duplicate images may be imaged on the film plane.

Subject matter which works well with the prism effect can only be decided by you. Because an image is being repeated, keep it simple or abstract. A boring image quickly becomes worse when repeated three or more times.

Split-Field lenses give the effect of two lenses at the same time—one focused on a nearby object and the other focused on a distant object. The split-field lens is simply half of a close-up lens mounted on a filter ring—half is glass, half is air. The nearby object is imaged by the glass portion. They are available in diopter ratings of +1, +2, and +3 for different degrees of near-object magnification. The ring also rotates so you can locate the foreground object wherever necessary. They are used the same as ordinary close-up lenses as described in Chapter 5.

I used a Hoya Vario-Cross attachment to add more impact to this silhouette.

I like the vignetting created by adding a filter onto the prism attachment.

Homemade Apertures can be used to cause out-of-focus highlights to take the general shape of the aperture. Cut a small geometric shape out of some opaque material which you can put in a gel holder or adapter ring. Imaging a pattern onto a high-contrast film creates an aperture you can later use in front of the lens. This kind of film is discussed in Chapter 4.

The highlights to be imaged in the shape of your pattern are often best used when combined with other images by making multiple exposures or sandwiching slides, so look for small bright spots in a dark field when shooting. Try illuminating crumpled aluminum foil to create your own highlights.

The lens should be nearly wide open for the aperture shape to be imaged. Adjusting focus also varies the size of the highlights, but you must experiment to get the effect you want. Try some of the previously mentioned attachments with this setup for stronger patterns. Multiple exposures with different apertures, colors and camera positions increase the possibilities even more. Exposure adjustment is sometimes necessary when you are using an aperture attachment in dim light. If it is difficult to see the meter reading or if the light level is below the meter's sensitivity range, meter without the homemade aperture and with the lens wide open. Add two or three steps of exposure by prolonging the *exposure time* when

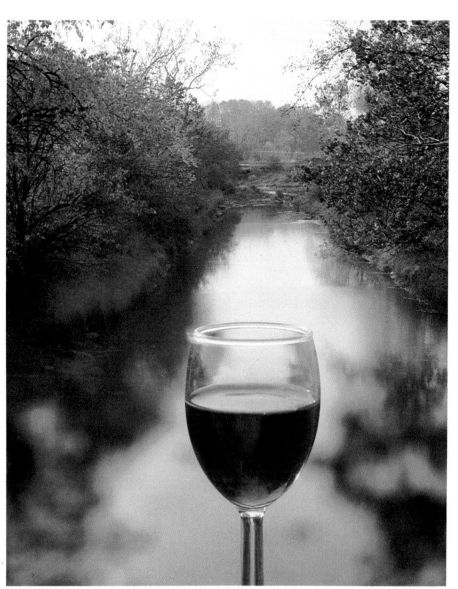

I used a split-field lens to expand the depth of field in this scene.

Split-field lenses are close-up lenses with half of the lens cut away. They give two zones of sharp focus—one at the focal length of the close-up part and the other where the camera lens is focused through the cut-away portion of the close-up lens.

A homemade aperture installed in an adapter ring that screws into the lens threads.

the homemade aperture is in place. Do not change the aperture unless you want to change the size of the highlight pattern. Bracket to gain experience in judging how the size of the aperture and certain scenes interact for highlight images of your own design.

A Masking Device is another attachment you can use for in-camera effects. The holder unit attaches to the front of the camera lens and masks are inserted into the front opening of the holder. The masks are opaque with areas cut out to allow portions of the scene to register on the film. A negative or reversed mask can then be used to record a portion of a different scene, which registers on the unexposed areas of the same frame. If the masks are well aligned, no lines will show, and the multiple imagery is more effective. Other masks have cut out shapes, such as a heart or a vignetting circle, so they can be used for the first exposure and no mask used for the second exposure. The imagery of the first exposure can then be superimposed onto elements of the second exposure or located in a dark spot so no image overlap is noticeable.

Keep the idea simple when first trying these techniques. Meter each scene without the mask and use the indicated exposure for the masked shot. Otherwise, the mask interferes with metering.

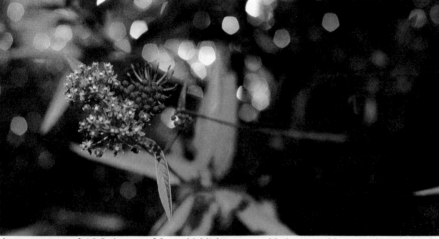

At an aperture of ƒ-2.8 the out-of-focus highlights are roughly hexagonal because the aperture in the lens is hexagonal.

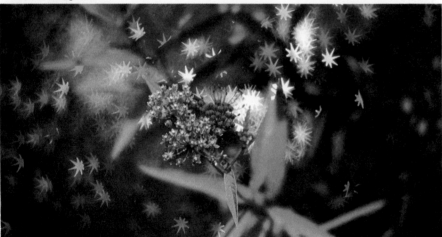

The highlights take on the shape of the homemade aperture.

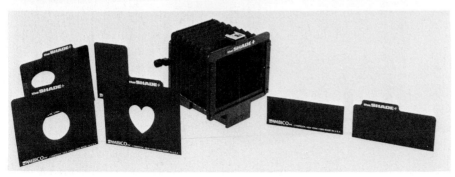

Bottom left
The Shade + made by Ambico can be used with different kinds of masks for different effects. Diffusing and vignetting sheets are also available.

The Ambico Shade + and two horizontal masks were used to make this double exposure. The top mask was used for the model and only the bottom mask was in place for the rack.

3

LIGHT

Light is a small segment of the vast range of electromagnetic energy—usually arranged according to wavelength in a diagram called the *spectrum*.

Short-wavelength radiation includes gamma rays, X-rays and ultraviolet rays. They are invisible to the human eye but can expose film. Infrared wavelengths are longer than visible light, and we feel them as heat. Two special films described in Chapter 4 can be exposed by infrared radiation.

The portion of the spectrum of which we are most aware is visible radiation or *light*. The colors of

light are also divided by wavelength, and today the standard unit of measurement for wavelength is the nanometer (nm), which is equal to 0.000000001 meter.

Light wavelengths range from about 400nm to 700nm. Most optical glass transmits wavelengths shorter than 320nm. Most films are sensitive to the blue region—that portion of the visible spectrum with wavelengths shorter than 450nm. *Orthochromatic* film records up to the green portion, 550nm; and *panchromatic*, or *pan*, films record red wavelengths to 700nm. Films and techniques that record various

parts of the spectrum for special effect are discussed further in Chapters 2, 4 and 5.

Light is a tool the photographer uses to translate form and space into colors or a tonal scale which is an interpretation of our three-dimensional world. In addition to light quantity, you must have a feeling for the light quality and the psychological effects produced by its variations.

Your use of light in special effects may be the sole effect, but try combining various techniques to make a photo with unique visual appeal.

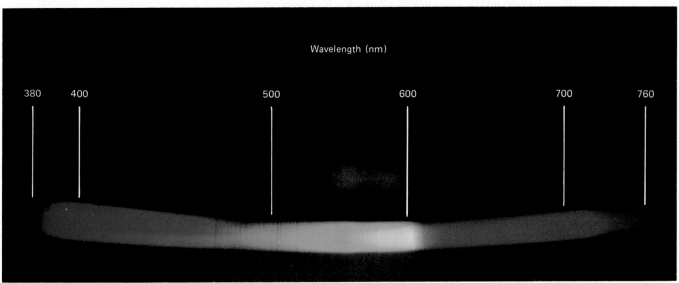

Sunlight passing through a diffraction grating is separated into its spectral components. Photographed at Flandrau Planetarium, Tucson, Arizona.

SUNLIGHT

Careful observation is the key to perception of subtle differences in the light qualities which exist during various times, subject positions and weather conditions. Sunlight is abundant and priced for everybody's benefit, so start with it and observe the dynamic interaction of sun and environment.

A simple exercise increases your awareness of the sun's changing position throughout the day. Choose a nearby building or outdoor sculpture and photograph it at two-hour intervals from dawn to dusk. Color film emphasizes the fact that light is more yellow in the early morning and late afternoon.

Long morning or evening shadows and the warm sunlight have a pronounced effect on mood. Fleshtones and landscapes acquire a warm and tranquil feeling. The colors are esthetically pleasing in most cases, but if color correction is desired, use a blue 82A filter.

Sunrises and Sunsets—Similar pleasing effects are possible when the sun nears the horizon during sunrises and sunsets. Clouds hovering about a setting sun signal an imminent display of color.

Sometimes, glowing multi-hued clouds are not enough to make outstanding photos, and foreground subjects or silhouettes can be included for a more interesting composition.

Exposure settings to photograph sunrises and sunsets can be made by taking a meter reading of a gray card or average scene with your back to the sun. Another way is to meter on the sky adjacent to the sun. Try a series of exposures. Use a variety of filters or make multiple exposures. A fill-in flash for foreground subjects adds intriguing color and separation between subject and sun.

6:00 AM

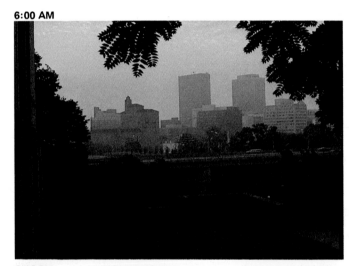

11:00 AM

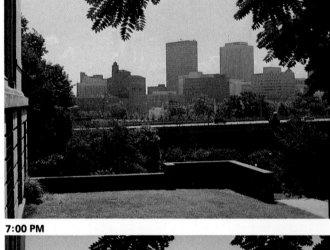

3:00 PM

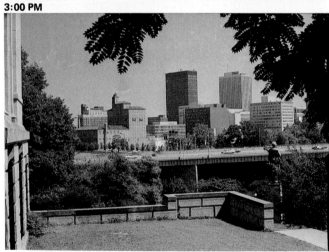

7:00 PM

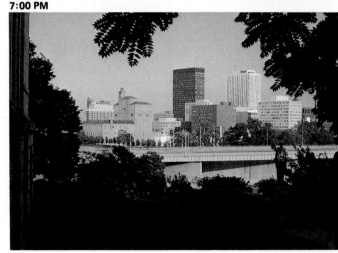

These photos illustrate the ever-changing colors, shadows and contrast that occur during the day.

NEVER LOOK DIRECTLY AT THE SUN THROUGH OPTICAL EQUIPMENT. PERMANENT DAMAGE TO YOUR EYE MAY RESULT.

The silhouetted oil derrick at sunrise breaks up the monotony of a cloudless sky.

I made the Chicago sunset more interesting by including city lights.

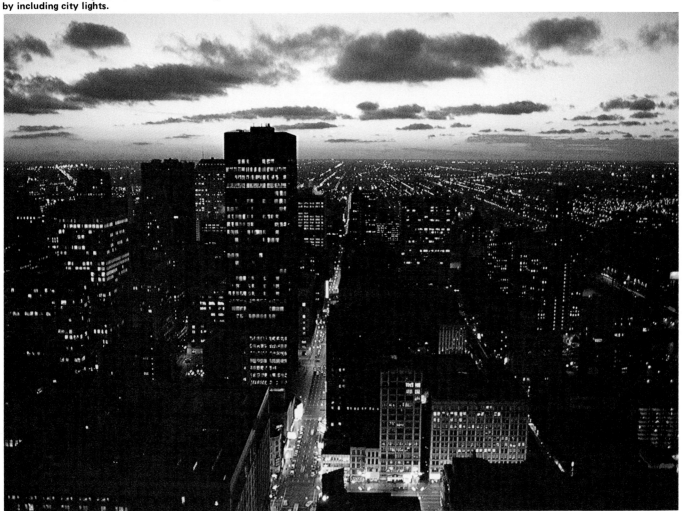

THE SUNNY-DAY f-16 RULE

Remember this rule and you'll be glad you did the day your exposure meter fails or you want to double check an exposure reading.

For subjects and scenes illuminated directly by the sun on a bright sunny day, shutter speed is the reciprocal of film speed when aperture is f-16.

Example: You are using ASA 125 film on a bright sunny day. Set aperture to f-16 and shutter speed to 1/125. If you are using ASA 32 film, you want a shutter speed of 1/32. The nearest marked speed is 1/30 and that's close enough.

When the sun is low, shadows seem to have an existence of their own. Elongated shadows sometimes have bizarre or striking shapes which can fill the entire frame to form an interesting scene.

DIRECTIONAL LIGHTING

A feature that has a great influence on photos taken in direct sunlight is the relative position of subject and sun. Because the sun's position with respect to the zenith causes variation, outdoor directional light can be classified into three categories: *front lighting, side lighting,* and *back lighting.*

Front Lighting—This occurs with the sun behind the photographer. The flat, uniform illumination on the subject tends to conceal shadows from the camera view because they are behind the subject. The illusion of depth and form are minimal, but this does not prevent front lighting from being used for special effect; other effects discussed can be used with front lighting. Try softening the harshness of direct sun with diffusers between the sun and lit areas of the subject. This works particularly well with small objects and facial portraits.

Side Lighting—When light comes from either side of the subject, the combination of light areas and shadows gives a three-dimensional effect to the photo. Line and form have improved texture and contrast relative to front-lit subjects. The strongest contrast results when side lighting is used on a cloudless day.

Maximum texture is usually achieved early or late in the day when the sun seems almost level with the subject. The subject can be positioned so the light skims the surface around 90° to the camera/subject line. Light at this angle sculpts forms by outlining one side brightly and placing the opposite side in shadow.

Back Lighting—Light originating from behind the subject tends to pick out and isolate parts of the scene against a bright background. The shadows are directed toward the camera when the sun is low and can be included as an important element in the composition. The back light should be in a position

Long shadows on the Shubert theatre are the key elements in an otherwise ordinary photo. Photo by Stephanie Walter.

Front-lit photos can also be unusual.

Use side lighting to emphasize textures and shapes.

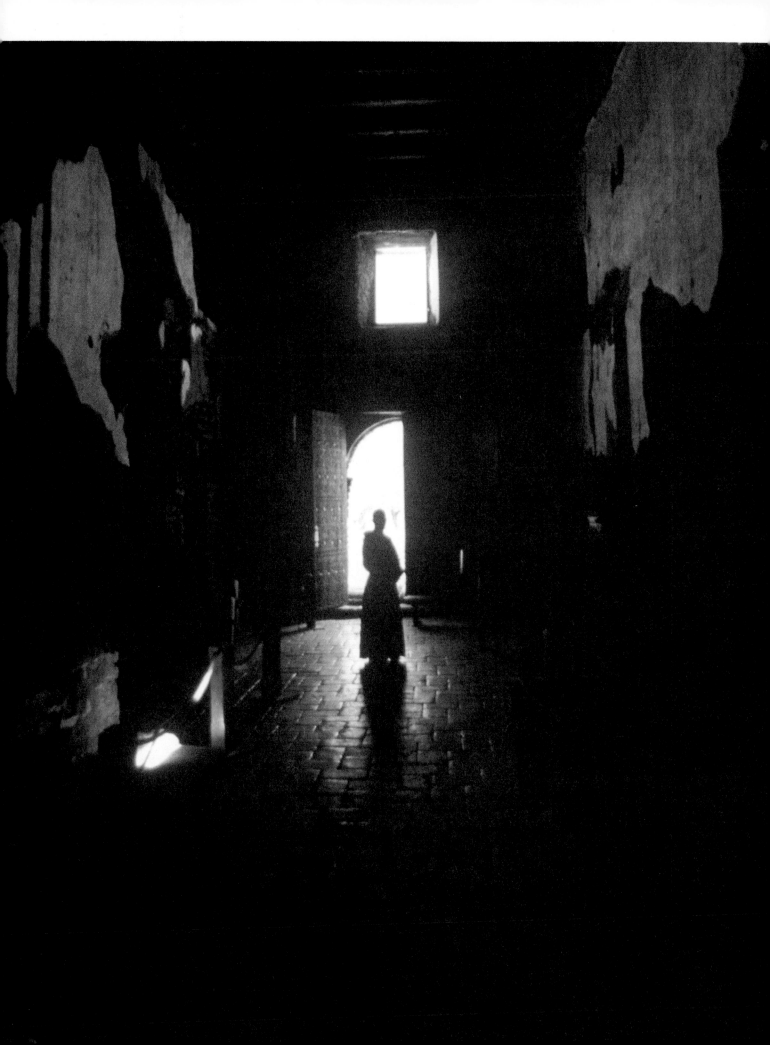

to emphasize the dominant portion of the scene, or the effectiveness of the light may be wasted. Back lighting can also outline or silhouette the main subject and make fine detail around the subject more discernible.

Flare and ghost images can be minimized by using lens hoods and multi-coated lenses, but sometimes they add an interesting effect of their own. The size of the ghost images can be adjusted with the *f*-stop. The smallest aperture makes the smallest ghost image.

Metering backlit subjects will fool the meter if you point the camera toward the light source. When exposing *for the light source or background,* meter with your back to the light while measuring from a gray card or an average subject. Use that exposure setting for the scene. This gives a properly exposed background and a silhouetted foreground. You can darken the foreground even more by underexposing. Fill-in flash or light from reflectors can reduce some unneeded shadows. Or you can expose for foreground detail by metering only the subject and not the background lighting. If the subject is dark, the background may washout from overexposure.

WEATHER

A slight veiling of clouds produces a diffuse light favorable for portraits, nature and some scenic views. Shade and heavy overcast conditions provide more diffuse light, and the light has a bluish cast which is sometimes noticeable in color photography. Subject contrast and shadows are reduced, and the brightness range of the scene may be reduced so it better fits the capabilities of color film. Diffuse lighting sometimes gives results similar to using a soft-focus lens attachment.

Wet-weather pictures normally evoke stronger feelings than those taken under fair-weather conditions. Remember how blue you sometimes feel during prolonged rainy spells of spring? To emphasize a similar feeling when shooting color on rainy days, try a tungsten-balanced film without a conversion filter. If you are already using a daylight-balanced film, try an 80B filter. To evaluate the differences later, make shots with and without the filter. I find filtering works best when the sky brightens a little at the end of a rainshower.

Opposite page
In this backlit scene, photographer Dennis Makes based his exposure on the interior light. This caused the detail in the windows to washout from overexposure.

Tungsten-balanced color film shot outdoors without a correction filter intensifies the cold-weather feeling in this landscape.

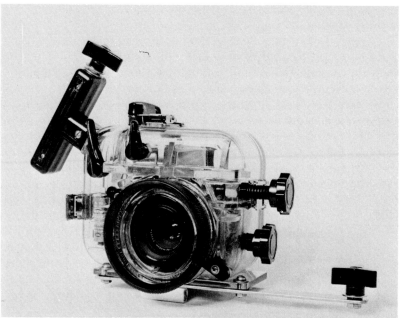

Underwater camera holders completely seal your equipment from the hazards of water. Photo courtesy of Ikelite Corporation.

This photo was made during a drizzling rain with a Nikonos II. Wet-weather photography often increases the color saturation of foliage. Photo by Ted DiSante.

Nighttime fog adds mystery to any scene.

Look for rainbows when your back is to the sun during rain showers. Mark Henry photographed this rare double rainbow.

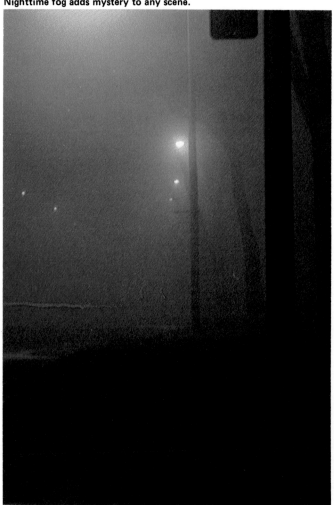

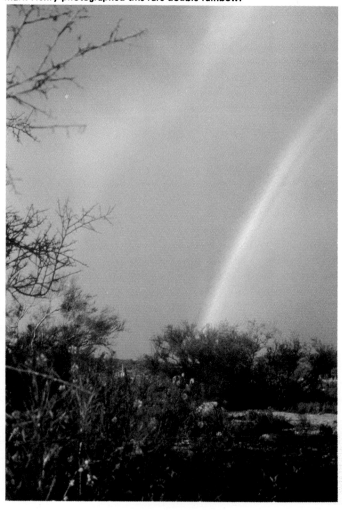

Snow, rain and drizzle have a diffusing effect due to light scattering from clouds and water in the air. Long exposures maximize the effect with color and b&w film. Rainbows and spring showers that occur with the sun shining are beautiful phenomena to photograph.

When in the rain, protect your camera and equipment. Photograph from under an umbrella or wrap the camera in a plastic bag with only the front part of the lens outside of the bag. You can also use an underwater camera, such as a Nikonos, or equip your SLR with an underwater camera case from camera shops or scuba diving equipment dealers.

Fog is another challenge to try if you like mood photos. The effects on colors and tones are more pronounced with fog than rain. Objects take on mysterious qualities as they partially disappear in an amorphous sea of white or gray. Fog can isolate a person from the environment and create a depressed feeling by lowering the contrast and hiding detail. A good time to shoot in fog is when the sun is on the verge of breaking through. The grays become lighter if they are far from the camera, and foreground objects retain darker tones or color for improved contrast and depth.

ARTIFICIAL LIGHT

Artificial light is more stable and controllable than sunlight. Special effects with incandescent tungsten lamps and flash are possible in the same way as with sunlight. A single artificial light can be arranged to create front, side or back lighting. Sometimes the light source creates the sole effect, but often it is used with other equipment or techniques such as in the discussion of still-life photography in Chapter 6.

Some basic considerations of artificial light are presented here and followed by special-effect suggestions. You may need reflectors, diffusers, holders and stands for some of them, and many are available for all kinds of purposes. But you should always consider the possibility of making your own accessories to fit the situation at hand. Most commercial photographers do.

What I like best about this fog photo is that the distinct foreground gives depth to the scene.

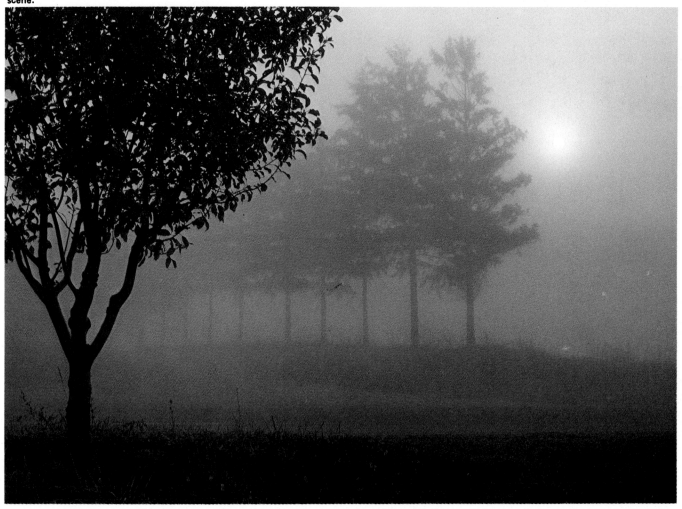

Tungsten Sources—Tungsten lights range from pencil flashlights to large studio floodlights, and the beam size varies from a sliver of light to a broad cover of soft light. Generally, the larger and closer the light source, the softer the light. More light surrounds the subject and lights it more evenly than a small or distant source.

High-wattage tungsten lamps come in three different color temperatures; 3400K, 3200K and 5500K, balanced for Type A, Type B and daylight color films respectively. The lamps vary in relative amounts of red, blue and green light. All tend to emit a warmer light as they are used—typically a decrease of about 100K during the lamp's life. The higher the color temperature of the lamp, the shorter the life. *Tungsten-halogen* bulbs give more light for the same power consumption, have a longer life and a more stable color temperature than regular tungsten bulbs.

Fluorescent Lighting—Fluorescent lights have a different color quality than tungsten lights. They emit bands of light from specific parts of the spectrum, and typically give daylight-balanced color film a bluish-green cast. To correct the color cast, a combination of magenta and yellow CC filters is usually recommended by the film or lamp manufacturer. If you have to get perfect color rendition, testing with various filters and films is essential. Some filter manufacturers make general-purpose screw-in filters which do a good job of correcting the color of fluorescent lighting. They are made for daylight and tungsten-balanced films.

Panchromatic b&w films are indifferent to color temperature. You can mix fluorescent, tungsten and daylight illumination in the same scene if you must. Orthochromatic and other special b&w films may require some exposure compensation when used with fluorescent lighting alone.

Opposite page
Stephanie Walter used a simple tungsten side light for this intimate portrait of legs.

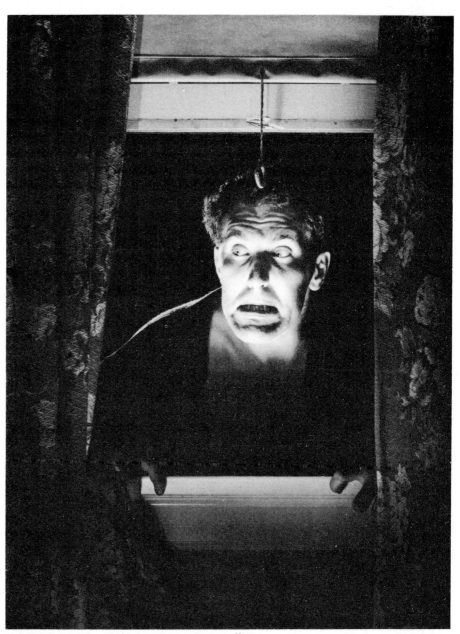

Lighting directed from below creates a caricature effect.

The worst aspect of uncorrected fluorescent lighting with color film is the effect on skin tones.

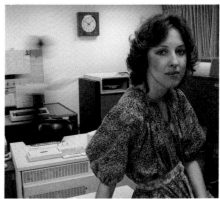

A Vivitar correction filter produces a much better result. Other manufacturers offer similar filters.

Electronic Flash—These are steadily replacing flash bulbs as artificial-daylight sources because they are more convenient, less expensive per flash and provide shorter exposure times. Light from a flash bulb can be as fast as 1/125 second, but some electronic flashes can give the same amount of light in only 1/20,000 second, and some automatic flashes have fast recycling times of less than a second for rapid-shooting sequences.

Short exposure times from a flash stop motion as if a "slice of action" is removed from the flow of events. Subjects moving too fast for us to see clearly can be analyzed and appreciated when photographed with a flash. Look for action within the effective range of the flash. This range is directly related to the flash *guide number* (GN). See Figure 3-1.

Automatic flash units simplify action shooting by giving the photographer a range of shooting distances in which the subject is properly exposed. These flash units make guide number calculations unnecessary.

When using electronic flash with an SLR camera, it is necessary to use the camera's flash-sync shutter speed or a slower setting. Electronic flash sync speed for modern 35mm SLRs ranges from 1/60 second to 1/125 second. A vertically operating shutter gives a faster sync speed than a horizontally operating shutter.

A flash can give telltale signs of its use and location. Used straight on the subject, it produces flat lighting with distinct shadows on a near background. If the model is looking directly at a flash on the camera, pink eyes may result from light reflected by blood vessels in the retina.

Flashes can be diffused, bounced and located in various positions for different shadow, highlight and depth effects.

In this photo, one tungsten light held above and behind the vase softly surrounds it with light.

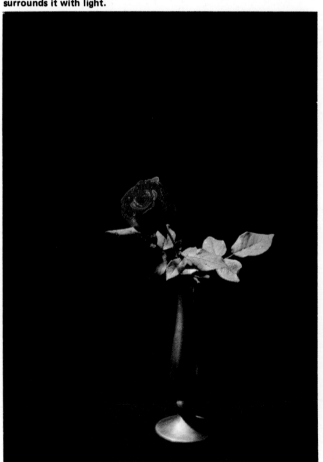

A flash was held in the same position as the tungsten light, but it produced a harsh, contrasty photo.

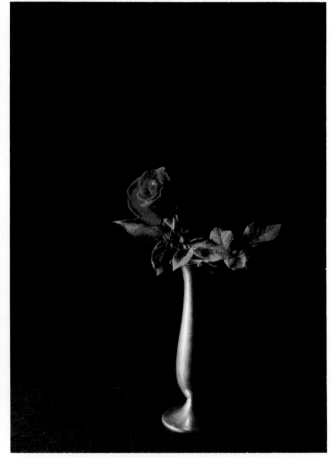

COMBINING FLASH WITH BACKGROUND LIGHT

Special effects are possible by taking advantage of the fact that a flash will synchronize at shutter speeds *slower* than the camera's designated flash-sync speed. For example, if the camera instruction manual says use 1/60 second shutter speed with electronic flash, you can also use any slower shutter speed, including B.

Thus, there are two exposure on the frame. One is due to the very short duration electronic flash and the other is due to ambient light operating for the entire time the shutter is open. If nothing moves, these two exposures overlap each other exactly, and only one image is formed on the film by the two light sources. A moving subject is imaged differently. It can be frozen sharply by the flash and also blurred due to the long ambient light exposure.

During one long exposure, three different light sources were used to make this image. Photo by Ted DiSante.

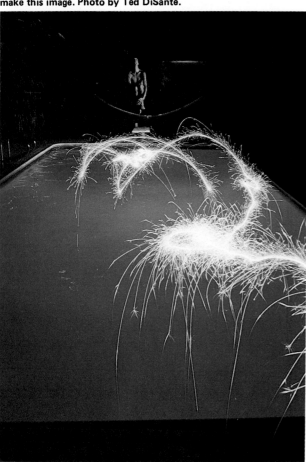

Figure 3-1

HOW TO USE FLASH GUIDE NUMBERS

DIRECT INDOOR FLASH

A guide number (GN) is published by the flash manufacturer based on the approximate light output of the flash. Guide numbers apply to flash bulbs and non-automatic electronic flash units. The GN is used to calculate an f-stop because most camera meters don't work with light from a flash. The formula is:

$$f\text{-stop} = \frac{GN}{Distance}$$

If the flash is mounted on the camera, the distance is from the camera to the subject. Focus on the scene and read the distance on the focusing scale of the lens or estimate it.

Example: If your flash has a GN of 99 feet and the subject is 9 feet away,

$$f\text{-stop} = \frac{99 \text{ feet}}{9 \text{ feet}}$$
$$= f\text{-11}$$

BOUNCE FLASH

If the flash is not mounted on the camera or the light is bounced, measure or estimate the total distance the light must travel to the subject. For instance, if the flash is bounced off a wall or ceiling, use the distance from the flash to the bounce surface plus the distance from the bounce surface to the subject. For bounce flash, open approximately two more stops because some light is absorbed by the bounce surface.

OUTDOORS

Guide numbers are based on indoor shooting in which reflections from room surfaces put more light on the subject. When shooting outdoors without these reflecting surfaces, open the aperture one-half to one stop.

CONVERSIONS

Sometimes GN is given in meters and sometimes in feet. The measuring units for subject distance and GN must agree. To convert:

$$\text{feet} = \text{meters} \times 3.3$$
$$\text{meters} = \frac{\text{feet}}{3.3}$$

A published GN is for one speed of film which should be stated. If you use a different film with a different speed, convert the guide number as follows:

$$\text{New GN} = \text{Published GN} \times \sqrt{\frac{\text{New Film Speed}}{\text{Published Film Speed}}}$$

Example: If your flash's GN is 60 feet for an ASA 25 film, but you want to use ASA 200 film and measure the distance in meters, use both conversion formulas:

$$\frac{60 \text{ feet}}{3.3} = 18.2 \text{ meters}$$
$$\text{New GN} = 18.2 \text{ meters} \times \sqrt{\frac{200}{25}}$$
$$= 18.2 \text{ meters} \times 2.8$$
$$= 51 \text{ meters}$$

TESTING THE GN

A GN is an approximation based on using flash in a typical indoor environment. You may want to test for the type of flash shooting you do. Place a typical subject a certain measured distance from the flash. It's best to mount the flash on the camera. With the published or converted GN, calculate the aperture setting needed. Bracket 1-1/2 steps in both directions in half steps and record the aperture setting for each exposure. Develop and choose the best-exposed photo. Then calculate the guide number:

$$GN = (f\text{-stop}) \times (\text{distance})$$

Example: The subject is 15 feet from the camera and flash. GN for the film you are using is 60 feet. Calculated f-stop is:

$$f\text{-stop} = \frac{60 \text{ feet}}{15 \text{ feet}}$$
$$= f\text{-4}$$

Bracket with f-2.5, f-2.8, f-3.5, f-4.0, f-4.9, f-5.6 and f-6.9. The half-stop settings are either click stops or can be closely approximated by setting the aperture between click stops. If the best exposure is from the f-2.8 setting, the adjusted GN is:

$$15 \text{ feet} \times 2.8 = 42 \text{ feet}$$

For your typical subject and shooting environment, the adjusted GN of 42 feet works better than the published GN of 60 feet.

Rick Gayle used tungsten-balanced film out-doors, but he taped an orange 85B correction filter over the flash window. This rendered the model in correct color, but left the back-ground blue because the color-corrected light from the flash didn't reach the background.

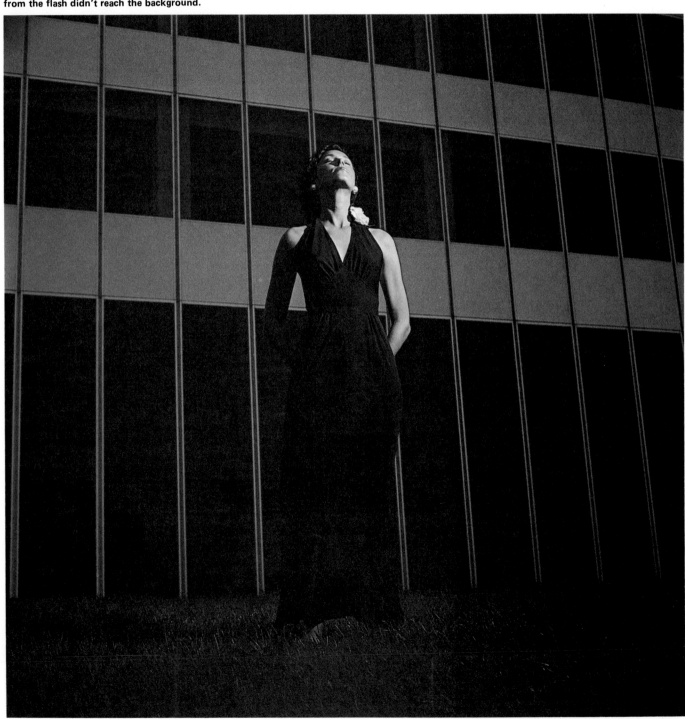

When the flash is fired by the camera, the flash occurs near the beginning of the exposure interval. Most electronic flash units have a button that allows you to fire the flash independently any time it is charged and ready to fire. With the camera on B and the shutter held open, you can fire the flash whenever you wish and as many times as you choose—provided the flash recycles fast enough. This is often called *open flash* because you fire the flash while the shutter is held open.

Foreground and background relationships can be manipulated with these two separate exposures. You can freeze foreground motion and let the background become blurred if it is moving, or subject motion can appear in front of a flash-frozen background. A moving subject and background can be in the same scene with either being flashed to freeze some of the action, and ghostly images result when this effect is used. You can also filter the flash to make a color distinction between subjects. Try to define the relationship between foreground and background visually; use the different techniques and see which works best for that scene.

Exposure Considerations—Meter for the background or ambient light with a slow shutter speed which synchronizes with the flash. Divide the aperture determined by the metering into the flash GN to find the flash-to-subject distance. If you can't use this as the camera-to-subject distance, do one of three things:

• Use a longer or shorter focal length lens and mount the flash on the camera.

• Attach the flash to a tripod or support at the calculated flash-to-subject distance and use a PC extension cord to connect camera and flash. This way you avoid changing lens or camera position.

• If the calculated flash distance is greater than the camera distance, but you don't have a sync cord, mount the flash with the camera. One exposure step of light is lost by either covering half of the flash window with your hand or by placing one thickness of tissue or handkerchief over the window.

These guidelines may be adjusted for a different effect by under- or overexposing the background light. If the subject is also front-lit by the ambient light, you may get best results by calculating both flash *and* ambient light exposure for one-step *underexposure*. The subject will be lit by the correct total exposure because the lights add, and some movement can still be imaged. Bracket for best results.

Another way to calculate exposure is to first decide on the f-stop necessary for the flash-to-subject distance you want. Then adjust shutter speed for the background exposure. Photo by John Cooper.

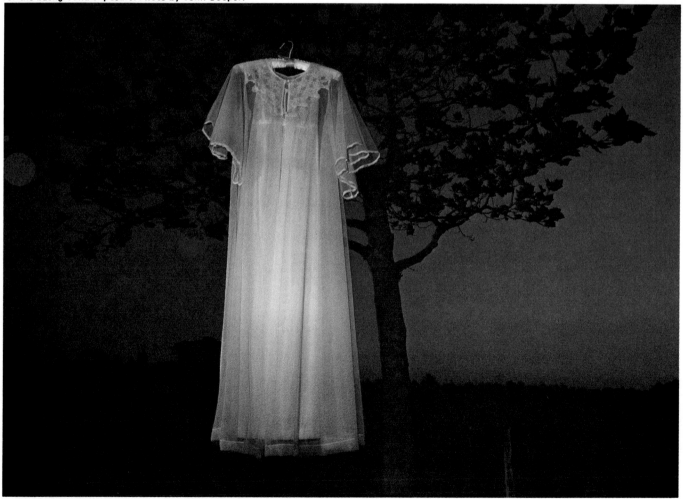

47

LIGHTING A SCENE

There are both ordinary and unusual ways to light a scene or subject. Sometimes more than one light source is used, and the resulting combination creates a certain *lighting ratio*. The main light creates the dominant light and shadow areas. Meter this light for proper exposure. The fill light softens shadows created by the main light and is usually to one side of it. Sometimes, fill light is supplied by reflecting main light from a white card or a mirror. The lighting ratio is the amount of light from the main light divided by the amount from the fill cast on the same subject.

Suppose the main light gives twice as much light as the fill on the same subject. This creates a *lighting* ratio of 2:1, and the subject has a *brightness ratio* of 3:1. This is the ratio of the light reflected from the subject—where the lights overlap—to the dimmest reflected light, where only fill light illuminates the subject. Brightness ratio is what you and the camera see when looking at the subject.

To measure the brightness ratio, meter a gray card placed in an area lit by both lights. Leave the card in the same place, turn off the main light and meter the card which is now lit by only the fill. The difference in exposure steps between the two readings is directly related to brightness ratio. Table 3-2 gives a range of step differences for measuring brightness ratios.

To create a certain ratio, place the main light to produce the desired highlights and shadows. Assuming the fill light is the same type of light source, place it farther from the subject than the main light. Table 3-2 gives factor L, which multiplied by the main-light distance gives the location of the fill light.

If you want to use two small flash units for your light sources, remember that most cameras have built-in dual flash contacts. One flash is attached to the sync socket on the body with a long PC cord,

and the other flash is attached to the camera's hot shoe. The camera triggers both units simultaneously when you take the picture.

In addition to the main and fill light, some photographers put a light on the background, overhead or behind the subject using either additional sources or reflectors to direct the light. With flash and tungsten sources, shields, diffusers, reflectors and filters can also be used for a desired effect. Place shadows where you want them, spread light, or filter it with different kinds of colored gels or glass.

Remember, a brightness ratio is only for one subject which exhibits a range of brightnesses because of the placement of lights. A low ratio implies a small difference between brightnesses or tones, and a high ratio implies contrasty tones. The *brightness range* of a scene is due

to all objects in the scene from the darkest detail in shadow to the brightest textured highlight.

High-Key Lighting—If both subject and background are predominantly white and are lit with a low brightness ratio, the lighting effect is called *high-key*. To create high-key photos, choose subjects with tones lighter than middle gray. Lighting a scene can be done with many lights from the front, side and above to eliminate dark shadows. According to Table 3-2, a low brightness ratio is achieved by having each light cast about the same amount of light on the subject. Slightly darker areas, such as a background, can be lightened by increasing the light in that area with reflectors or by adding another light.

An important part of high-key setups are blacks and reflective objects. To avoid a photo looking flat

Use high-key lighting for a subtle effect. Construction by Chris Tanz.

LIGHTING RATIO AND BRIGHTNESS RATIO			

Lighting ratio (R) = $\dfrac{M}{F}$

Brightness ratio = $\dfrac{(M + F)}{F} = \dfrac{M}{F} + \dfrac{F}{F} = R + 1$

HOW TO SET UP FOR FILL LIGHTING			
Lighting Ratio (R)	Brightness Ratio	Distance Ratio (L)	Exposure Difference (Steps)
1:1	2:1	1.0	1.0
2:1	3:1	1.4	1.6
3:1	4:1	1.7	2.0
4:1	5:1	2.0	2.3
5:1	6:1	2.2	2.6
6:1	7:1	2.5	2.8
7:1	8:1	2.6	3.0
8:1	9:1	2.8	3.2

Table 3-2 For lamps of same intensity: Fill light Distance = (L) x (Main Light Distance)

and overexposed, a small dark area is needed to catch the eye and imply that all tones are in the picture. Do it by creating a small shadow somewhere or by putting a small dark object in the scene.

Reflections from shiny objects are controlled by using diffused light. Drape white sheets around the scene and place lights all around and behind them. Diffusers on light sources work less well because the camera and photographer may still be reflected by the object. Put a white sheet of cardboard with a circular hole cut in it over the lens to reduce camera reflections.

Meter the scene carefully because of the special lighting. With tungsten or sun illumination, measure on a gray card in the scene so you expose properly for the non-existent middle gray. The brightness of the scene will fool an exposure meter if the scene is measured directly because the scene is not average. The resulting photo will be underexposed. Bracket to obtain overexposures from slight to extreme.

Tungsten lamps heat the scene and may make it uncomfortable for you or your models. Flash sources are helpful here, but the expense of many units may be prohibitive. If you can't use more than two flashes, increase lighting efficiency by positioning mirrors or reflective plastic sheeting outside the camera's view to reflect light onto the subject. Photographing small objects with two flashes allows plenty of bounce light to spread on the scene. Diffuse the sources a bit to lower the inherently high-contrast lighting.

A flash meter is ideal for metering a multiple-flash setup. Some automatic flash units have sensors in the flash body or on an extension cord to tell the flash when to turn off the light to get correct exposure. If the sensor is separate, put it with the camera and connect it to the main flash which triggers slave units. Bracketing is recommended, and careful evaluation of the results will make the next similar setup easier to judge.

High-key scenes are not limited to studio or inside shooting. Subjects on a beach, in the snow or in a desert have high-key potential if other objects in view are also light and have subdued shadows. High-key color photos have pastel shades and muted hues. Use some of the special films mentioned in Chapter 4 with high-key scenes. Grain in b&w films or push-processed color slide film works nicely with the special bright qualities of high-key lighting.

Ken Woisard used a flash straight at the subject to produce a thin shadow line, which becomes the only dark tone in this high-key composition.

Low-Key Lighting—The opposite of the high-key effect is achieved with *low-key* lighting. High brightness ratios are used and sometimes only one light source is employed for an extremely stark lighting effect. Subject and surroundings are darker than middle gray and shadows abound.

In these scenes, a glint of highlight is necessary to prevent the photo from appearing too dark. Use a reflected highlight or a small white object to imply a full-scale tonal range in the picture.

Position the light or lights from the side, underneath or behind the subject. Lighting low-key scenes is aided by using shields or barn doors on the lights to locate and create shadow areas. Deep shadows will always be in the scene, and their location relative to the main subject is important because the darkness helps define the lighter tones or colors. Shadow control is useful in low-key lighting.

Metering should be done in a shadow area with detail in it. Meter that region, and set the camera for *two steps less* exposure. This should preserve detail in the dark regions which dominate the scene. Low-key scenes are everywhere, so give yourself an assignment to discover or create some.

NIGHT LIGHTS

Shooting at night is a stimulating challenge for the special-effects photographer. In addition to using a flash at night, other sources such as the moon, lightning, city lights and moving lights can be part of photos made more exciting by the mystery of darkness.

Photographing at night implies

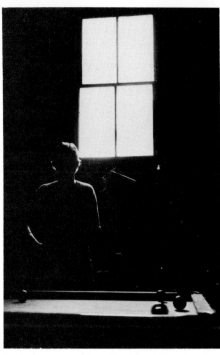

Silhouettes can often be turned into low-key scenes. Photo by Forest McMullin.

You can exercise some extra control in low-key scenes by printing the photo a bit darker than usual while still retaining some highlights. Photo by Chris Schneiter.

Light from the moon is the same color temperature as daylight. The color cast is due to long-exposure reciprocity failure. Photographed with Kodachrome 64 at f-2.8 for 30 minutes with a CC20R filter.

tion and daylight-balanced film if you shoot in color. The color temperature of moonlight is the same as a midday sun because moonlight is reflected sunlight. Suggested exposure settings for different phases of the moon are given in the accompanying table. The exposure times *are not* corrected for reciprocity failure. Bracketing is recommended, but bracket by changing aperture because doubling exposure times compounds the problem of long-exposure reciprocity failure.

The effect of moonlit photos depends on subject matter and other lights in the scene. Depending on how they are lit, slowly moving objects may be imaged as blurs, and quickly moving objects may not be imaged at all because they aren't in the same place long enough to record on the film. This lets you

will image a moon that is well above the horizon in about 1/4 of the frame. Use a tripod with long lenses to avoid blur. The accompanying table gives exposure recommendations for different types of moons as subjects.

Shooting the Stars—Stars do not radiate enough light to photograph other objects. The easiest way to photograph starlight with an SLR camera is to record the star trails with a long exposure. Because of the earth's rotation, stars in the northern hemisphere seem to circle the North star once every 24 hours at 15° per hour.

The thickness of a star trail imaged on the film depends on two factors—camera aperture and star brilliance. A simple test shows the effect of both. Attach the camera to a tripod and focus at infinity

EXPOSURE WITH THE MOON AS THE LIGHT SOURCE			
Phase*	ASA 100	ASA 200	ASA 400
Full Moon	f-2.8, 2 min.	f-4.0, 2 min.	f-5.6, 2 min.
Half Moon	f-1.8, 2 min.	f-2.8, 2 min.	f-3.5, 2 min.
Quarter Moon	f-1.4, 4 min.	f-1.4, 2 min.	f-2.0, 2 min

*high in clear sky

EXPOSURE WITH THE MOON AS THE SUBJECT			
Phase*	ASA 100	ASA 200	ASA 400
Full Moon	f-16, 1/125	f-16, 1/250	f-16, 1/500
Half Moon	f-11, 1/125	f-11, 1/250	f-11, 1/500
Quarter Moon	f-8, 1/125	f-8, 1/250	f-8, 1/500
Crescent	f-5.6, 1/125	f-5.6, 1/250	f-5.6, 1/500

*high in clear sky

A 200mm lens was used to make this triple exposure of a full moon.

long exposure times and sometimes reciprocity failure. Refer to Chapter 1 for specific information about reciprocity failure compensation. Equipment which may be useful at night includes a tripod, a locking shutter-release cable, a small penlight to illuminate the camera controls and a spot-type exposure meter, which measures small light sources without being unduly influenced by the predominant darkness.

The Moon as Light Source—Shooting moonlit scenes requires long exposure times, reciprocity correc-

run around the scene with lights or a flash and not worry about being part of the picture. The photographed scene appears amazingly similar to a photo shot at midday if you give enough exposure and correct for reciprocity failure.

The Moon as Subject—To expose for the moon itself, remember it is a subject illuminated by a bright sun. The sunny-day f-16 rule applies to a full moon high in a clear sky. The moon as subject is bright enough to let you use conventional shutter speeds with a medium-speed film. A 500mm lens

with the North star in the middle of the frame. With the shutter set on B, make successive four-minute exposures on a single frame of fast film such as ASA 400. Use a large aperture for the first exposure and reduce the aperture one step every four minutes until you get to f-8. Larger apertures and brighter stars cause the thickest trails. For this test and star photography in general, find an area away from city lights and pick a moonless night.

Inclusion of a tree or house in the foreground may improve the composition of celestial photos.

With the North star again as a focus point, set the aperture at the opening which gave star trails you like most and expose with the same type of film for as long as desired. Refer to Chapter 1 to correct reciprocity failure in b&w and color films. The result should be an intriguing circular star pattern possessing depth because of a familiar foreground silhouette. The foreground may also be lit with flash or moving lights. Or a crescent moon may give enough light to create some detail in the foreground without overexposing the sky.

Lightning Photography—Capturing elusive lightning flashes requires patience and a little luck. Avoid going out in a thunder storm with tripod and camera. Unless the storm is restricted to a distant part of the sky, it can be very dangerous. Normally I shoot through an open window or doorway.

With the camera on a tripod, point it in the direction where you saw the last few flashes and open the shutter to B. Whether you close the shutter after one flash or leave it open for two or more is your creative choice. Chain lightning gives long streaks in the image, but sheet lightning illuminates broad areas of the sky.

Depending on the detail you want in the sky or foreground, there are options in choice of aperture. I prefer *f*-11 or *f*-16 with medium-speed film such as ASA 125 because a minute or two may pass before you catch a flash of lightning. Long exposures tend to overexpose the sky—especially if sheet lightning is also occurring. Some photographers try their luck with larger apertures to get a bright-

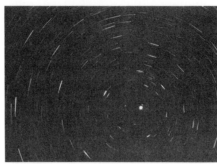

I aimed the camera at the North star and exposed Tri-X for 30 minutes at *f*-2 and then for 10 minutes at *f*-4.

The house was "painted" with light from street lamps during a 40 minute exposure at f-2.8 on Tri-X.

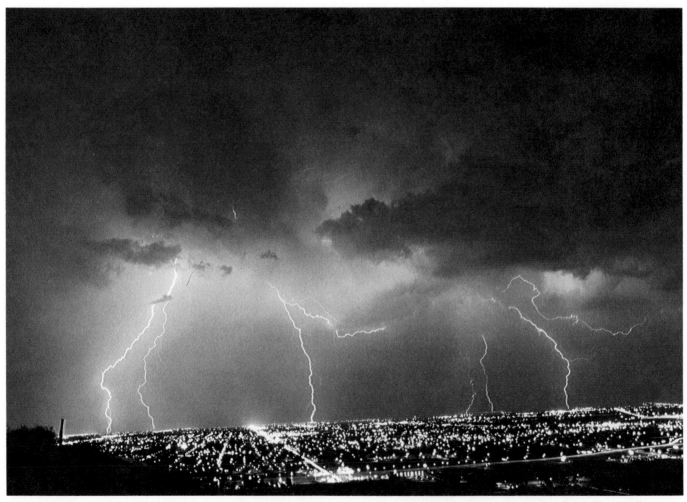

If you are going to photograph lightning while outside, make sure the storm is far away. For this photo, photographer Ralph Wetmore II was on a mountain during a storm over the city. And during the two-minute exposure time, lightning flashes occurred three times.

er image of lightning and better detail in the sky or nearby buildings. Try both.

For more effect, try filtering different flashes while using color film. Use a flash to light foreground subjects to make multiple exposure having lightning images. **Saving Moons and Lightning for Later Use**—Sometimes it's handy to have a moon or lightning that you can put into a photo to improve its composition or interest. You can do it by recording the moon or lightning first, then double-exposing later with another scene.

On a night with good moon or lightning conditions, load a roll of film in the camera. Before you close the back, remove the film slack by turning the rewind crank clockwise. Make alignment marks on the film and camera. A wax pencil or India-ink pen will do. Close the camera back and advance the film three frames. Shoot the roll, and make notes of how the images are placed in each frame. Remove the roll and store the film in its original container for future use. When that day arrives, reload the film and realign the marks on the film and camera. Shoot the roll again and refer to your notes so you can place the previously exposed images in a dark area of the new exposure.

If you would rather process the film after shooting moon or lightning scenes, you can still add them to other photos. A negative of lightning has a clear sky area, and the lightning is a black line. This negative can be used in a negative sandwich as described in Chapter 7. A moon negative can be used in other multiple-printing techniques also covered in Chapter 7.

Moving Lights—Motion at night allows the photographer to record trails of light which can imply action, time or abstraction. Photos made under these conditions are prime candidates for other kinds of special treatments, including slide sandwiching, darkroom manipulation, multiple exposures and filtering.

Skyrockets, flares, pinwheels and other fireworks are fairly predictable light sources once the display is underway. With the camera focused on the expected area, set the shutter on B and the aperture at f-11 or f-16 with ASA 125 film. Open the shutter when the light is in the field of view of the camera, which can be on a tripod or hand-held for different effect. Close the shutter when the light has passed. You can make multiple exposures by not closing the shutter, but ambient light will probably overexpose the frame

Try combining a fireworks display with other elements. Photo by Kent Wood.

53

unless you use a piece of black cardboard as a manual external shutter over the lens between displays. See Chapter 1 for making multiple exposures this way.

Traffic patterns are fun to photograph in all types of surroundings. Bright city streets, lit buildings or lonely roads work as effective backgrounds for a fixed-camera exposure. Exposure recommendations are difficult to make, but if the background is important, expose for it. Usually a 30-second exposure with a small aperture and medium-speed film such as ASA 125 can record light trails in the field of view. Bracket liberally and remember reciprocity failure. Try different vantage points ranging from a low-level street shot to a high-rise perspective.

An interesting variation is to photograph vehicular and city lights from a moving object. You can attach the camera to a bicycle, motorcycle or car and shoot with the camera set on B and aperture at f-11 or f-16. Tripod screws on clamps are available at most camera stores, and these tools will hold the camera securely. For safety, have someone else drive while you operate the camera.

Painting With Light—If you want to control the moving light source, the simplest way to do it is with a light you can hand hold and move in any direction. Use a flashlight, a light bulb in a reflector, a flash or even a candle. The light is pointed at the camera so trails are made or used to illuminate elements of the total scene.

If you are outdoors at night or in a dimly lit interior, and you want more light on the scene than your lighting gives, illuminate the scene by parts. Attach the camera to a tripod, frame the scene and open the shutter on the B setting. Move around the scene while slowly panning the light to eventually "fill" the dark areas with light long enough so the scene is recorded on the film. This technique can be used for large or small areas. If you need to be in the field of view, wear dark clothing

so you won't be imaged. A flash is best used to light specific areas of a scene, but tungsten light will fill a scene easier because you can move it while it is on.

Pendulum Patterns—Making geometric patterns is indoor experimental fun with moving lights. This exercise in abstraction requires a penlight, string and a darkened room. A masked flashlight that gives a small circle of light will also work as a source. Attach a 30-inch string

to a ceiling hook with the other end fastened to the rear of the light. Lay the camera on the floor under the light or use a small tripod to hold the camera. The latter is preferable so you can check the field of view. Set the pendulum in motion, frame it as you choose and start the exposure.

Try a 30- or 40-second exposure at f-5.6 on a medium-speed film such as ASA 125. Bracket a full step in both directions. The odds

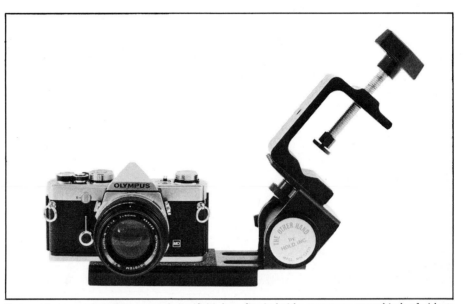

Camera clamps, such as this one made by Hold, Inc., firmly hold a camera to many kinds of objects.

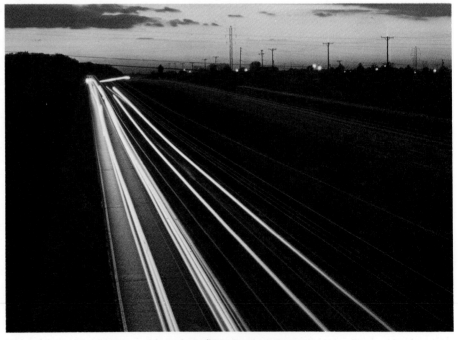

I used a 16-second exposure to record the traffic pattern and sunset.

are against producing the same pendulum motion each time, so duplicate patterns shouldn't be expected.

Placing pieces of colored cellophane or filters over the lens during the exposure produces a multi-color effect. Double-exposing is another variation to explore. Instead of using a complicated double-exposure technique, use the camera on the B setting, leave the shutter open and place a piece of black cardboard or the lens cap over the lens between exposures. Other variations include different mounting arrangements with longer or shorter strings and hanging the light from two strings attached to different pivots.

Using a Flash at Night—Flash units at night or with a dark background allow a multitude of creative lighting techniques for imaginative photographers. You can light a single object surrounded by darkness because of the rapid light falloff of the flash. Create different lighting angles with multiple flashes while the shutter is open. Filter different flashes for multiple-exposure color effects, but remember: a filter absorbs light. An adjustment in camera position or aperture is necessary to prevent underexposure with non-automatic flash units. Combine flash exposure with other nighttime exposures. For instance, sparklers or powerful penlights can be used as a moving source to make light trails while the shutter is open. A flash exposure will "freeze" the person holding the light. Nearly all cameras trigger the flash at the beginning of an exposure with a B setting, so you may want to trigger the flash manually during the exposure. Have people make a drawing, sign their names with light or dance with the lights. With the flash you can stop motion whenever you choose. Try making portraits with the subject outlined with moving lights while the shutter is open. Complete the portrait with a flash exposure.

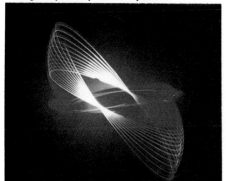

A single-exposure pendulum pattern.

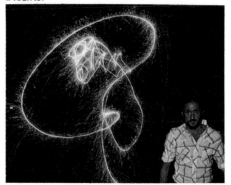

Portrait of the Artist as a Young Man **by Ted DiSante.**

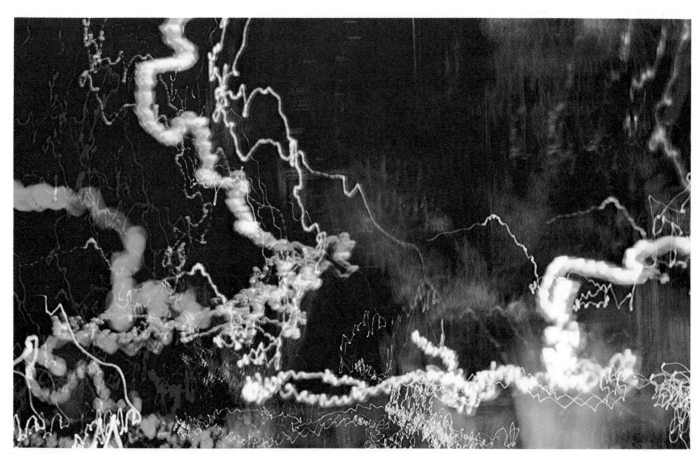

Dennis Scalpone created these light trails by holding his camera out of a moving car for one minute.

FILM

Special effects are possible with *any* film, but this chapter deals with some unusual ones. Instructions supplied with film often provide information which is helpful even if you are going to deviate from the instructions! I can't overstress the fun and importance of experimenting with films. But always write down what you did, so you'll be able to reuse an effect—even if it's a surprise.

HIGH-CONTRAST FILMS

In the past, the special-effects products commonly available to amateurs were diffusing lenses, red filters and b&w infrared film. Then microfilm and high-contrast films became available. For most photographic situations, I prefer the beauty of a full-scale photographic print, yet there are times when bold contrasty designs are appropriate. The devotees of high-contrast films are active and their work is finding popular approval.

A quick way to get powerful graphic effects is to use 35mm high-contrast film. Two kinds are currently available. Kodak High Contrast Copy Film 5069 is a panchromatic film available in 36-exposure rolls. Kodalith Ortho Film 8556 is an orthochromatic litho film. The 35mm size is only available in 100-foot rolls, but you can load it into 35mm cartridges.

Of the two, High Contrast Copy film is probably the best choice for occasional use. Its ASA tungsten rating of 64 is faster than Kodalith, although for daylight use the ASA rating is only 32. The film is primarily designed for making copy negatives of printed matter. The negatives can be greatly enlarged because of its fine grain.

In comparison, Kodalith has a maximum daylight speed of ASA 10 and a tungsten speed of ASA 6. When properly exposed and developed, it yields stark blacks and whites, and it's perfect for making title slides as described in Chapter 8. **Exposure**—Meter on a gray card and bracket a half step each way. Because of the narrow exposure range, you can record either highlights, middle tones or shadows in high contrast. See Chapter 7 for a discussion of tone separation.

Using your camera with these films requires a different approach than photographing with conventional film. Some subjects don't work well in high contrast. Pointing your camera at any subject catching your eye and hoping for good results is wrong. Remember, the film will give much more contrast than you see, and you should bracket for best results.

Normally exposed and developed scene using Tri-X.

By shooting High Contrast Copy Film, you can get graphic results directly.

Kodalith Autoscreen Ortho Film has a built-in dot pattern.

Despite the ease of shooting high-contrast film, photographers who enjoy darkroom work usually prefer to make photos with normal film and copy the originals to get high contrast. Methods for using Kodalith or High Contrast Copy film as a duplicate or intermediate negative are relatively simple. You can contact print or enlarge the originals. Opaquing background, making tone separations and experiments during development offer more opportunities and better control for special

results. If you record a scene originally on high-contrast film, there is no way to get a normal print from it, so your options are limited.

Litho Film Types—Litho films are made by Eastman Kodak, Du Pont, Fuji Photo Film, Agfa-Gevaert, 3M, Ilford and others. Sizes range from 35mm rolls to 4" x 5" to 16" x 20" sheet film. You can buy negative films, dupe films, orthochromatic, panchromatic and even film with a halftone printing screen built right in. This special litho film is called

Kodalith Autoscreen Ortho Film 2563. A dot pattern appears on the processed film which gives it a special textured effect. More uses of litho materials are discussed in Chapter 7.

Special developers are recommended by film manufacturers to give maximum contrast. They are called *litho developers* and are sold in liquid or powder form. The other processing steps and chemicals are the same as with conventional film. Less contrasty results are achieved

with regular film or paper developers, but the development times, temperatures and dilutions must be determined by testing with the brand of film you use.

FAST AND GRAINY FILMS

Litho and microfilms are slow and can be greatly magnified with little image degradation because of their fine-grain emulsions. Films with opposite characteristics also have their place in special-effects photography. Some 35mm films are incredibly fast, grainy and have unique esthetic appeal when enlarged to maximize grain.

The films are classified under the general name of *recording films.* One type obtainable in 35mm at most camera stores is Kodak 2475 Recording Film. It has a speed range from 1000 to 4000!

This film instantly solves some photographic problems we've all encountered. The short-exposure-time effects of Chapter 1 can be used with normal or low-light shooting; getting maximum depth of field is easier; or some night photography can be done with normal daylight exposure times.

My favorite use of the film is to make a print which exploits the coarse grain of the negative. A misty dreamlike effect is sometimes created by these grainy photos. Shades of gray become particulate and less distinct as the print is enlarged or viewed up close. Of course some subjects work better than others, and in my opinion, the simpler the better.

Using grain to your advantage for surreal effects depends on several factors, and some darkroom work is necessary to use the film most effectively. Rating the film at its highest possible speed requires longer development time or an increase in developer temperature. This is called *push-processing.* Both contrast and grain increase. Table 4-1 indicates different development times and temperatures necessary for using Kodak 2475 Recording Film at a film speed of 1000 or 4000.

Regular fast b&w film, such as

PROCESSING KODAK 2475 RECORDING FILM					
Film Speed	Kodak Developer	Development Time (min.) and Temperature			
		68°F (20°C)	72°F (22°C)	85°F (29°C)	95°F (35°C)
1000	DK-50	6	4-3/4	2-1/2	1-3/4
	HC-110 (Dilution A)	4-1/2	3-1/2	2	1-1/4
	HC-110 (Dilution B)	9	7	3	1-3/4
4000	DK-50	9	7-1/2	3-3/4	2-1/4
	HC-110 (Dilution A)	8	6-1/2	2-3/4	1-3/4
	HC-110 (Dilution B)	15	11	6	3

Table 4-1

Paul Akmajian compounded the grainy effect of Kodak 2475 Recording Film by photographing sand.

58

Kodak Tri-X and Ilford HP5, which are rated at ASA 400, can also be used at higher film speeds if given extended development. Some developers such as Acufine or Ilford Microphen are designed for this use. Recommendations come with the developers for increasing the effective speed of fast films, but some testing is usually necessary when rating films two or three steps faster. Table 4-2 contains starting guidelines for using Ilford HP5 at higher speeds with different developers.

B&W INFRARED FILM

Another film intended for technical applications is an infrared-sensitive film. The sensitivity and graininess of Kodak High Speed Infrared Film 4143 make it another film for the creative photographer. It has extended sensitivity to radiation we can't see. Infrared radiation lies beyond the visible red portion of the spectrum in the order of increasing wavelength—see the spectrum diagram in Chapter 3.

Most films have a cutoff in sensitivity at visible red—between 600 and 700nm. This film extends that cutoff to 900nm, allowing you to record how different subjects reflect or absorb infrared. This feature is useful in photography for botany, zoology, archaeology and other scientific fields. The film is panchromatic, and filtering is necessary to eliminate ultraviolet and some visible radiation which interferes with the film's infrared response.

This film has many uses for special-effects photography. It gives tonal distortions, halo effects on highlights, penetrates haze and is quite grainy.

Metering and Filtering—Because the amount of infrared in daylight varies with time of day and weather, liberal bracketing of two steps in either direction of the meter reading is recommended. Until you are more experienced with outdoor scenes, shooting five frames for each scene should give one easily printed negative. Infrared radiation in tungsten-lit scenes is less variable, and you'll

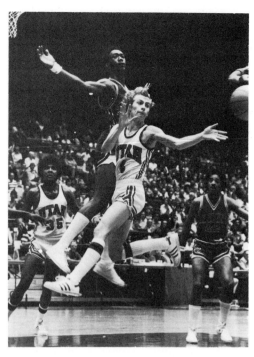

Tri-X pushed to an Exposure Index of 1600 with Acufine developer allowed a 1/500 second shutter speed to capture peak action. Photo by Dennis Makes.

PUSH-PROCESSING ILFORD HP5 FILM				
Film Speed	Developer	Dilution	Development Time (min.) and Temperature	
			68°F (20°C)	75°F (24°C)
800	Ilford ID-11 or	none	11-1/2	7-3/4
1600	Kodak D-76	none	18 to 22-1/2	12 to 15
800	Ilford Microphen	none	8	5-1/4
1600	Ilford Microphen	none	9-1/2 to 12	6-1/4 to 8
3200	Ilford Microphen	none	14 to 18	9-1/4 to 12
1200	Kodak HC-110	1 + 7	12	8
800	Acufine	none	4-1/4	3
1600	Acufine	none	10	6-3/4
800	Acu-1	1 + 5	7-1/2	5
1200	Acu-1	1 + 5	15	10
1200	Ethol UFG	none	5-3/4	3-3/4

Table 4-2

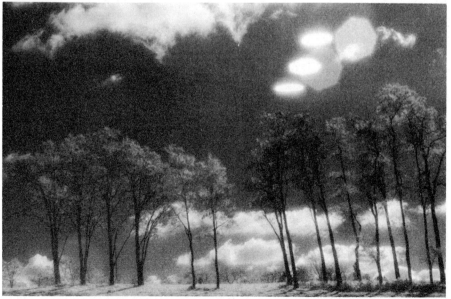

Interesting tonal distortion is one of the main benefits of Kodak High Speed Infrared Film. Nancy Sloane used a 25 red filter for this landscape.

soon become a good judge of exposure settings.

The accompanying table gives trial ASA settings for metering and shooting with infrared film and various filters. A non-filtered photo looks very similar to a photo taken with regular panchromatic film except for some lightening in the shadows. The lightest filter you should use to avoid this is an 8 yellow or 15 orange. These make viewing the subject easy, eliminate ultraviolet and blue, and still give an infrared effect. The 58 green filter transmits infrared and green, which does not record much because of the relative insensitivity of the film to green. It lightens foliage and darkens the sky more than yellow or orange filters. The 25, 29 and 70 filters are all dark red and intensify the infrared effect more than the 58 green. The 87 and 88A are visually opaque and transmit only infrared. If you want to use one of these filters, compose and focus the scene before putting the filter on the camera. Set the film speed as if no filter was being used. Then increase your exposure by 1-2/3 steps for the middle exposure of your bracketing range.

Focusing—Infrared radiation focuses in a plane slightly behind the camera's film plane, and some focus adjustment is usually needed except when there is enough depth of field, such as with short-focal-length lenses. Most camera lenses have a red dot or line on the depth-of-field scale to correct for the focus shift. Focus on a subject and read the focused distance. Transfer the focused distance setting from the normal index to the red mark by revolving the focusing ring. If your lens doesn't have the red mark, re-volve the focusing ring slightly so the lens elements move *away* from the film. This is an approximate solution, and shooting at f-11 or f-16 gives enough depth of field in most cases. This focus adjustment is not necessary with color infrared film.

Infrared Flash—Consider using either the 87 or 88A opaque filter over the window of a flash. To get a trial Guide Number (GN) for your flash, first calculate a GN based on an ASA 80 film. See Figure 3-1 for the formula. Divide this GN by 1.8 to get the trial GN for b&w infrared film and the 87 or 88A filter.

The gel filter should be tightly taped along the edges of the flash window. Use opaque tape such as electrician's tape or Scotch Photographic Tape #235. When the flash is fired, only a dark spot of red is seen, and most subjects are unaware of it. Shooting in a dark room or at night with an invisible flash can give some surprising results.

Composing and focusing is inhibited by the dark. Use a small aperture if you can so depth of field may compensate for focusing error. Like a tungsten source, flash is a consistent source of infrared, and one test roll should give you a usable guide number.

Tonal Distortion—Tonal distortions of the image are due to the amount of infrared radiation reflected by the subject. The darker the filter, the more the final print shows how certain subjects interact with infrared. A blue sky becomes dark, but clouds stay white. Water absorbs infrared and becomes dark. Different kinds of foliage reflect infrared in varying degrees, but most grasses and trees appear much lighter in the print than in a normal panchromatic photo.

Caucasian and Negro skin reflect infrared and have about the same tone as in a non-infrared photo, but eyes darken and hair lightens in the print.

Handling—Infrared film needs careful handling to avoid fog and undesirable changes in sensitivity.

When using infrared film, use the red dot (arrow) as the index mark for focused distance, rather than the normal index.

This nighttime photo was lit with a flash filtered with the 87 opaque filter.

SUGGESTED FILM-SPEED SETTINGS FOR USE WITH KODAK HIGH SPEED INFRARED FILM				
	SLR METER		ACCESSORY METER	
Filter	Daylight	Tungsten	Daylight	Tungsten
no filter	80	200	80	200
8, 15	80	200	64	160
25, 29, 70, 58	80	200	50	125
87, 88A	See Text	See Text	See Text	See Text

NOTE: If you choose to meter with the filter *over* the accessory meter, set the meter's ASA dial as if no filter were being used. Meter the scene, set your camera, place the filter over your lens, and shoot.

Photo made with Plus-X Pan Film.

High Speed Infrared Film, no filter used.

High Speed Infrared Film, 12 yellow filter used.

High Speed Infrared Film, 25 red filter used.

Unexposed film remains stable when refrigerated in its original package at 55°F (13°C) or colder, and exposed film must be refrigerated below 40°F (4°C) if it is not processed within a few hours after exposure. Before loading or processing the film, allow it to reach room temperature while it is still packaged in the plastic film canister.

The film cartridge can't be handled in subdued light without causing fog because the felt trap is not effective in stopping infrared radiation. So load the camera or processing reel in total darkness only.

The data sheet packed with the film suggests developers and times as starting points for processing. The results you seek may require some adjustment in time and temperature. Grain and contrast increase as longer development times or higher temperatures are used. And some apparent speed loss may result if a fine-grain developer is used. The processing steps after development are the same as with conventional films.

COLOR FILM

Color photography is a special effect in itself. When compared to the original scene, the image color is obviously imperfect. But we usually don't compare the image to the original scene and are content with the colors of the film when it is properly used.

Brands—The major producers of color slide and negative film are Agfa-Gevaert, Fuji Photo Film, Eastman Kodak and Konishiroku Photo.

Color evaluation tests are done by these companies using judges from the expected group of film users. Fuji films are tested for the Japanese photographer, Kodak and Konishiroku films mainly for the American photographer, and Agfa-Gevaert films for the European photographer. This tends to give a statistically correct color balance for those people. Therefore, cultural preferences and differences give each film some of its unique color characteristics.

Some photography magazines occasionally run comparison photos using various films to show the differences. Things to look for are skin-tone rendition, tinges of color in whites and subdued shadows, contrast, richness of blacks and the color balance of a middle gray. ASA speeds range from 25 to 400 and this contributes to variations in sharpness and grain which you can also evaluate. These differences are even observable among films made by one manufacturer.

One economical way to do your own testing is for you and a group

Kevin Marks accidentally extended the first development time when processing Ektachrome 200. This makes the film look grainy, improperly color balanced and a bit overexposed, but all created an interesting special effect.

of friends to go on a field trip. Spend a full day in an interesting locale and have each photographer use a different film. Evaluate the results together and discuss your impressions. You may decide the film you are now using is not the right one for the type of shooting you mainly do.

Push Processing—Some color slide films can be rated up to 2-1/2 steps faster than their normal speed. Special processing called *push-processing* is done by some labs for an extra charge, and Eastman Kodak also offers a one-step push-processing service. The first-developer time is extended for the E-6 process, and the other steps are performed as usual. Any color slide film compatible with E-6 processing will work. Directions for push-processing are contained in home-processing kits for these films, but some experimentation may still be necessary.

Results of push-processing are increased contrast and grain, a slight decrease in maximum density and sometimes a shift in color balance. The splashy colors, grainy image and higher film speed make the extra money or time spent well worth it. You may get the right combination of effects for a photo you thought couldn't be done.

Faster slide films, such as Ektachrome 400, 200 and 160 Tungsten, maximize these effects best when pushed to the 2-1/2 step limit of ASA 2400, 1200 and 1000 respectively. Slower films such as Ektachrome 64 show the effects less well. Agfachrome 64 and 100 and Kodachrome 25 and 64 do not have the capability of being pushed. They are manufactured and processed differently than E-6 type films.

Color negative films have a much wider exposure latitude than color slide films. And the printing process can compensate for up to two steps of underexposure. If you want to push-process color negative films, you will have to do your own experimenting with home-processing kits because the manufacturers of color processing chemicals do not give information on pushing the film, and the service is not offered by regular film labs. As the development time is extended, a rise in contrast and grain results. A shift in color balance, which makes the negative difficult to print, also occurs.

COLOR INFRARED FILM

A color film expressly designed for false-color rendition is Kodak Ektachrome Infrared Film. It is compatible with E-4 processing done by a Kodak lab, local lab or with a home-processing kit.

Color Rendition—Figure 4-3 shows the color dyes formed by each layer of the film. The yellow filter absorbs blue light to which all layers are sensitive. The extended sensitivity in the infrared-sensitive layer is the same as the b&w infrared film, but infrared radiation is red in the developed image. Red light becomes green and green light becomes blue.

Ektachrome 400 pushed to a film speed of 1600. Notice the color shift, grain and contrast. Photo by Ted DiSante.

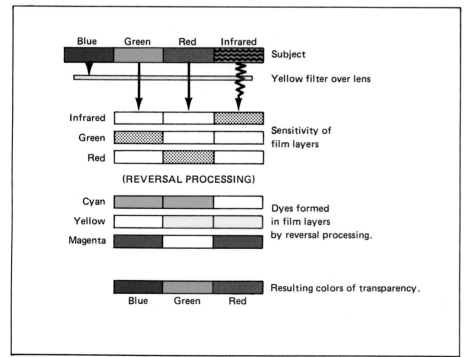

Figure 4-3/Color formation with Kodak Ektachrome Infrared Film.

Even more variations are possible if you use color filters. The sky can be green, pink, magenta or blue if a 25, 47, 56 or 12 filter is used. Foliage or other infrared-reflecting objects are predominantly red. Skin tones can be made magenta with an 11 green filter or green with a 25 red filter. Photograph people in open shade or with back lighting because portraits or close-ups with harsh front lighting have excessive contrast. Polarizing filters work well with the film because they increase color saturation for most scenes. Try it as a copy film to make normal slides look unusual.

Exposure—Coping with the exposure problem is again made easier by bracketing and record keeping. The film is rated at ASA 100 for daylight and ASA 50 for tungsten, based on using a 12 yellow filter. Bracketing is advised when using an assortment of filters. Try bracketing one step to either side of the metered exposure. A focusing adjustment for infrared is not necessary with this film because only one of the emulsion layers records the invisible radiation.

Using a Flash—Using tungsten illumination requires extra color correction, which can be avoided by using electronic flash or blue flashbulbs when indoors. To get a trial GN for your flash, first calculate a GN based on ASA 200 film. See Figure 3-1 to do this. Divide this GN by 1.4 to get the trial GN for the 12 yellow filter, flash and color infrared film combination.

Red filter used

Green filter used

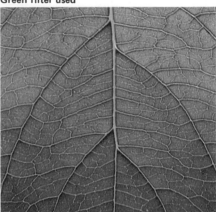

Ted DiSante backlit the leaf with a small flash unit.

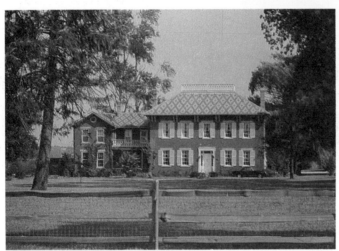

Photographed with ordinary color film.

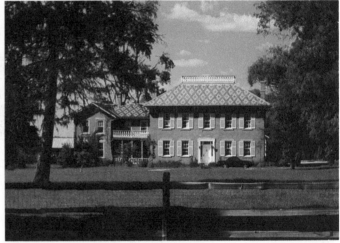

Ektachrome Infrared Film, 12 yellow filter.

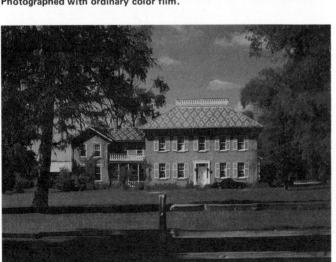

Ektachrome Infrared Film, 23A red filter.

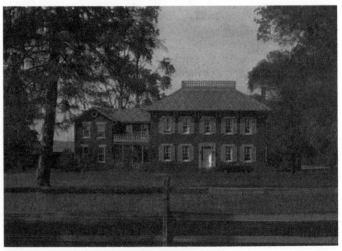

Ektachrome Infrared Film, 47 blue filter.

If you are using a different filter, the trial GN can be calculated by dividing the ASA 200 GN by the square root of the filter factor. Example: Suppose you are using a 25 red filter which has a filter factor of 8X. If the ASA 200 GN is 140 feet, the trial GN can be obtained by dividing 140 feet by the square root of 8.

$$\text{Trial GN} = \frac{140}{\sqrt{8}} \text{ feet}$$

$$= \frac{140}{2.83} \text{ feet}$$

$$= 49 \text{ feet}$$

Handling—As with b&w infrared film, color infrared film should receive special handling. The three layers of the emulsion change characteristics differently if improperly stored. Typically, the film loses infrared sensitivity and develops a cyan cast.

To store properly, freeze the unexposed film in the factory package at 0°F to -10°F (-18°C to -22°C) and allow at least 6 hours for the packaged film to come to room temperature before opening. After exposure, immediate processing is recommended, but when impossible, store the film in the plastic canister at a temperature below 40°F (4°C). Loading a camera or developing tank must be done in total darkness to prevent fogging.

KODAK PHOTOMICROGRAPHY FILM 2483

When the most saturated and contrasty color is needed, try Kodak Photomicrography Film 2483. It is extremely contrasty with fine grain for maximum image definition. These characteristics are helpful to the microscopist who photographs low-contrast specimens.

The film is rated at ASA 16 and balanced for daylight illumination. Because it is so contrasty, exposure latitude is small, and careful metering with an 18% gray card is recommended. Bracketing a half step in each direction from the meter reading is good practice.

Subjects—A photographed scene will show more contrast than it originally had. If you shoot a flatly lit scene, such as through a diffusion attachment or rain, the increase in contrast and color saturation will make the scene appear more normal.

Abstract photos of pure colors are intensified by the extreme color saturation of the dyes. Use this film for close-up work, just for the sake of colors or use it to shoot polarized crystals as discussed in Chapter 5. With this film, 35mm slides can be enlarged to a 16" x 20" print with no image degradation. Try it as a copy film.

I used normal color film for the top photo and Kodak Photomicrography Color Film 2483 for the bottom to show how contrast increases and colors shift.

Handling—The film should be handled as any regular slide film. Store it at 55°F (13°C) or lower in the original packaging. Exposed film should receive E-4 processing as soon as possible after exposure, but it can be frozen until then.

COPY FILMS

Many of the techniques in Chapters 7 and 8 require manipulation of replicate images. Often a copy of a negative or print is required so the original won't accidentally be ruined during manipulation, or so more images can be easily made from a manipulated print that is hard to make again. Sometimes, masks or intermediate images are made from originals. Whatever the need, a copy film exists which makes the work possible. Copying prints is discussed in Chapter 8, but making copies can also be done in the darkroom by enlarging or contact printing onto copy film. Each copy job is unique, and some testing of the copy film is usually necessary for best results. Some good copy films are mentioned here. For detailed information about copying see Kodak Publication M-1, *Copying.*

High-Contrast Films—The litho films mentioned earlier are available in orthochromatic and panchromatic varieties. They eliminate middle grays of an image and render stark blacks and whites unless developed differently from the manufacturer's instructions. Sheet-film sizes and 35mm rolls let you do high-contrast work in or out of the darkroom.

With these films, pinholes often occur in the areas you want to be black. These can be remedied by opaquing them so no light can get through. Special opaquing fluid, pens or ruby-red cellophane tape can be used to block offending white

My favorite use of Photomicrography Color Film is for abstract foliage photography.

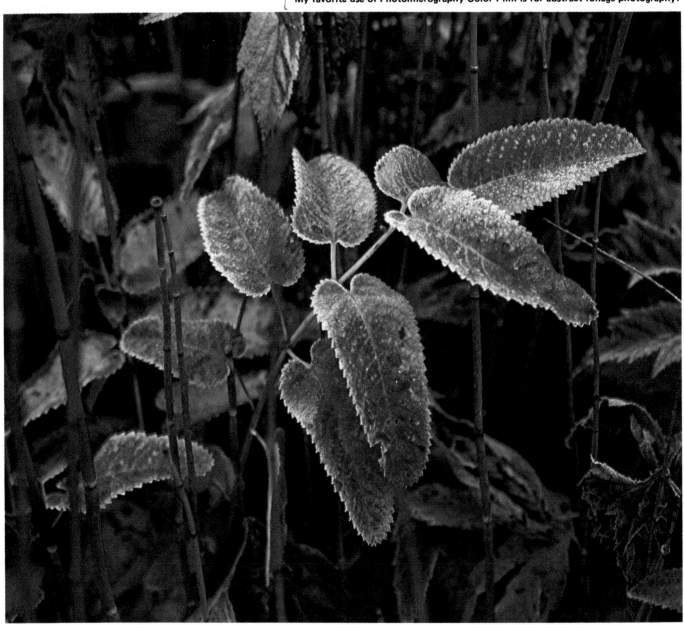

areas. They are available at camera or graphic-arts stores. The ruby-red tape passes only red light to which regular printing paper and orthochromatic film is not sensitive.

Litho films can be made into copy negatives or positives for high-contrast printing. For good reproduction, use them to copy printed matter, line drawings or any high-contrast subject. They are ideal for making masks that block light from image areas during exposure.

Kodak Professional Copy Film— When copying continuous-tone prints, the major problem is getting good tonal separation in the dark areas of the copy negative. Kodak Professional Copy Film is an orthochromatic film designed to separate tones in the dark areas of the negative, and highlights are not muddy or dark in the subsequent print. The film is not available in 35mm rolls, and a camera that uses sheet film must be used to copy prints. You could also use it with an enlarger to copy 35mm b&w negatives or positives.

Testing of the film is recommended for the kind of printing paper you use for the copy print. After you make a manipulated print with hours of time and much paper invested, a good copy negative is a must if you want more prints to look the same as the original.

Kodak Fine Grain Release Positive— This relatively inexpensive film is available in 35mm and sheet-film sizes. Because it is orthochromatic, it can be developed by inspection under a red safelight. It has a clear base, which means b&w transparencies can be made from negatives. Try contact printing 35mm negatives to get b&w slides. It is also useful as an intermediate positive or negative image. It is about half the speed of a typical printing paper and can be developed in paper developers.

Regular Pan B&W Films— The standard fast, medium and slow b&w camera films can be used for copy work. One problem with using these films for copying continuous-tone material is that highlight detail may be lost or muddy if the film is processed normally. Some exposure and contrast adjustment of the negative is necessary to increase the contrast of the copy image so highlight detail is retained in the final copy print. Slight overexposure and an increase in development time are usually necessary. Exact adjustments can only be obtained through testing.

Because the films are panchromatic, they give a close approximation of the tonal relationship of the colors in an original color image. They are also available in sheet film

if you need a large negative or positive image.

If you are interested in shooting and processing b&w transparencies, try Kodak Panatomic-X as a reversal slide film. It has a clear base like a transparency, and it is an ideal copy film for your best prints. Use it as an intermediate positive in some manipulative darkroom procedures. Special reversal chemistry for the film called Kodak Direct Positive Film Developing Outfit is available at camera stores.

Direct-Duplicating Films— Eastman Kodak makes two copy films that yield duplicate images of an original without special reversal processing. They are Kodalith Duplicating Film and Kodak High Speed Duplicating Film. If a negative is projected or contact printed onto one of these films, the processed copy film is also a negative image. As with reversal film, more exposure makes the image lighter, and complete overexposure gives a clear piece of film.

Both films are orthochromatic and only suitable for contact or enlarger printing. Only sheet film sizes are available. Use the films for making enlarged duplicate negatives, masks or laterally-reversed images. The film base is designed so the emulsion can be exposed through it, and this allows you to make the image laterally reversed.

The processing steps are standard development, stop bath and fixing. The litho film is best developed in a litho developer, and the continuous-tone film can be processed in paper or film developer. Some contrast control through development is possible.

Kodak Ektachrome Slide Duplicating Film— This color slide film is designed for copying color materials without an objectionable contrast increase in the copy. It is available in 35mm rolls and can be processed with E-6 home-processing kits. The film can be used with tungsten or flash illumination plus appropriate filtration.

Use it to copy your best color originals, manipulated slides, or to make color slides for manipulation.

SOME KODAK COPY FILMS						
		ASA SPEED		Spectral	AVAILABILITY	
		Daylight	Tungsten	Sensitivity	35mm	Sheet Film
B&W	High Contrast Copy Film	32	64	pan	X	
	Kodalith Ortho Film	10	6	ortho	100' rolls	X
	Kodalith Pan Film	40	32	pan		X
	Professional Copy Film 4125	25	12	ortho		X
	Fine Grain Release Positive	40	10	ortho	X	X
	Regular Pan B&W Films	varies		pan	X	X
	Direct Positive Panchromatic	80	64	pan		X
Color	Ektachrome Slide Duplicating Film 5071 (process E-6)	see data sheet	see data sheet	tungsten	X	X

68

5

CREATIVE COLOR

All of the techniques in this chapter can produce pictures with *intense* color saturation. By manipulating film, chemicals and radiation you can create color images for special effects that reach the limits of your imagination.

Diazochrome film is a non-silver product available in many colors and saturations. It is used as a copy film and can be sandwiched with transparencies to give color combinations as unordinary as you like.

Crystallized chemicals possess a color potential which remains hidden until illuminated by polarized light. No two crystal patterns are alike because you make them yourself with simple and easy-to-get chemicals and supplies.

Fluorescent photography shares some of the mystery of polarized-light effects because the fluorescing action of short-wavelength radiation is mostly masked by other colors of light. By using a special light source and carefully filtered color film, you can explore the weird color possibilities of ultraviolet.

DIAZOCHROME FILM
Diazochrome film can be used to make slight alterations in ordinary color transparencies, or it can be used to make images with bright contrasty colors for graphic effects.

Opposite page
Polarized light can reveal hidden colors caused by stress planes in plastic and crystals. Photo by Kevin Marks.

Diazo material can be used in ordinary roomlight, so a darkroom is not necessary. The following procedure gives the basic how-to information. By carefully following this technique, you'll be able to produce diazo colors and images. But patience is required for this creative, experimental process, so work carefully and you'll avoid frustration. If things don't turn out right, re-read the instructions and your notes recording what you did.

Figure 5-1/Some diazo colors.

SOME DIAZO DISTRIBUTORS

Technifax Corporation
195 Appleton Street
Holyoke, MA 01040

The Charles Bruning Co.
1800 W. Central Road
Mt. Prospect, IL 60056

Diazo film is not sensitive to ordinary room light and is exposed by a light source which contains some ultraviolet radiation. It is a *positive-working* process—color forms where light does not strike. The unexposed part of the film forms a predetermined color when developed with ammonia fumes. Figure 5-1 shows a color assortment of some diazo films which received no exposure prior to development. A few other colors and a dense black are also available. The films come in 8-1/2" x 11" or 5-1/2" x 8-1/2" sheets and can be purchased from some graphic-supply stores and the distributors listed in the accompanying table.

In a darkroom you can make 4" x 5" or larger b&w high-contrast positives from your 35mm images, and then contact these with your diazo films, but I'll assume you want to work in the 35mm format because it is economical and doesn't need a darkroom.

Equipment and Supplies—Refer to Table 5-2 for a list of materials. You will need a large glass jar with a hook on the inside surface. I use a piece of wood on top of the lid to anchor the hook and screws. The hook holds the film clip which hangs inside the jar. Plastic clothes pins can substitute for a metal film clip if the jar is deep enough.

The film is developed in ammonia fumes. Ammonia packaged for household use is safe when used in

69

a well-ventilated area, but careless use and excessive inhalation will irritate your eyes and lungs. Heed the precautions on the ammonia bottle. Do the developing in a large, well-ventilated room.

Procedure—Put the sponge in one of the empty jars and pour in enough ammonia to saturate the sponge. This prevents accidental splashing in case the bottle is bumped or dropped. Cover the jar temporarily with a plain lid—this is the *developing jar.*

To make a small contact-printing frame, tape two pieces of 2-inch square slide cover glass along one edge. Select a contrasty negative or color slide and place the emulsion against the light-sensitive side of a piece of diazo film. The large sheet of diazo film is sometimes notched, and the light-sensitive side is facing you when the notch is in the upper-right-hand corner. If there is no notch, scratch a corner of the film—the side from which the coating comes off is the light-sensitive side. Notch the large sheet so you don't have to scratch the film each time you use it. Usually I cut a piece of film slightly larger than the 35mm image so I can easily handle it by the edges. Place the two films into the printing frame, close it and tape along the edge opposite the tape hinge. This holds the films tightly together. Then expose the film.

Although many bright light sources can be used for exposing diazo films, the slide holder in a slide projector provides easily controlled conditions. The sun or a sun lamp will also work, but exposure-time testing will be necessary. With a 500-watt slide-projector, try a 75-second exposure with a color slide or 40 seconds with a b&w negative. Always put the slide or negative between the light source and the diazo film. It you do it the other way, you won't get an image on the diazo—it will be clear.

Take the exposed diazo film from the sandwich and attach it to the film clip and then hang the clip from the jar lid with the hook. Unscrew the plain lid from the devel-oping jar and replace it with the lid holding the diazo film. A quick switch keeps most of the ammonia fumes in the developing jar.

While the film is developing, watch the color density and contrast increase. Standardize on a three- or four-minute developing time so you can vary only exposure time to get the color density you desire. After development, switch lids again and screw the lid holding the film onto the empty jar. This minimizes fumes from ammonia on the film or lid. A slight headache will warn you the ammonia is beginning to affect you, so take an occasional fresh-air break.

The film dries almost immediately after it is removed from the developing jar, and it is ready for use. The original image is not harmed unless it is scratched or smudged from careless handling.

The image that forms after development is a rough replica of the original except for color. A color slide produces another positive image; a b&w negative yields another negative. The diazo film is high-contrast; it will have colored areas and clear areas, but few shades in between.

Long exposures let more light through the middle densities of the original and give lighter colors than a short exposure. Proper contrast and density results from a combination of development and the minimal exposure needed to remove the color from image areas that should be clear.

Short development gives a less contrasty image than long development. Unless you want subtle effects or the original is very contrasty, you probably won't like the results of short development.

COLOR ALTERATIONS

My interest in diazo film began when I decided to improve faulty

MATERIALS FOR DEVELOPING DIAZO FILM
2 empty 12 oz. or 16 oz. jars with lids
1 small plastic sponge cut to fit the bottom of a jar
1 stainless-steel film clip or plastic clothes pin
1 U-bolt attached to a jar lid
1 bottle of household ammonia
2 2-inch-square cover glasses or a contact-printing frame
1 package of reversing film from the diazo dealer
Strong light, such as a slide projector or sun lamp, for printing
Assorted diazo films in various colors

Table 5-2

This is the equipment I use to make diazo images.

color slides, especially those with overexposed skies, large areas of specular highlights or weak colors. With the array of diazo colors available, you can add nearly any color to your slides and increase the impact of the image. To get color in the light areas of an original, an intermediate image must be made with *reversing film* which is available where you get the diazo materials. As an alternative, you can make the intermediate negative with high-contrast b&w film processed conventionally, but it takes more time.

Remove the slide from its mount and sandwich it with the reversing film. Place the films in the cover-glass printing frame as described earlier. Insert it into a slide projector with the original image nearest the bulb, and expose for about 75 seconds for a color slide or about 40 seconds with a b&w image.

Develop the reversing film in *plain water* for one minute. Do not touch the face of the film or you'll leave marks. Rinse the film in a wetting agent, such as diluted Kodak Photo-Flo, and hang it with a film clip to dry.

Examine the dry reversing film. Where the original was light, there will be density in the reversing film. The image is yellow with short exposures and becomes amber with long exposures.

Sandwich the dry reversing film with a piece of diazo film. Put the glass sandwich into the slide projector and expose for about half the time you would with an original slide—about 30 seconds. Because the density of the reversing film is less than a normal slide or negative, more light is transmitted through it during exposure.

Process the diazo film and sandwich it with the original. If the reversing film and the diazo were properly exposed, the highlights on the original will now be colored on the diazo film. Slight color on the diazo may be visible in the less dense areas of the original, but usually this won't matter.

The diazo film color you select for the sandwich depends on the effect you want. You can make the sandwich look realistic or wildly different. Make a sky blue, green or red, adjust skin tones for strange results or make a dull sunset photo more effective with red or orange. You can project the sandwich or copy it if you want to work with the original again. Make a print or copy slide from the sandwich. Some special copying techniques are described in Chapter 8.

For your first attempt, select contrasty subject matter with simple lines and shapes. An image on reversing film has less density variation than the original, and the diazo image has little or no density variation in the colored areas. This gives distinct areas of color on the diazo film which can be easily registered with the original. You may wish to register two or three diazos with the transparency and enclose them all in a 2 x 2-inch glass slide mount. But do not use the amber reversing film as part of the combination because it may adversely affect color film dyes.

Process the film in plain water.

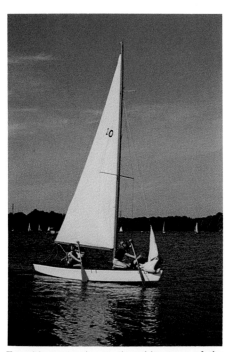

To add some color to the white areas of the slide, first sandwich the original with reversing film and expose it.

The reversing-film on the right was exposed for less time than the one on the left and is best for this kind of color alteration.

Diazo images made from the lighter reversed image.

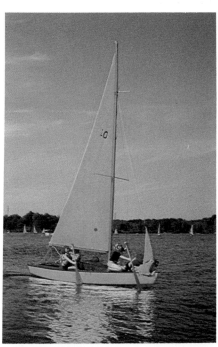

I chose the orange diazo image and sandwiched it with the original.

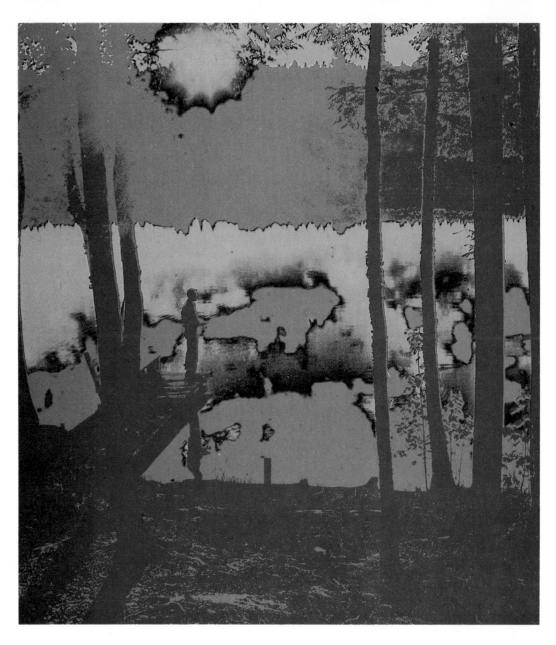

Diazo films give you extra creative control to make many different images from one photo.

With diazo film you can sometimes salvage overexposed color slides such as this one.

Blue and red diazo images were sandwiched with the original for an unrealistic, but effective photo.

DIAZO COMBINATIONS

Combining two or more diazo films with an original lets you create any color image you can imagine. From an original color slide or b&w negative, make three reversed images with reversing film. Vary the exposure times to get images of different densities. With the reversing-film images make three diazo films of different colors. You could also make diazo images with different densities and colors directly from the original.

Put all the diazo images on a light table and experiment with combinations. From this assembly of colored films you should be able to make one outstanding combination composed of 2, 3, or 4 pieces of film in register.

Some images work better slightly out of register. In some combinations, the areas with color coincide to block out each other, and these obviously won't do. When light colors overlap, such as a pale red and blue which gives purple, the effect looks good. If the original is light, you may want to include it in the combination, but it is not necessary if you also have diazos made directly from the original.

Another variation of the combination, or *posterization,* method requires making *tone-separation* negatives or positives on litho film in a darkroom. The narrow exposure range of litho film can record different densities of the original. Depending on exposure, you can record the shadows, midtones or highlights of an original. Because of its inherently high contrast, litho film gives better tone separations from medium and low-contrast originals than reversing films. Each of the tone separations can then be contact printed on various colors of diazo film which are assembled into sandwiches or multiple-copied to create one image. After you gain experience by creating diazos from high-contrast originals, you may want to try the extra control provided by litho film. Posterization is also discussed in Chapter 7.

The original slide.

From the original I made 6 different diazo positives.

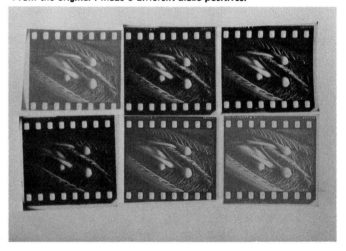

Then I made negative diazo images with reversing film. Notice that some are lighter than others.

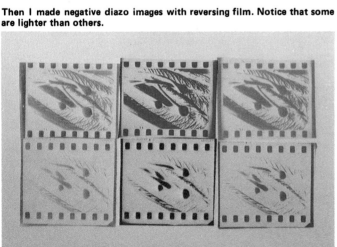

A number of different color combinations are possible when you start combining positive and negative images.

CRYSTAL PHOTOGRAPHY

Polarized light has many uses in photography. In Chapter 2 the usefulness of a polarizing filter for darkening skies and controlling unwanted reflections is described. Polarized light is also used to produce colors and patterns which are not normally seen as light passes through crystals.

POLARIZER SOURCES
Edmund Scientific Co.
7782 Edscorp Bldg.
Barrington, NJ 08007
Bausch and Lomb Inc.
Science and Optical Division
1400 N. Goodman
Rochester, NY 14602

The crystalline material can be naturally formed crystals from the earth, certain kinds of plastic or common chemical compounds. These include food additives such as dextrose, benzoic acid, ascorbic acid and vanillin.

The essential items are two polarizing filters. The crystalline material is photographed between the polarizers, so a polarizing filter for your camera won't work here. Glass or plastic polarizing sheets can be bought from local scientific-supply stores or from the distributors listed. Two three-inch-square sheets are large enough for the type of

work described here.

To try the polarized light effect, put a piece of cellophane between two polarizers. The cellophane will substitute for the chemical crystals you'll be photographing later. Hold the assembly up to a light and rotate the top filter, also called the *analyzer*. Watch the rainbow-like colors shift.

At one point in the rotation, much of the cellophane becomes dark blue and areas with bright colors have maximum contrast. The polarizers are now at right angles to each other. If the cellophane is removed, no light passes through

Cellophane between two sheets of polarizing material.

the polarizers. In this position, the first polarizer passes light rays travelling in only *one plane,* and the analyzer is oriented to prevent these *plane-polarized* rays from going any farther.

When the cellophane is inserted between the polarizers, the light rays are split into *two* plane-polarized components at an angle to each other. This is called *double refraction* or *birefringence* and is due to built-in stress from the plastic or crystal formation. The analyzer then selects components of the two plane-polarized rays and combines them to make a single plane-polar-ized ray of a certain wavelength. Variation in stresses inside the material creates the different colors. Rotating the analyzer assembles different components of the plane-polarized rays, and this changes the colors you see. You can photograph the material with the polarizers in the orientations that give the most pleasing patterns.

After observing or shooting a few pictures of cellophane stress patterns, you may want to discover the many patterns in crystallized chemicals. Unlike using cellophane, precautions are necessary when using chemicals. The biggest danger is mis-handling them or carelessly leaving them out in the open. Harmful substances should be locked up and kept out of reach of children or unsuspecting adults. Many photographers have safely made and photographed crystallized chemicals by following the methods and simple precautions described here.

Some useful chemicals for making crystals are listed in Table 5-3. They can be purchased at a well-stocked drugstore or chemical-supply house. There are two simple ways to make crystals. They are the *melt method* and the *evaporation method.*

Maximum contrast results when the polarizers are at right angles to each other.

The Melt Method

Materials

2 3-inch-square polarizers
Powdered chemical from Table 5-3
Several 2-inch-square cover glasses
4 spring-type clips
A heat source such as a clothes iron
A small plastic spoon

1 Materials for the melt method.

2 Spoon some grains of the chemical powder over the middle of a cover glass. Urea powder is shown here.

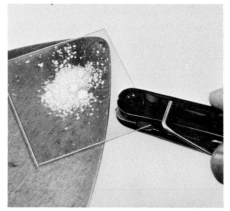

3 Heat the glass evenly by moving the tip of the iron along the underside of the glass while holding the glass with a spring clip. Ventilate your work area with a fan or open a window so you don't inhale chemical vapors.

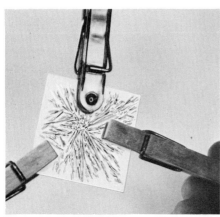

4 Do not boil away the melt. As soon as the powder melts, clip another piece of glass on top. This spreads the liquid into a thin film between the two glasses. Let it cool next to the source of ventilation.

Crystallization takes from a few seconds to a few minutes. When cool, it should have a waxy, translucent look, not an opaque-white look.

5 Test the cooled slide with the polarizers. To observe maximum color saturation, place the polarizers together in front of a light source and rotate one until the light blacks out. Retain that orientation. Slip the crystal sandwich between the polarizers and look for a colored pattern.

If there are no colors, something went wrong. The crystal may be too thick or the chemical may still be liquid. Correct this situation by allowing extra cooling time and some slippage of the cover glass.

A few bubbles are characteristic of most slides made by the melt method, but they are usually small and will be fewer if slow heating is used.

If the slight fumes from the melt method are irritating in spite of the safety precautions, the *evaporation method* may work best for you. Except for the heat source, the materials of the melt method can be used for the evaporation method. Table 5-3 shows which chemicals work with both methods. The powders are dissolved into solution with water or an organic solvent, then allowed to evaporate and recrystallize on glass while covered or uncovered. Recrystallization may be slow and unpredictable. One solution I made took three weeks to form crystals, but they were exquisite and well worth the wait.

I recommend you make notes of what you are doing and how it affects the results. Eventually you may be able to control the results better. Then you can vary the amount of chemicals used, the solvent, the method and time of evaporation, or any combination of these. Don't feel constrained. Use your imagination to explore and find new images. Experience is the best teacher because not all efforts at making crystals will be successful. The colors result from light traveling through the crystal. And one that is too thick or too thin won't produce bright and colorful patterns.

CHEMICALS FOR MAKING CRYSTALS

Chemical	Melt	Evaporation	Comments
Adipic acid	X		Melting point (M.P.) 152°C (116°F); a general-purpose food additive.
Powdered Ascorbic acid (Vitamin C)		X	Rubbing alcohol (70% ethyl) is recommended solvent.
Benzoic acid	X		M.P. 122°C (100°F); food preservative.
Bromo-Seltzer®		X	Soluble in water.
Citric acid	X		M.P. 153°C (117°F); food additive.
Dextrose (glucose)	X		M.P. 146°C (113°F).
Epsom Salts		X	Make dilute solution and use cover glass for thin crystals.
Niacinimide	X	X	M.P. 129°C (104°F); soluble in water, ethyl alcohol or glycerol.
Phenyl salicylate	X		M.P. 42°C (55°F).
Salicylic acid (Salol)	X	X	M.P. 159°C (319°F); food additive; soluble in water. **Warning: Hot vapors are irritating.**
Sodium thiosulfate (Hypo)	X		M.P. 48°C (59°F); **Warning: Boiling causes hazardous sulfur oxides.**
Tartaric acid		X	General purpose food additive; **Warning: Contact causes eye irritation.**
Urea	X	X	M.P. 133°C (105°F); both methods give good results.
Vanillin		X	Soluble in 12 parts of water, 2 parts glycerol and 2 parts 95% alcohol.

Table 5-3

I like the large black areas that often occur in crystals made using the melt method.

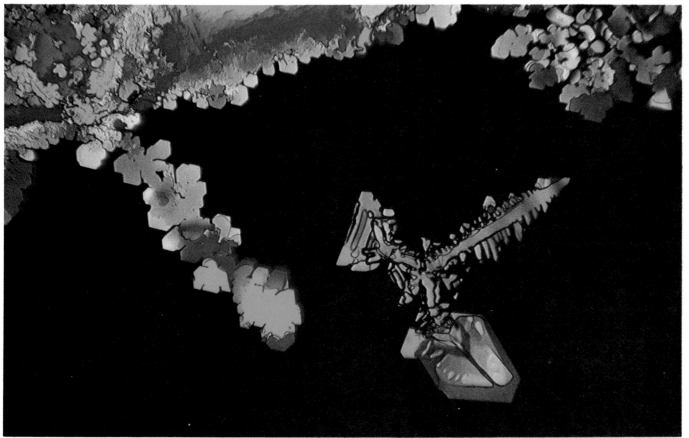

A sodium thiosulfate crystal made using the melt method.

The Evaporation Method

Materials

Water or alcohol as solvent
Powdered chemical from Table 5-3
Small container to mix solutions in
Wetting agent such as Kodak Photo-Flo

2 3-inch-square polarizers
Several 2-inch-square cover glasses
4 spring-type clips
A small plastic spoon

1 Wash a cover glass in Photo-Flo, or some other wetting agent, and drain, but do not wipe dry. This prevents the chemical solution from beading on the glass.

2 Dissolve a small amount of powder in the solvent. For your first attempt, try dissolving 1/4 teaspoon of urea or tartaric acid in an ounce of water, or try dissolving ascorbic acid in 70% ethyl rubbing alcohol.

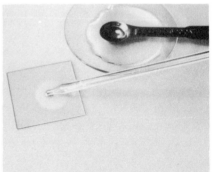

3 With the spoon, sprinkle a few drops of the solution onto a cover glass and spread them around. The glass can be covered with another cover glass and clipped or left to evaporate uncovered. Either way, put it where it won't be disturbed.

4 Recrystallization may take days or even weeks. Slower evaporation gives larger crystals. Clamping slows drying as does using water as a solvent. You can even partially evaporate the liquid uncovered and then clamp on a cover glass for the rest of the evaporation.

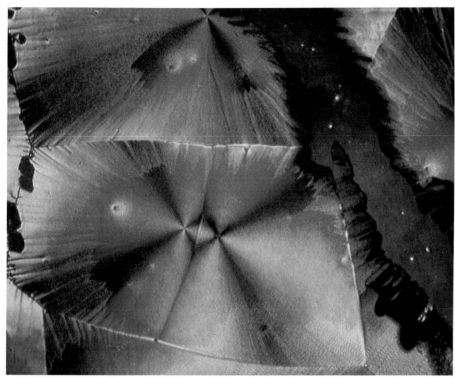

This ascorbic acid crystal was formed by evaporating uncovered.

Storage—Save the crystals until you've accumulated enough to photograph with color film. Don't wait too long because delay increases the risk of crystal deterioration from moisture absorption or reactions with air. If you must store them, put crystals in a sealable container with some packets of silica gel. Sealing the edges of the crystal sandwich with 3/8-inch Scotch Polyester Tape #850 also helps preserve the pattern. By using these safeguards, I've had some crystals last three years, but the more volatile ones deteriorated with time.

Close-Up Shooting—To photograph the crystals, you'll want to reproduce the pattern with a magnification of at least .75—if the crystal is completely covering a 2-inch-square cover glass, and you wish to fill the 35mm frame. A variety of equip-

Salicylic acid crystals formed by the evaporation method.

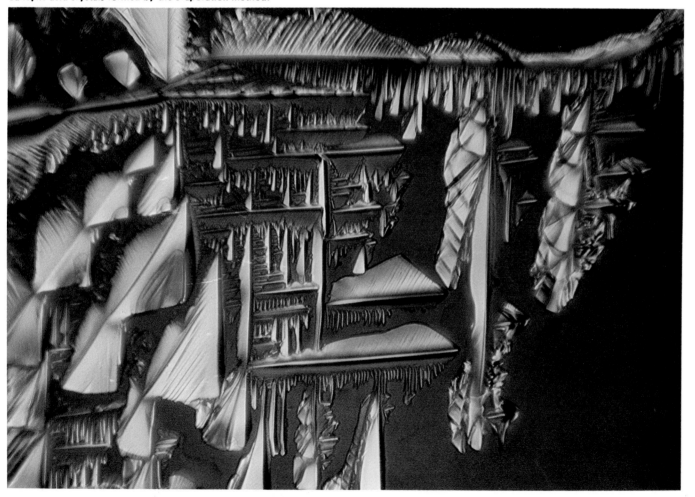

ment is available to increase magnification. A detailed discussion of macrophotographic techniques is in HPBooks' *SLR Photographers Handbook* by Carl Shipman. So I'll just present a quick survey of the methods in the order of their relative cost and image quality they give.

Close-Up Lenses are generally the least expensive accessories, and you may already have some. Usually these are classified by *diopter ratings* of +1, +2, +3 or +10, Table 5-4 gives the equivalent focal length of the lenses and combinations. Image magnification depends on the focal lengths of the prime camera lens and the close-up lens. The magnification formula in the table works when the prime lens is focused at infinity—this is minimum magnification. Magnification increases as you focus the prime lens on near objects.

For example, a 200mm prime lens and a +3 close-up lens gives:

$$M_{min} = \frac{200mm}{333mm} = 0.6$$

I recommend you use only one close-up lens because image quality and edge sharpness worsen considerably when you stack them.

Extension devices add more space between the back of the lens and camera body. The different ways of getting extension vary in price and versatility.

Extension Tubes are cheapest. They are often sold in sets of three tubes. They are different lengths, but when combined usually add to 50mm or 55mm of extension. Table 5-5 shows how to calculate the necessary extension for a certain magnification.

A problem results from using attachments with an ordinary lens not designed for close-up work. Some flatness of field is lost at magnifications greater than 1.0. Typically, the corners and edges are blurred. This can be corrected only partially by small aperture settings.

Macro Lenses are designed for closeup work and solve the flatness-of-field problem. Usually they need an extension tube for magnifications of 1.0, but some are available with

CLOSE-UP LENS FOCAL LENGTH	
Close-Up Lens Diopter Rating	Focal Length (mm)
1	1000
2	500
3	333
1 + 3	250
2 + 3	200
1 + 2 + 3	167
10	100

$$\text{Minimum Magnification} = \frac{\text{focal length of prime lens}}{\text{focal length of close-up lens}}$$

Table 5-4

HOW TO FIGURE EXTENSION

X is the needed extension between lens and camera body

M is the desired magnification $= \dfrac{\text{Image size}}{\text{Subject size}}$

F is the focal length of the lens
$X = M \times F$

Example: To get a magnification of 0.75 with a 50mm lens,
$X = 0.75 \times 50mm = 37.5mm$

Table 5-5

There are many different ways to make close-ups, and they vary in cost and resulting image quality. Here is some Pentax equipment for macro work.

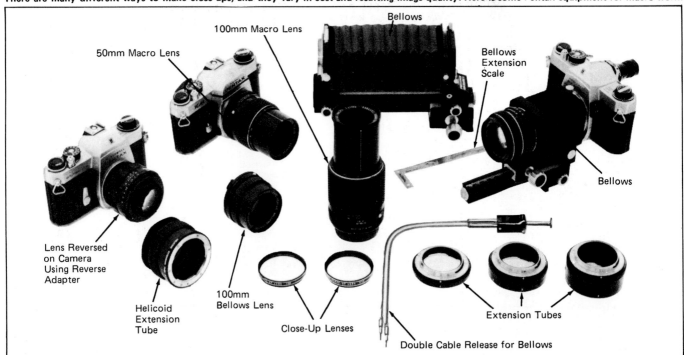

50mm Macro Lens

100mm Macro Lens

Bellows

Bellows Extension Scale

Bellows

Lens Reversed on Camera Using Reverse Adapter

Helicoid Extension Tube

100mm Bellows Lens

Close-Up Lenses

Double Cable Release for Bellows

Extension Tubes

this capability built in.

Macro lenses and normal lenses should be used with *reversing rings* when magnifications greater than 1.0 are desired. These rings screw into the lens filter threads and allow you to attach the front of the lens to the extension device.

A Bellows Unit can give more extension than tubes and can be adjusted for any desired extension within its range. The bellows/macro lens combination gives highest magnification and image quality. A bellows and normal lens gives the next-best image quality with some sacrifice in edge sharpness.

To backlight the crystals you'll need a light source which transmits uniformly through the crystal and polarizers. The least expensive way to do this is to tape a polarizer and crystal sandwich to a sheet of diffusing material and place a light behind it. The diffuser may be white translucent plastic or a sheet of ground glass. Both may be available at your camera store. The light source can be a tungsten bulb, a flash or sunlight coming through a window.

A Slide Copier, which attaches to your bellows, makes photographing the sandwich easy. Some have adjustments for cropping in any direction and slots for inserting filters. Any convenient light source can be used, and a diffuser is built in. Generally, slide copiers sold as a complete unit with a built-in lens are of poorer quality than those intended for use with a separate bellows and lens.

Some photographers use a *light box* to shoot the crystals. Slide sorters or illuminators can be used, but an inexpensive light box is easy to make. It can also be used for other lighting and copy techniques

Light boxes, such as this Macbeth model, are handy sources of back light. Photo courtesy of Macbeth Color and Photometry Div. of Kollmorgen Corp.

in Chapters 3 and 8. You'll find it to be a very handy tool.

Regardless of the equipment you use to photograph the crystals, there are a few more considerations for best results. You can use any color film including the special color films mentioned in Chapter 4, but make sure the light source and film are properly color balanced. The light diffuser may act as a color filter and change the color temperature of the source. If you notice this, compensate with a color filter.

Be sure the crystal sandwich and film plane are parallel to minimize depth-of-field problems. A level aids in checking for parallelism. The camera system can be mounted on a tripod or copy stand for adjusting the distance between lens and sandwich. Usually the meter in your camera will automatically compensate for the light loss due to magnification of the image, but until you have gained some experience with your equipment and setup, bracket on both sides of the meter reading. Write down the settings so you'll learn to judge meter readings better and bracket less.

FLUORESCENT PHOTOGRAPHY

No doubt you've seen the effects of *black light* on certain dyes or fabrics. These intense colors are due to ultraviolet radiation stimulating atoms in the dye molecules and causing them to emit light by *fluorescence.* With a black-light source, specially colored objects, filters and a dark room, you can photograph the phenomenon for special effect.

The Physics of Fluorescence—Understanding the physics is not essential for creative imagery, but it is fun to know. Ultraviolet radiation can be divided into two kinds; refer to the spectrum in Chapter 3. *Short-wavelength* ultraviolet is from 200nm to 320nm. This range causes sunburn and eye damage, is not transmitted by ordinary glass and is used as a germicide. Some of this band is transmitted through the atmosphere. *Long-wavelength* ultraviolet ranges from 320nm to 400nm. It just reaches the visible portion of the spectrum and is trans-

A Nikon bellows unit, reversed macro lens and slide copier.

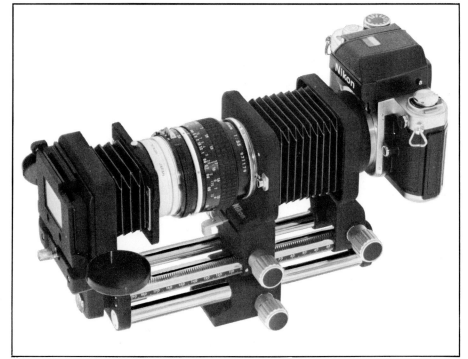

mitted by regular camera lenses and glass. This is the black light used to stimulate fluorescence.

Fluorescence is induced light emission due to the absorption of radiation by certain substances—in this case dye molecules. These substances fluoresce if the induced light emission happens only while the radiation is on. If the light lasts longer, the phenomena is called *phosphorescence.* Phosphorescent lamps—improperly called *fluorescent*—may fog film in a darkroom even after the lamp is turned off!

Materials—Long-wavelength ultraviolet sources are generally called *black lights* because a dark chemical coating inside the glass filters out the harmful short-wavelength radiation and most of the visible light. Specialty stores dealing in posters and psychedelic lighting often carry black-light lamps and fixtures. They are available in standard 18- and 48-inch lengths. They look and install like regular fluorescent lamps, but emit a dark blue light when on. All major electrical lamp manufacturers make and code them F-15T9-BLB.

Filters are needed over the camera lens if you want to exclude light from the lamp and record only the ultraviolet-induced light from the object you are photographing. Pale yellow filters such as the 2E or 2A are most effective. An 8 yellow or an 85 color-conversion filter also work, but they cut deeper into the blue and green light.

More than 2000 dyes and pigments fluoresce. Many of these materials are in household items such as cloth, paints, unrefined oils, leaded glassware and some powdered detergents. Table 5-6 lists some common pigments and their fluorescent colors. Fluorescent crayons, chalk and spray paints are available at artist-supply stores.

The range of photographic possibilities is vast. Paint objects of your own making or spray-paint cattails and other natural objects. Arrange still lifes by assembling a combination of flowers and glassware for a photo. Watercolor paints or powdered chalk can be added in small amounts to water and placed in glassware for an unusual glow. Because many clothes contain fluorescent dyes, it is possible to photograph people with this technique. Try rubbing some petroleum jelly

SOME PIGMENTS THAT FLUORESCE

Pigment	Fluorescent Color
Aluminum hydroxide	Light Blue
Chalk, ground	Red to Brown
Chalk, natural	Dark Yellow
Cinnabar, pure	Dark Red
Cinnabar substitute (Lithol Red)	Cinnabar Red
Cinnabar substitute (Permanent Red)	Carmine
Kaolin	Red-Violet
Light Spar	Violet
Magnesium carbonate	Violet
Magnesium oxide	Blue-Green
Orpiment	Bright Yellow
Red lead, pure	Dark Red
Red lead substitute (Helio Orange)	Reddish-Brown
Shale, ground	Dark Blue
Talcum	Dark Red-Violet
Titanium dioxide, pure	Dark Violet
Titanium white extra	Deep Violet-Blue
Ultramarine blue, pure	Dark Blue-Violet
Ultramarine blue substitute (Victoria Blue)	Dark Blue-Violet
White lead	Rose-Brown
Zinc sulfide	Orange
Zinc white	Light Chrome Yellow

Table 5-6

Some of the equipment you'll need to do fluorescent photography.

82

Water colored with fluorescent pigments produced an eerie glow under a black light.

onto the face and hands of the subject to accentuate body features.

Exposure—Colors induced by a black light are most intense in a dark room. Metering in a dark room can fool your meter due to the dominant darkness. If possible, meter the colored part of the scene with the camera held close to the subject. Use that setting at the pre-ferred camera location. Some scenes may not have much light, so adjust for reciprocity failure with long exposures or use a fast film. Bracket two steps in both directions from the meter reading and record your settings.

An electronic flash can be used if it is filtered with an 18A filter, a glass filter which transmits radiation from 320nm to 400nm. You'll have to determine a GN for this setup; see Chapter 3 for information about guide numbers.

Try combining other techniques described with fluorescent lighting. Use the camera effects of Chapter 1, the attachments of Chapter 2 or the special color films of Chapter 4.

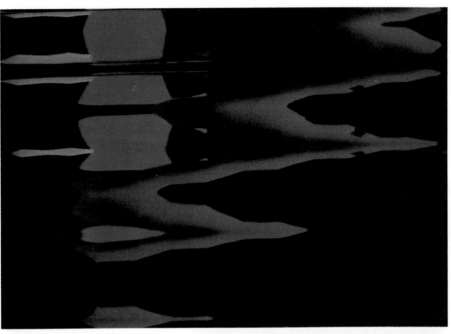

Above
Fluorescent paper makes graphic reflections when placed behind a block of glass. Photo by Ray Rosenhagen.

Right
Painted objects become a fascinating design in this photo by Ray Rosenhagen.

SUBJECT MANIPULATION

6

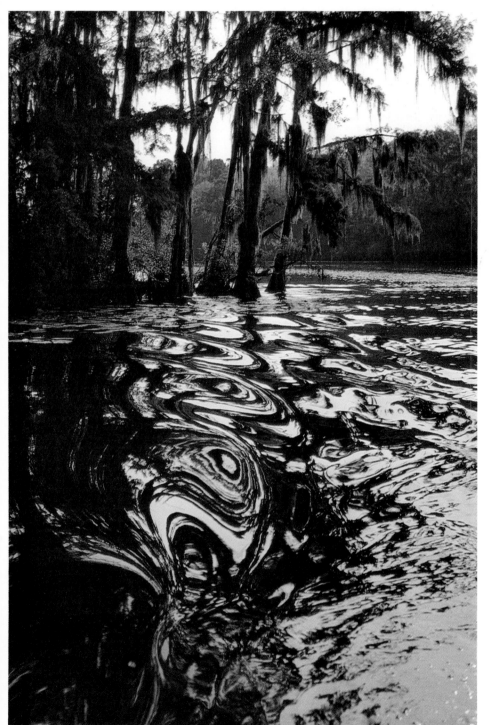

If you want to go beyond candid photography, work with a subject and involve yourself with it. Mood, meaning and impact of a picture can be changed by altering the shooting procedure. Modern, sophisticated cameras with automatic features simplify the technical side of photography and help you make realistic photos of interesting subjects. You can also make *unrealistic* photos based on your interpretations and interaction with the subject.

This chapter deals with manipulating the subject for special effect. A variety of translucent, transparent or reflective materials can be used to distort, duplicate or treat the subject in the abstract.

REFLECTIONS

Reflective surfaces can be almost anywhere, and they can be exploited photographically to manipulate a subject for special effect. The extent of manipulation depends on what you want because you can often *control* the location and shape of the reflected surface. Whether you use water, plastic, metal or mirrors, the reflection can range from a realistic image to an unrecognizable, but evocative, distortion.

Boat wake distorts reflections of trees in a Louisiana bayou.

Water Reflections—Using water as a reflective surface is a convenient place to begin because you need no special equipment. Water surfaces are variable both in color and reflective characteristics. Rivers reflect less than small ponds, and the surface of a mountain lake seldom looks like water in a swimming pool. After a rain, wet pavements and scattered puddles are also excellent for day and nighttime reflections.

A lake may be smooth and mirror-like in the morning, have ripples and turbulence during the day and become calm again at night. Water depth, angle of light and sun, or shade affect the color and contrast of a reflected image. Overhead light does not work well for water reflections unless you want a reflection of the sky and clouds. Usually, early or late in the day gives the best sun position for reflection of subjects near the water. Ripples in the surface break the reflected image, and the effect can be as subtle or as obvious as you wish. You can cause ripples by tossing a pebble into the water after the reflection is framed.

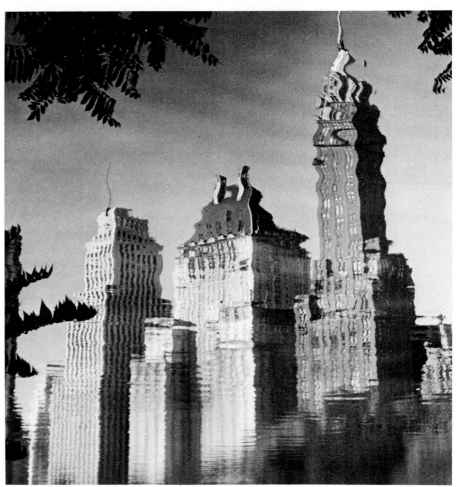

To make this photo I waited until the water was nearly calm.

Sunsets and water reflections are always a good combination. Photo by Dennis Makes.

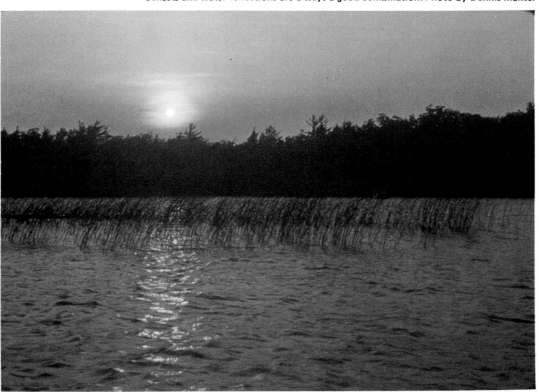

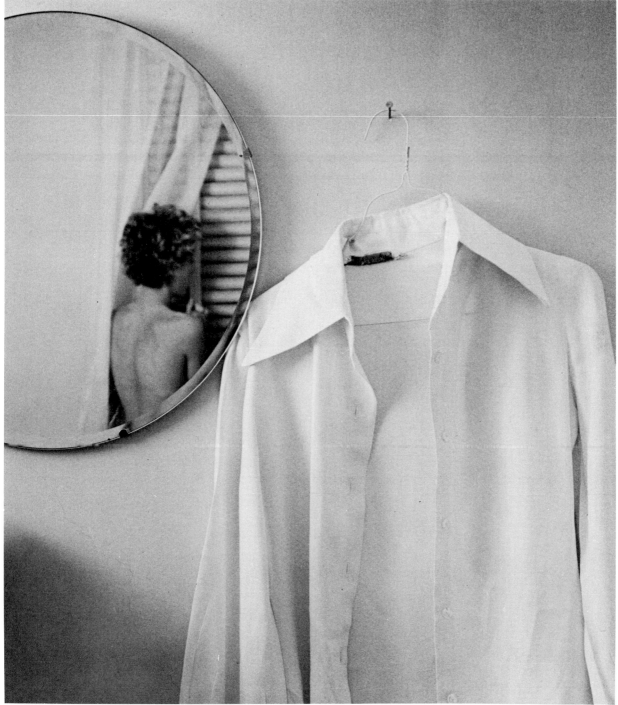

In this self-portrait, Stephanie Walter emphasized focus on the shirt.

Think wet when looking for reflective surfaces. Water creates dazzling reflections, but oil films and soap bubbles also make interesting colors and shapes.

Mirrors—Reflections from mirrors are another source of exciting images, and a variety of effects is possible.

If you want both the subject and the reflected image in focus for the photo, you must adjust for the *apparent* distance between subject and reflected image. For instance, if the subject is five feet in front of the mirror, the image seems to be the same distance behind the mirror. To get both subject and image in focus, you need a depth of field of at least 10 feet. Make a visual check by using the depth-of-field preview control on your camera. Use selective focusing to get the effect you want.

Lighting a scene that includes a mirror surface must be done carefully. The angle at which the light strikes the mirror is the same angle at which it is reflected. The light source should be placed to light the scene, but not reflect directly into the lens—unless this is the effect you want.

A small pocket mirror is useful for making twin images. Hold the mirror edgewise against the front rim of the lens. Adjust it while looking through the viewfinder to get the subject and reflection combination you like. For example, a skyline or row of trees seen in the top half of the viewfinder produces a nearly identical image in the lower half of the frame if you hold the mirror at the bottom of the lens. Use a tripod to hold the camera, hold the mirror steady during exposure and use a short exposure time.

A small cracked mirror is comparable to a prism accessory because it produces more than one image of an object when held near the lens. The subject is fragmented by the facets of the surface. You may need to tape the back of the mirror to hold it together.

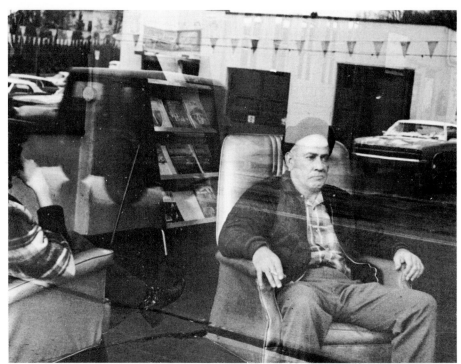

Man in Window **by Stephanie Walter.**

If you want a clear mirror image, make sure the camera is on a tripod, the mirror is clean, and use a fast shutter speed so mirror shake won't be recorded.

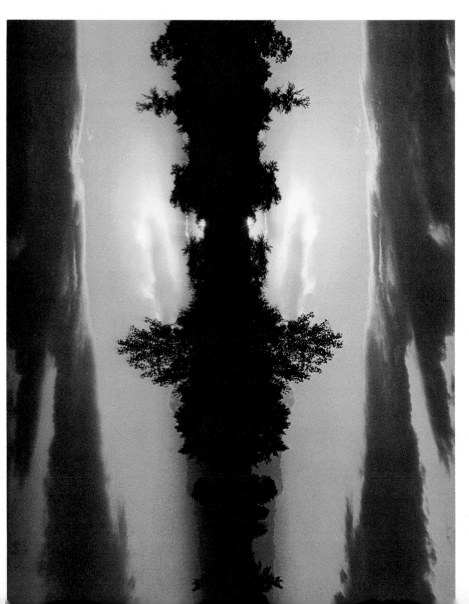

I consider this scene my Rorschach sunset.

Kevin Marks photographed this segmented sky in Toronto, Ontario.

Distorted Reflections—Flexible polished metal and plastic sheets create rippled and distorted reflections. Ferrotype tins or chromed metal sheets are ideal light-weight, flexible mirrors. Reflective sheeting in various colors also works well and can be purchased in art-supply stores.

The image is duplicated, stretched or distorted according to the bends and curves in the material. Arrange the reflecting surface and the subject, then notice the variations in the image change as you change camera angle or the shape of the reflecting surface.

Abstract color schemes and images can be made by shaping plastic sheets or metal and arranging colored paper to reflect in the material. The variability of the distorted surface creates an array of possible photos.

I made this pattern by crumpling aluminum foil and photographing a reflection of colored paper.

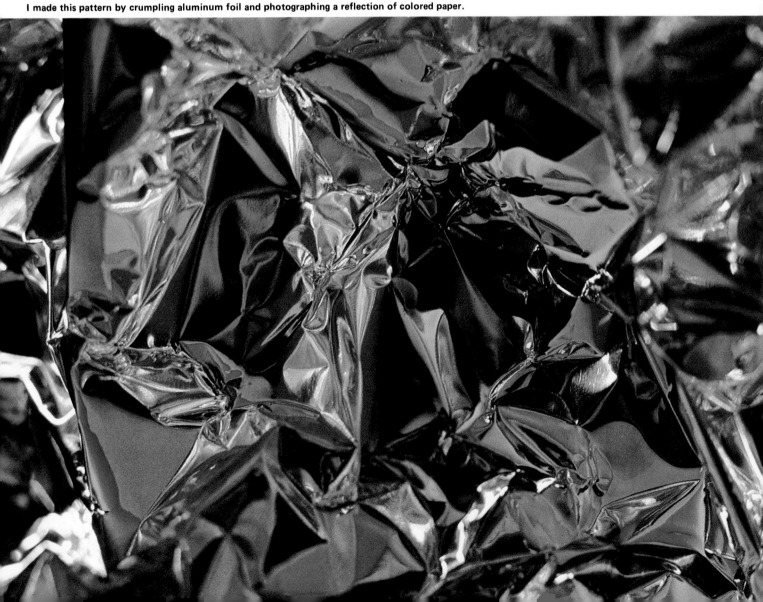

Try multiple exposures, filtering the light source, special lens attachments, or use the abstract image in combination with other photos as described in Chapter 8.

Variations—Light the subject directly when using flexible mirrors unless you want to use the material as a reflecting light source. You can shape plastic sheeting or aluminum foil to cast interesting patterns of light onto a subject. Even flat mirrors can be used this way, but the light is not as scattered. Try filtering the light to make it a different color than ambient light in a scene. Photos with mirror effects don't have to include the reflector in the scene.

Try using the subject and the reflected image in different ways. Shoot the subject and reflection, just the reflection, or parts of both as you consider the relationship between the subject and its image. Selective focus is a powerful technique when used with reflections.

Mirrored building panels often produce wavy images. Photo by Stephanie Walter.

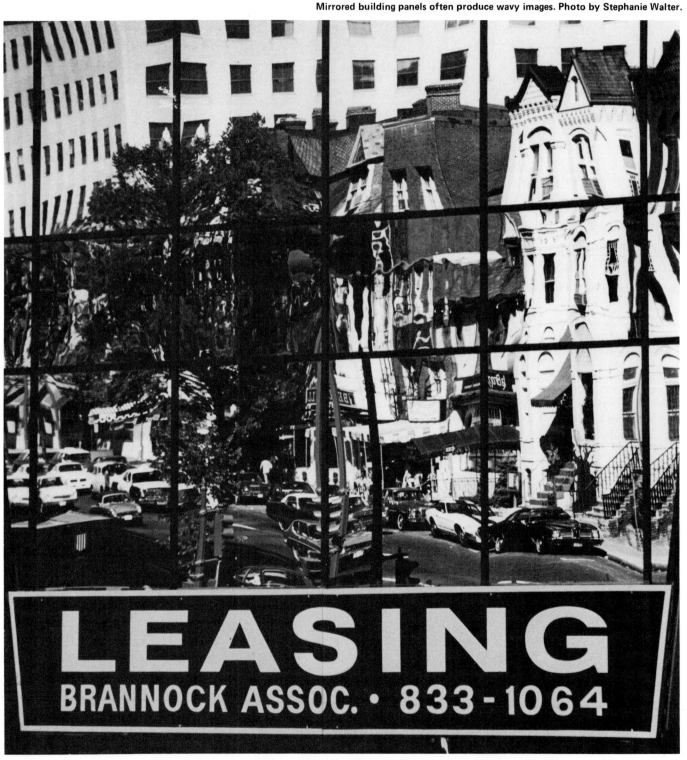

LEASING
BRANNOCK ASSOC. • 833-1064

STILL LIFES

A still life is an arrangement of inanimate objects. You arrange subject matter and lighting to please personal taste and create a desired effect. Many special techniques in this book are applicable to still-life photography. The setup can sometimes be kept intact for weeks to produce a desired result with repeated shooting sessions, so still lifes let you learn more about photography and special effects at your own pace.

In a still life the objects usually have something in common. The objects can be fruits, vegetables, flowers, bottles, plates, glassware or other compatible objects. After you select the items, arrange them in a simple unified design with one item as the principal element. The dominant item can be off center, in front, placed highest or lowest.

A cloth-covered table or illustration board makes a good base, and a plain wall is often used as a background. Use a backdrop of paper or cloth to eliminate a horizon line by using one long piece of the material to cover the base and background areas. No horizon shows because there is no corner where the background meets the base.

Shooting a still life is a relaxed activity. Inanimate subjects won't blink their eyes at the wrong moment or complain about hot lights. What you learn about lighting and composition makes you more skillful at all kinds of photography.

As you arrange lights in a still life, you'll discover the dark areas are as important as the bright areas. The photographer Edward Steichen once shot more than a thousand negatives of a teacup and saucer against a black velvet background to learn subtle gradations of light and shadow. You don't have to go to this extreme, but do spend time working with shadows in a setup. They add depth and mood and can also be used to fill vacant areas in the foreground or background. The main shadows are created by the main source, but fill lights, reflectors, barndoors or shields are used to adjust the main shadows. A light on the background is sometimes necessary to separate foreground from background for a more three-dimensional effect.

Assign yourself a still-life project and investigate the variety of interpretations which are possible with different techniques. Use several kinds of lighting for the same arrangement. Try soft, diffuse lighting reflected from a photoflood or harsh illumination from a flash. Make a low- or high-key scene. Shoot in either color or b&w. Try other special-effect techniques described in this book. Experiment, learn and have fun.

Glassware—Shooting glassware is an elegant and easy way to combine

Lighting for still lifes doesn't have to be complicated to be effective. For these two still lifes, photographer Rick Gayle used one diffused photoflood plus a white card to control shadows.

91

special effects with still lifes. With simple backdrops and lighting you can convert a plain object into an exciting design.

The backdrop can be a large sheet of diffusing plastic or glass or a textured pane with a visible pattern. These materials are available from glass or home-improvement stores. I use a 2-foot-square sheet of plastic because it is light and unbreakable.

The glass or plastic backdrop is held in position by two simple supports, Figure 5-1. Another piece of glass or plastic can be placed flat on the supports as a base for the glassware. Put a plain paper or cloth underneath the base so the wood doesn't show.

Wide rolls of paper available from art-supply stores can be used as an inexpensive seamless backdrop if you don't want to make supports. Tracing paper is also a good diffusing material for backlighting.

Choose a simple wine glass or goblet for your first attempt. Place it on the base and compose the scene. Put the background out of focus if you want to soften any horizon line. Back light the scene by placing the light behind the vertical backdrop and pointing it toward the glass. The back light will accentuate the edges of the glass and outline its simple beauty.

To add more dimension to the rounds and curves of goblets or vases, use top, front or side lighting. Diffuse or bounce the lights to avoid harsh specular highlights. Natural light from a window can also be effective front or side lighting.

Try using a light tent to reduce reflections when photographing shiny objects. Place white sheets or diffusing material such as large sheets of tracing paper around the subject. Hang them from the ceiling or attach them to stands. This distributes the light evenly and eliminates shadows.

Distracting reflections are minimized by a tent because the plain white diffusing material is reflected in the object. To reduce the size of the camera reflection, cut a circular hole in a piece of white cardboard large enough for the lens to fit through. The white cardboard surrounding the camera diffuses some more light. If white sheets of cloth are used to make the tent, slip the camera lens through a break or hole in the sheets. Moving the lights may also help reduce camera reflections.

Opposite page
Same setup as below, but with a beaded glass background and shot in color to make a completely different photo.

Figure 5-1

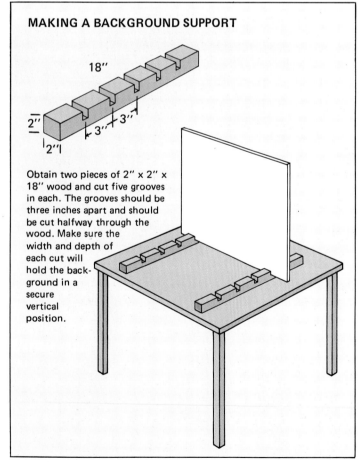

MAKING A BACKGROUND SUPPORT

18"

2"

2"

3" 3"

Obtain two pieces of 2" x 2" x 18" wood and cut five grooves in each. The grooves should be three inches apart and should be cut halfway through the wood. Make sure the width and depth of each cut will hold the background in a secure vertical position.

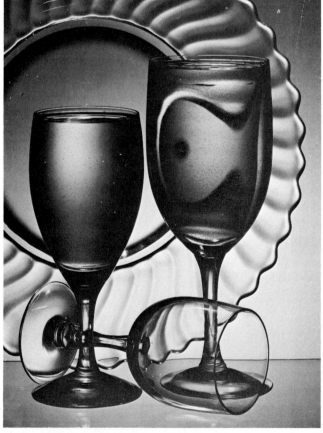

A glass plate served as background for this elegant Ben Jakobowski composition.

92

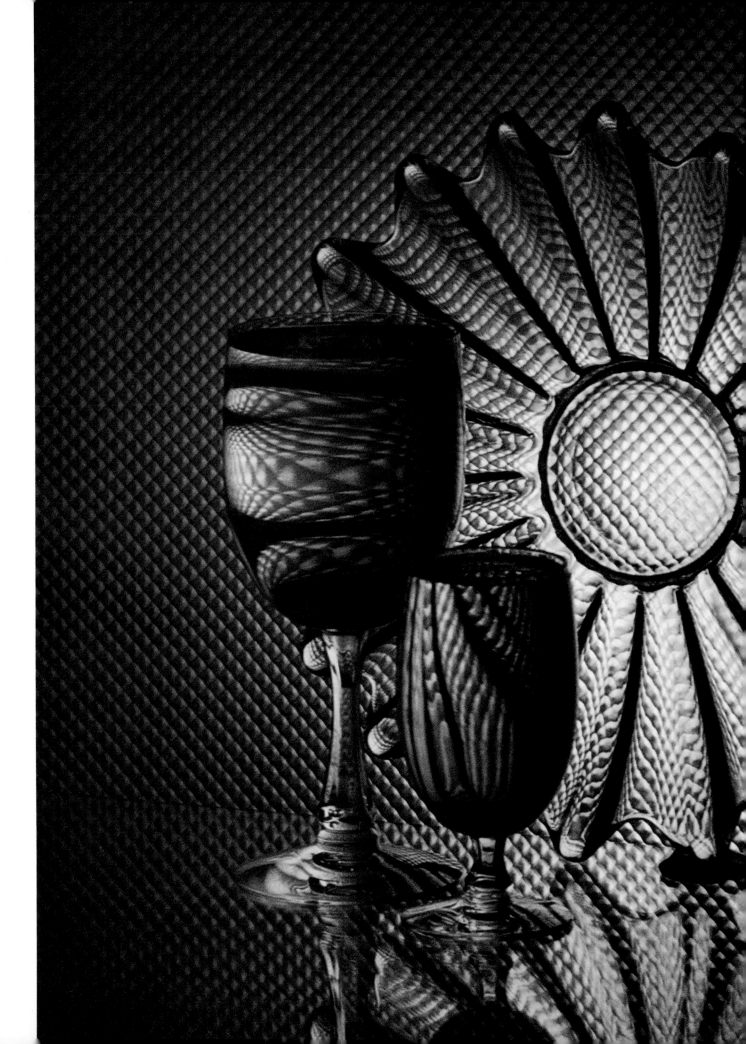

One way to add color to the scene is to place colored cellophane or theatrical gels between the light source and backdrop. If filter scorching is a problem, try reflected colors. Use bright-colored cardboard as reflectors and arrange the light at a 45° angle to the reflecting surface. The glassware edges will show some of the colors from the lights.

Combine different kinds of glassware in a scene. Interesting visual effects can occur when one glass is placed in front of another. Water in a glass distorts things behind it because the water acts as a lens.

dance (dăns, däns) *v.* **danced, dancing, dances.** —*intr.* **1.** To move rhythmically to music, using prescribed or improvised steps and gestures. **2.** To leap or skip about excitedly; caper; frolic. **3.** To bob up and down. —*tr.* **1.** To engage in or perform (a dance). **2.** To cause to dance.

You can even add the extra effect after you make the photo as discussed in Chapters 7 and 8. Photo by Ted DiSante. Definition reprinted by permission of *The American Heritage Dictionary of the English Language.* **©1978 by Houghton Mifflin Co.**

PEOPLE

Manipulating a human subject is the opposite of candid photography. The model is posing or doing things at your request to achieve a certain photographic purpose—in this case for special effect. Ideally you are working *with* the subject to make an interesting image, and a relationship of trust and cooperation gives best results. Discuss your ideas with the model before or during the shooting. Ask his or her opinion about what you plan to do. Whether you use the opinion or not is less important than the interest you show in soliciting it.

A special-effect people picture is usually worth the extra effort it takes to make it. Photo by Ted DiSante.

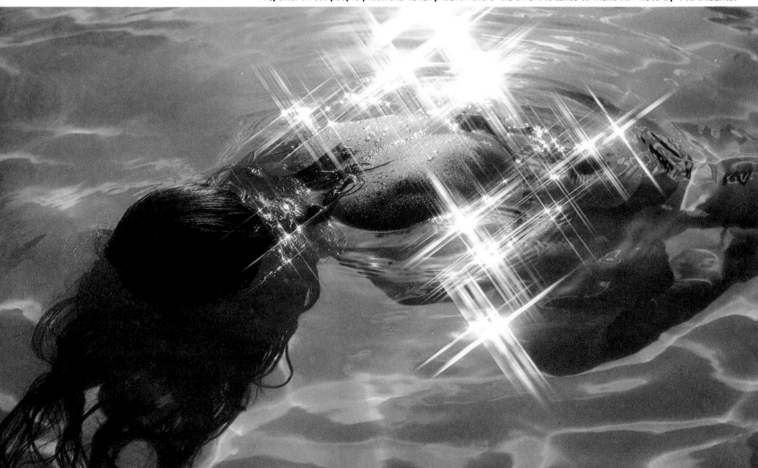

MODEL RELEASE FORMS

If you plan to use a photograph of a person for publication or if you receive payment for making it, obtain a model release form and get it signed by the model. It gives you rights to use the photo. Payment or other consideration, such as a credit line for the model, is usually arranged before the form is signed. This can protect both you and the model from future problems concerning money, invasion of privacy, or ownership rights. If your model is a minor, the form must also be signed by a parent or legal guardian. A sample form is shown.

If you aren't going to pay models for their time and effort, offer them a duplicate print or slide of the best photo. This is a common courtesy and will help you get more models for future photographic sessions.

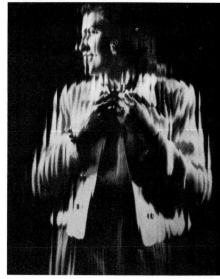

Glass backdrops have many uses for creative distortion.

MODEL RELEASE FORM

Date_____

Photographer_____

Address_____

For valuable consideration, I consent to and grant the use and reproduction by you, or anyone authorized by you, of any and all photographs that you have taken of me this day. All negatives and positives, together with the prints, constitute your property and may be used for any purpose without further compensation to me.

Model_____
(signature)

Address_____

I am over 18 years of age. Yes_____ No_____

* * * * * * * * * * * *

I certify that I am the parent or guardian of_____

the model named above, and for the value received I give my consent without reservations to the foregoing on behalf of him or her.

Parent_____
(signature)

Date_____

The best photographs of people communicate something about the person in the scene. Make the effect fit the subject. If the person is active, put motion in the photo with one of the methods described in Chapter 1. Enhance beauty with some of the attachments and lighting described in Chapters 2 and 3. Create distinctive studies of a person with the different films discussed in Chapter 4. Create humorous effects with special lenses. Combine effects and techniques, but use them to support the person or people in the photograph. People are usually the most important element in this kind of photograph.

Another way to photograph people is to let them be the effect. Have your model do something unusual. Photograph the person's hidden talent. Disguise, make-up or mask the subject for a feeling of fantasy. Go beyond normal portrait technique, and you'll create a special effect.

SELF-PORTRAITS

The self-portrait is a traditional way artists have presented themselves and their style to the public. It can force you to use some self-knowledge because it is an interpretation of your self. Of course it doesn't always have to be true, accurate or even serious, but you should try to visually express your personal thoughts, ideas and feelings.

A self-portrait is a good way to practice some of the techniques in this book. It may be practice for a later shooting session with another person or it can be pure personal expression. One photographer I know kept a photographic diary of herself during an important and hectic year of her life. It is a way of keeping a visual record of new looks, attitudes and ideas.

In a self-portrait, you don't have to coerce the subject, sign a model-release form or even pay the model. You are totally in charge. Some

Discovering Mt. McKinley

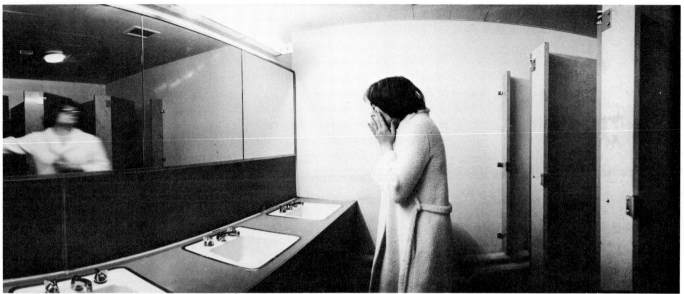

Did you ever look in the mirror and someone else was looking back?

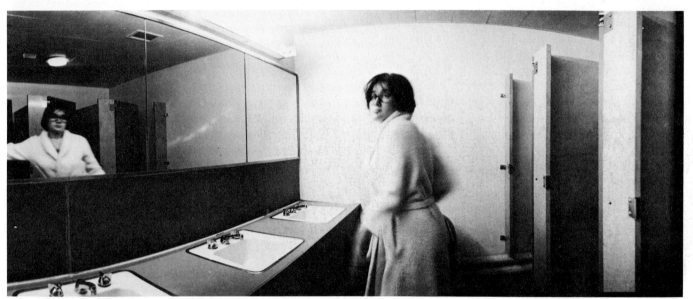

It may be your imagination . . .

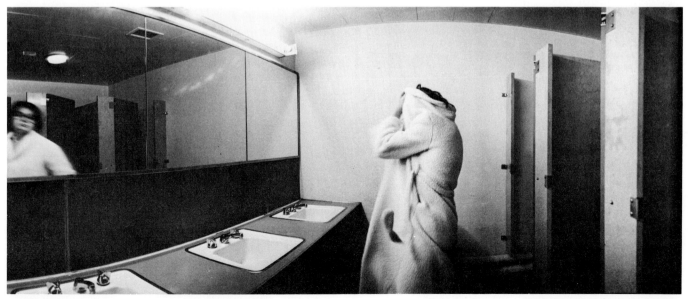

. . . but who's ready for reality that early in the morning?

Self-portrait series by Cindy Sirko.

extra equipment makes working alone easier. A tripod is useful so you can be away from the camera during exposure. Most cameras have a self-timer control which gives a delay of about ten seconds before the exposure is made. During the delay, you get in position for the scene you have set up.

On some cameras the B setting can be used with the self-timer. The shutter opens and closes, but there is no consistency in exposure time among brands. You can time your camera to see what the exposure time will be. For example, the Olympus OM-1 and OM-2 used at the B setting with the self-timer give an exposure time of about three seconds.

Long shutter-release cables allow you to be in the scene and trigger the shutter without delay at the appropriate moment. They are ideal if you want to shoot your own peak action. If the shutter is set on B, long exposure times can also be done remotely. The shutter stays open as long as the cable release button is depressed.

If you want to hold the camera and make a self-portrait, try a wide-angle lens such as a 24mm. Hold the camera at arm's length pointing toward you. The wide field of view will include not only you, but also an expanse of background. The arm with the camera need not be in the scene if you are clever about how you hold the camera.

Mirrors are often used in self-portraiture. Sometimes the camera is included in the photo. It can be cropped out later, or it can be visually effective by labeling you as a photographer.

A mirrored image is laterally reversed. Your left side becomes your right side and vice versa. If the image is a slide, you can correct this by reversing the slide in the projector. If it is a negative, print it with the emulsion side up.

The special-effect self-portrait is a category as open as your imagination, and any of the techniques in the book can help you make a photo distinctly personal. Express yourself visually by including your attitudes and moods in a photo showing subject and photographer are one and the same.

REAR & FRONT PROJECTIONS

A slide projector can create interesting effects when used to project backgrounds or illuminate a subject. Still lifes or human subjects are used with projected images. A flat translucent background is used for rear projection, but with front projection the subject usually receives the image.

Rear Projection—A flat translucent background like the one suggested for the glassware photos is a good rear-projection screen. Aim and focus a slide projector from behind the screen so the desired image fills the background. Then position a

still life or model in front of the background. If you don't want the subject silhouetted, it must be lit. The lighting should be controlled so it doesn't wash out the projected image.

Ambient light is minimal. Use careful side, top or front lighting on the subject. The amount of light on the foreground and subject should be balanced with the amount of light from the projected image so the film can record both. If the light on the foreground subject is much brighter than the projected background, a photo exposed for the background will make the front matter too light or washed out. The reverse is also true. The meter reading for the background alone should be within a step of the meter reading of the foreground.

If you can't balance lighting in the setup, a long and a short exposure can be combined on one frame. Drape a black cloth over the background screen for the first exposure. Attach the camera to a tripod, compose the scene and arrange foreground lights. Take an exposure reading from a gray card because a predominantly black background may cause the meter to give overexposure. Make the first exposure. Remove the black cloth from the background screen and turn on the projector. Turn off the foreground lighting, meter the projected image and make the second part of the double exposure. The unlit fore-

This combination portrait of Ansel Adams and self-portrait was made by hand-holding a camera equipped with a 24mm lens. Photo by Ted DiSante.

This is the setup I use for rear-projection photos.

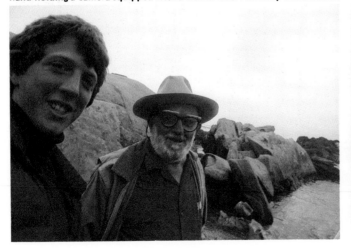

ground masks itself so it won't interfere with the first exposure, if neither it nor the camera are moved for the second exposure.

Projector bulbs have a color temperature of about 3400K, so you may want to filter the projected beam if you light the foreground with a flash. Use an 80B filter over the projector lens to balance the color temperature of the lights.

The rear-projected image will be sightly diffused by an improvised translucent background screen. Special rear-projection screens minimize but do not eliminate this effect. With rear projections you may want to use selective focusing. Depending on the background you are using, you may want both it and the foreground in focus or either one in focus.

Try combining travel scenes with people in the foreground or make an "impossible" photo such as a burning candle in a projected underwater scene.

Front Projection—Another way to manipulate a subject with a slide projector is by placing the projector in front of the subject. An image is projected onto the subject and the result photographed. A light-toned still life or model is best for this technique. If the subject is middle gray or darker, the projected image will be dark and not very contrasty. Using a dark background will make the projected image seem brighter with any subject.

Compose the scene and arrange the slide projector so you will not be in the beam. You can use the beam as the only source of light or balance it with ambient light. Be careful not to light the model or still life where the projected image will be. If the subject is not flat, the projected slide will be focused sharply in only one plane and will bend around the object. For some abstract or readily recognizable images this won't matter.

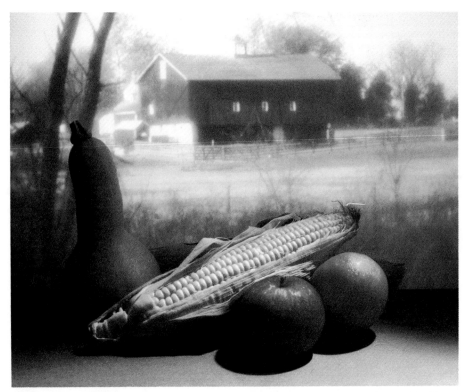

The projected image is less sharp than the foreground subjects, but you can usually use this effect.

To create this strange image, photographer Mark Henry first photographed an eye on slide film. He projected the slide onto aluminum foil through a red gel with a hole punched in it, and then photographed the foil.

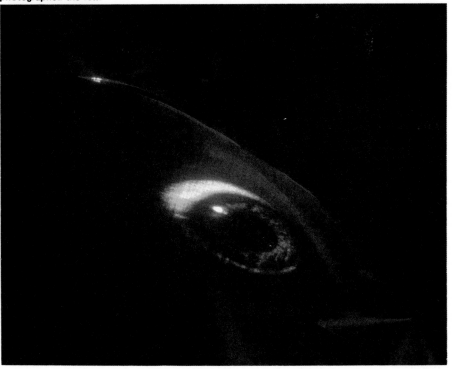

7

MANIPULATION IN THE DARKROOM

Many photographers find the darkroom gives a second chance at making great pictures. For this chapter it is assumed you have experience with enlarging, contact printing, chemical solutions, burning and dodging to get the best print possible from a negative.

Don't be afraid of the darkroom if you have never processed film or prints. The fundamentals are simple. For basic information about b&w and color processing, read HP Books' *Do It In The Dark* by Tom Burk. Once you have some experience developing film and making regular prints, you can start using some of the techniques described here. They are presented in order of increasing difficulty.

Most of this discussion is about b&w materials because learning and experimentation involve waste. Color materials are costlier than b&w materials, so I recommend you master a method in b&w first. The b&w image can be as exciting and esthetically pleasing as a color image. And a properly processed b&w image can also last years longer than a color image.

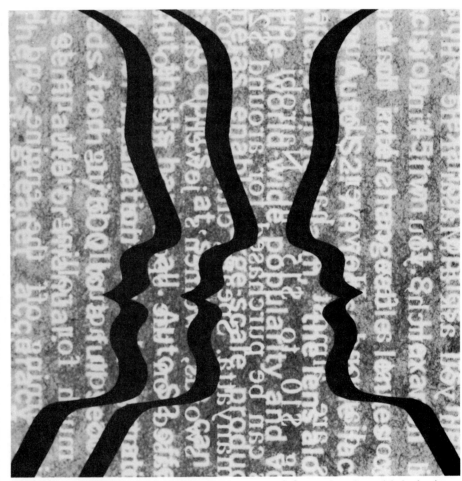

Rick Gayle made this simple photogram by cutting out words from a magazine article in the shapes of profiles and then contact printing them with a piece of printing paper.

Some of these techniques can be done easily by using color slide film. Techniques described in Chapters 5 and 8 let you experiment economically and create special images in color. Duplicate slides or prints can then be made from your best work.

Some darkroom manipulations can hide flaws in a negative. Or they can sometimes make a superb visual statement from an ordinary negative. Whatever visual mood, emphasis or abstraction you want is possible with these techniques.

The danger lies in overdoing a particular method, thus making your work seem to be all effect and visually meaningless.

One way to use this information is to practice each technique with existing negatives and slides. Try to master and control the methods and their potential. Make careful notes in case you find a better or more personal way of using these ideas. They are guidelines for some effects and should not inhibit any experiments you want to pursue. Once you know the techniques well and can control them, you'll be able to choose the most suitable method for a specific idea.

PHOTOGRAMS

Working independently, three artists pioneered and popularized photograms during the early decades of this century. Without a camera, Man Ray, Laszlo Moholy-Nagy and Christian Schad made photographic images that revealed contours and shadows of objects and created tonal abstractions of everyday things.

Today, courses on darkroom technique often begin with the photogram. These can range from very simple and stark shadow images to modified use of the full range of tones in a print. Many photographers trace their enthusiasm for the medium to their first photogram.

To make a photogram, set the enlarger to illuminate the area of the printing paper you intend to

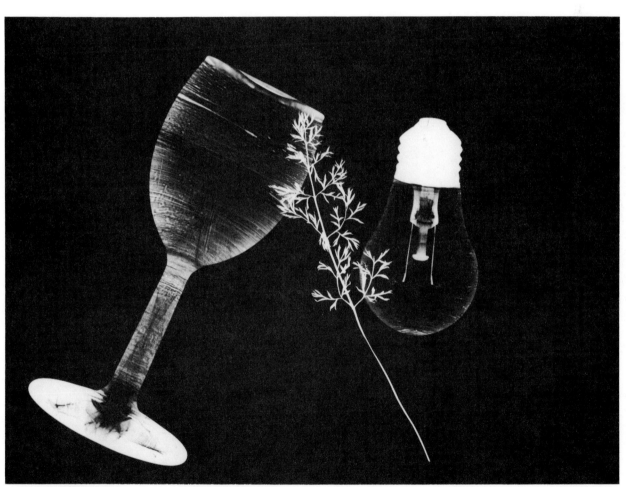

Translucent objects create shades of gray in a photogram.

101

use. Install the negative carrier without a negative in it. Turn off the enlarger. Under safelight, place a piece of printing paper in the easel. If you don't have an enlarger, an ordinary ceiling lamp in a darkened room will work. Place some objects such as keys, leaves or whatever you choose on the paper and make a series of test exposures with the enlarger or ceiling lamp. Develop and fix the test print. Expose a photogram using the best exposure for your selected arrangement. Develop and fix the print.

Opaque objects prevent light from reaching the paper, and those areas are white in the processed print. The background can be a dark gray or black, depending on total exposure time.

Photograms with gray tones in them are more appealing to some photographers than stark b&w ones. Experiment with soft and hard edges. Soft gray edges can be made by slowly moving the object or holding it above the print on a sheet of glass.

Flexible objects held flat under a sheet of glass will create hard edges. Or, make both hard and soft lines by not holding the object completely flat on the paper. Try leaves, feathers and ferns both ways to see which you prefer. Gray tones can also be made by splitting the total exposure into separate exposures with different objects.

Combine projected images and photograms to make intriguing prints. Project a negative or positive on the paper, and during part or all of the exposure time do the photogram manipulation. The photogram manipulation may need a different exposure time than the projected image, and some burning or dodging may be necessary to get best results. A small penlight may help for local burning-in on the print.

Photograms can be as simple or complex as the idea they are supposed to convey. Use them with other techniques in this chapter. Try them with toning, copying or coloring as described in Chapter 8.

The Cibachrome process and other reversal color-printing products are ideal for color photograms. Flowers, feathers, colored glass or butterfly wings are good subjects for this technique. The objects are

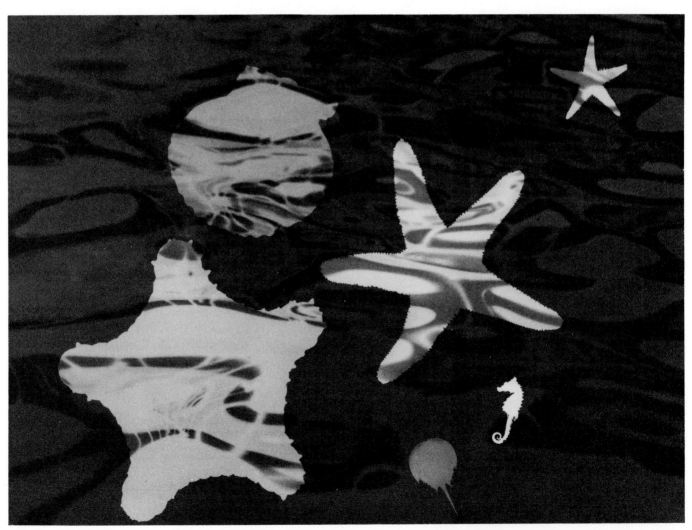

I placed the figures on top of the printing paper at different intervals during the negative exposure.

102

placed on the paper and exposed as with any photogram. With reversal material, more light makes a lighter image, so the background and possibily the image area is white in an overexposed print. Do a series of test exposures. Try using color filters to create a colored background. Use masks to get a black background with bright spots of color.

Whichever method you use to make photograms, you'll find it requires patience and experimentation. It is a simple technique that can be used by the photographer and non-photographer alike. Besides some minimal darkroom skills and equipment, all you will really need is imagination and the desire to create.

TEXTURE SCREENS

Texture screens were first used years ago by photographers who were trying to imitate paintings, etchings and charcoal drawings. This use declined with the rise of naturalistic photography, but recent trends in photography and the graphic arts have revived and expanded the use of texture screens. They are now used for more than imitative effects. Some photographers use them to complete the photo's visual message.

You can buy various cloth textures, reticulated grain, brush strokes, etch marks, marbles, dot patterns and others. Whether the pattern is particulate, diffuse, rough, lined, dotted, regular or irregular affects how we interpret the print.

I confess I sometimes add texture to salvage a scratched or damaged negative. The right texture often hides the fault completely.

The screen is placed between the light source and print so it is imaged on the printing paper. Small screens and large screens can be purchased at camera stores. Small screens are sandwiched with the negative; large screens are held in contact with the printing paper.

To use a small screen, insert it together with a negative in your enlarger's negative carrier. Make a test strip using different exposure times. Exposure time for the final print will be slightly longer than usual because of the extra density of the negative/screen combination.

A variety of texture screens, such as these available from Paterson, can be purchased in camera stores.

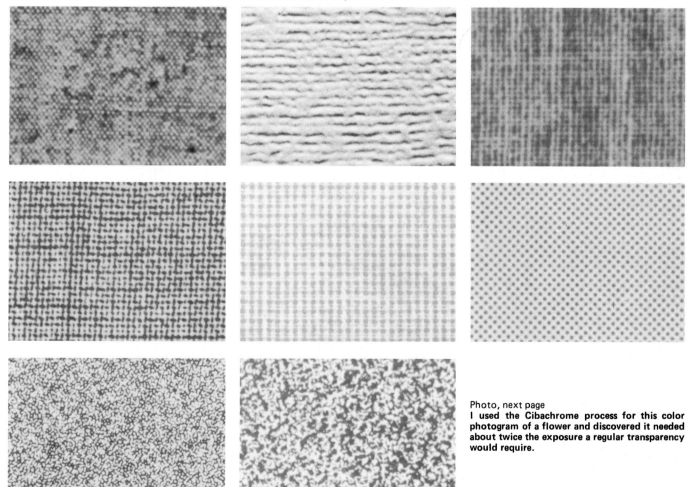

Photo, next page
I used the Cibachrome process for this color photogram of a flower and discovered it needed about twice the exposure a regular transparency would require.

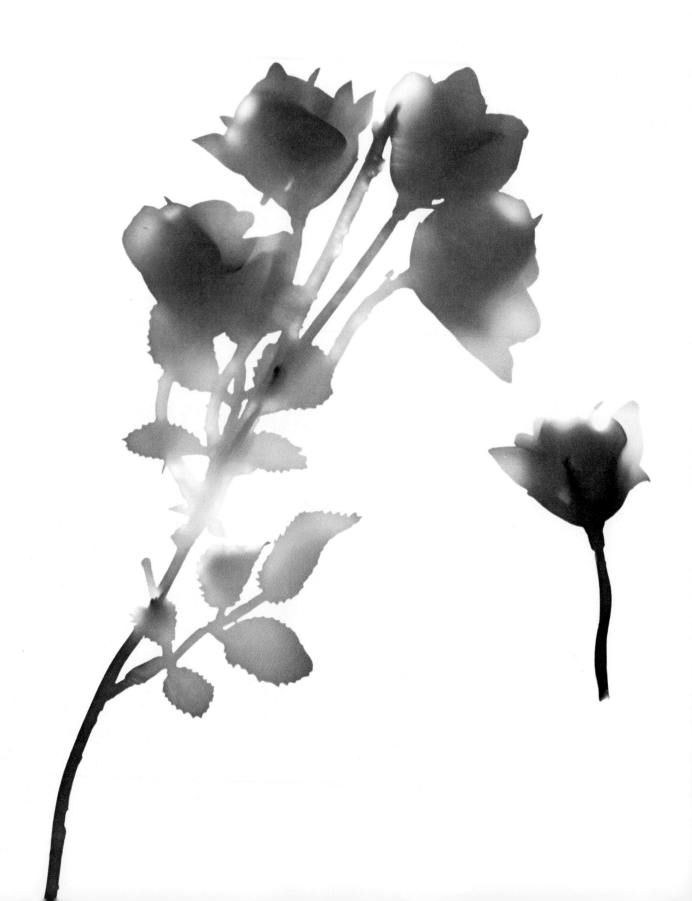

After processing, you may decide the print has too much texture and not enough picture. Separate the screen and negative with a thin piece of cover glass or clear plastic to soften the screen effect, or reverse the screen so its grain is a base thickness away from the grain of the negative. You can also use a large aperture in the enlarger lens and focus only on the negative for more softness of the screen image.

If the texture is still too prominent, print the negative and screen separately on the same piece of paper. Experiment with preliminary test strips. The screen generally needs only a fraction of the exposure time the negative requires.

After trying small screens, you'll appreciate the advantage of a large screen placed over the paper. Tape the paper on the easel or baseboard, and place the screen over the paper. Depending on the sharpness of the screen image you want, you can either hold it flush to the paper under a clean sheet of glass or let it lie on the print. Expose the paper.

If the paper is taped in place, the screen can be removed after part of the exposure. Turn off the enlarger after the screen exposure, remove it and then finish the exposure. Varying the amount of exposure through the screen can result in subtle textural differences.

Prints made with texture screens excite some photographers and they begin to seek new and unusual textures. They photograph ferns, grasses, peeling paint, wood patterns and window screens to make their own small screens. Thin or underexposed negatives work best. Subjects such as fabrics and paper textures are best photographed by transmitted light from a light box. And you can make large contact screens by projecting your 35mm negatives onto sheets of litho film or copy film.

Eastman Kodak makes a litho film with a special screen built into the emulsion. The film is Kodalith Autoscreen. After a continuous-tone negative is enlarged onto it and the film is processed, the image has a dot pattern intended for use in printing-press reproduction. You can also contact print a negative or positive onto this film and enlarge the new image onto regular litho film to get still larger dots in the print.

Design your own screens and photograph them or make screens from textured plastic, grainy film or moiré patterns. Diffusing material such as tracing paper or translucent plastic sheeting makes effective contact screens to create soft images.

MANIPULATION AT THE IMAGE PLANE

Any deviation from standard enlarging methods changes the projected image in some way. This manipulation shows and can be recorded in the image plane under the enlarger. To create special effects you change the enlarger position, the image plane or both. Distortion

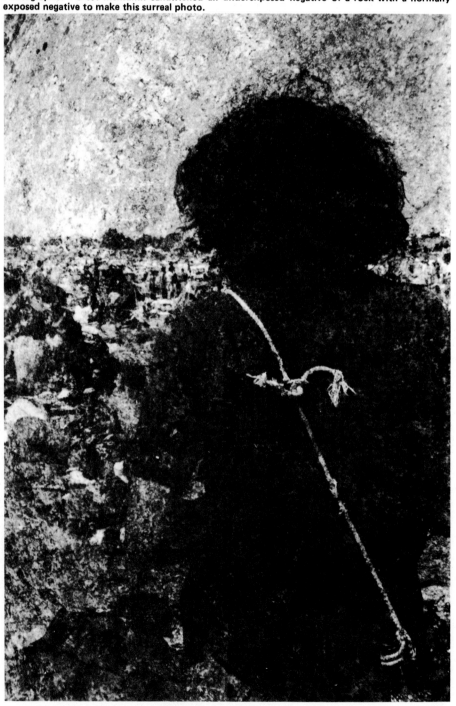

Photographer Forest McMullin sandwiched an underexposed negative of a rock with a normally exposed negative to make this surreal photo.

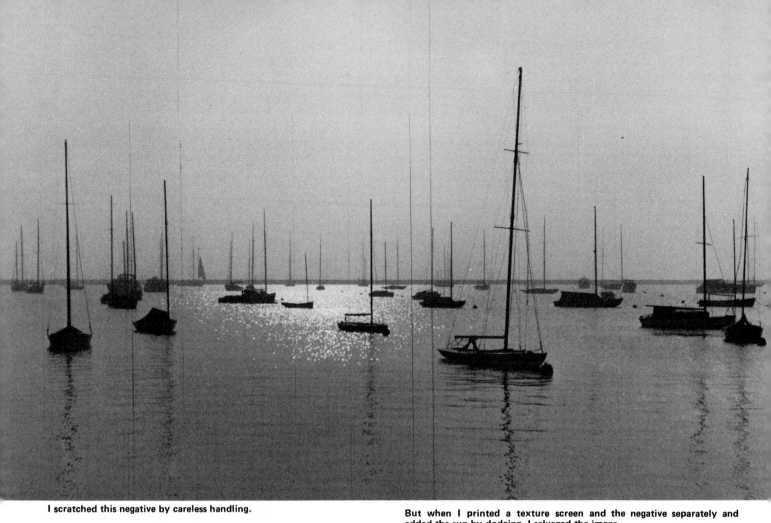

I scratched this negative by careless handling.

But when I printed a texture screen and the negative separately and added the sun by dodging, I salvaged the image.

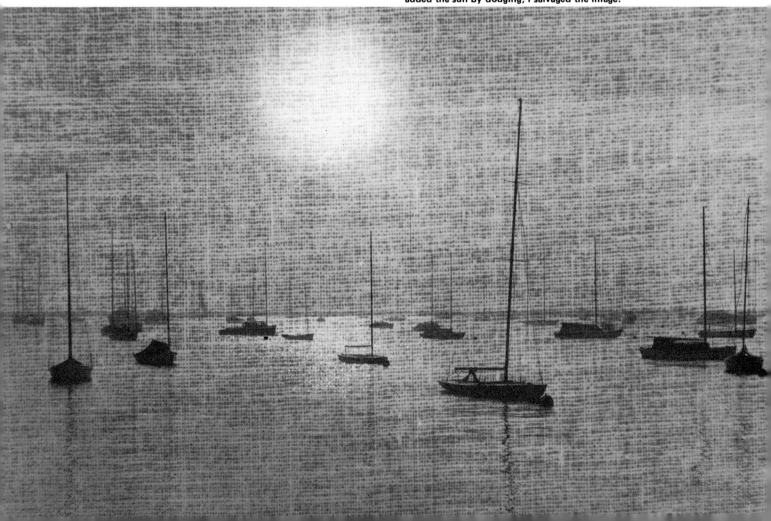

can be corrected or done intentionally, and some in-camera effects can be imitated with an enlarger.

Distortion Correction—Some image-plane manipulation in the darkroom is analogous to the swings, shifts and tilts of view cameras. Amateurs can correct some of the distortions the professional controls with his large-format camera. For example, when you tilt your camera upward to photograph a tall building, the vertical lines converge toward the top. This is because the image plane of the camera is tilted with respect to the building. This makes the building look very tall, but it falsifies the building's width and makes it seem to lean backwards.

You can correct this kind of distortion in the darkroom. Put the negative in the enlarger and focus it on the easel. Now tip the easel at an angle so the large base of the building is at the high end of the easel and the small top of the building is at the low end of the easel. Adjust it to straighten the sides of the building until they are parallel. The distortion you create largely compensates for the original in-camera distortion. Prop up the easel and refocus the image with a small lens aperture to get enough depth of focus so the entire image is sharp. Dodging or burning may be necessary because one end of the easel is closer to the light source than the other.

See if your enlarger head tilts. Some do, and tilting the negative produces the same kind of image distortion as tilting the easel.

Deliberate Distortion—With the same techniques you can easily create distortion. Stretching or compression of the image is possible, and you can try just about any combination of easel and enlarger shifts.

Buckling the print paper gives

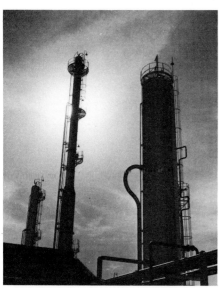
Notice that the towers are not vertical.

When you tilt the easel this way, you must do some dodging on the image area closest to the lens to prevent unequal exposure.

You can get unusual effects by bending or buckling the printing paper.

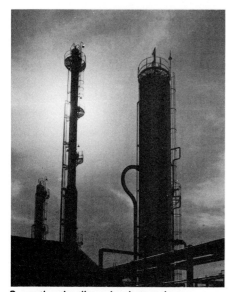
Correcting the tilt made a better photo.

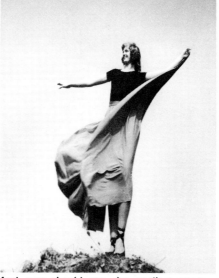
And you should use the smallest aperture possible to keep good focus.

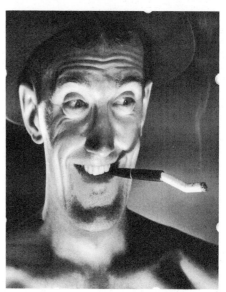
This is the result of the buckling method.

a wavy effect to the image. Put a piece of focusing paper under the enlarger and secure it at one end with thumbtacks or tape to a flat movable surface. Force a gentle bend in the paper and secure the other end to maintain the bend. Put the negative in the enlarger and focus on the paper. The paper may have to be adjusted or moved for best image orientation. A downward bend is made by attaching each end of the paper to a support such as a book and inducing a sag in the middle by pushing the supports together. Double bends and lengthwise bends are also possible.

Make sure to get adequate depth of focus for printing. Replace the focusing paper with a sheet of printing paper and make a test strip. Dodging and burning is also necessary for this method because of the bends and twists in the paper.

Printing Motion—Printing a negative several times on a single sheet of paper allows creation of symmetrical designs, patterns and the illusion of motion. Simple contrasty subjects on a plain background are most suitable for this technique. If you see a good subject for this printing method with distracting background detail, shoot it anyway. Later make a copy negative and opaque the distracting detail. Other background imagery can be put in later with masking and multiple printing methods discussed later in this chapter.

To make a print suggesting movement, project the negative onto the paper, and expose for the normal exposure time. Set the enlarger timer for more than the normal time. At the end of the normal exposure, slowly pull the easel in the direction corresponding to the subject motion. The easel will roll smoothly if you put three or four round pencils under its flat bottom. Move the easel smoothly for a continuous blur effect, stop and start it for multiple images with blur in between, or move it only between individual exposures for distinct multiple images. Practice and test strips will help you determine how the easel must be moved for the effect you want.

Another trick is to change image magnification during exposure. Rack the englarger head up or down during or between exposures for an exploding effect. You may even want to move the easel between successive magnification adjustments. Again the density of the multiple images can be varied with exposure time and motion of the enlarger or easel.

Make symmetrical patterns and

By moving the easel during printing, I created a streaking image and gave it the illusion of motion.

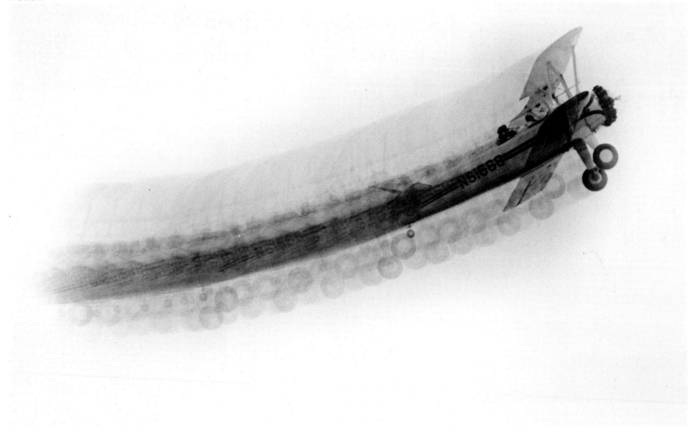

compositions by rotating the easel during exposure. Take a large piece of cardboard and cut it into a 10-inch diameter circle if you are enlarging onto 8" x 10" paper. Anchor the cardboard with a thumbtack in the center so it rotates under the enlarger. Place the center of the image rotation over the thumbtack and secure the paper to the cardboard with thumbtacks or tape in the corners. Another way is to put the easel on a revolving tray such as a Lazy Susan.

You can revolve the paper during or between exposures. Rotating the easel between exposures gives a more distinct composition. Some careful exposure tests are necessary and are based on the amount of image overlap for each exposure. If you want to revolve the image 360° in 30° increments, thus making 12 exposures, give each exposure at least 1/12 full exposure time. Marks on the turntable help you turn it an exact amount each time.

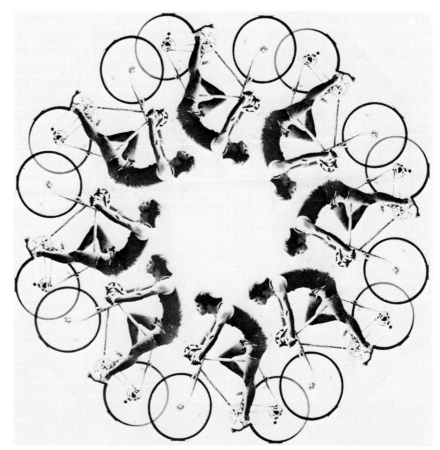

Because I printed only 8 images with little image overlap, I gave each position full exposure.

To make a more interesting image from this photo I changed magnification during the exposure.

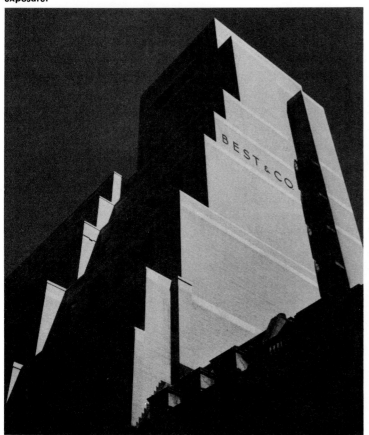

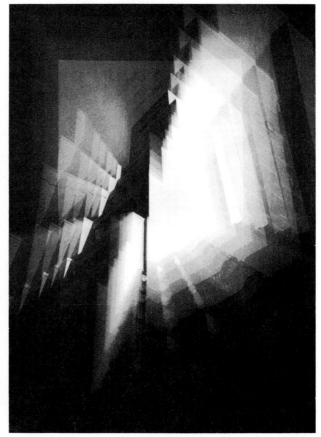

109

REVERSED TONES

The reversed tones of a negative have an interesting esthetic appeal. Sometimes the negative image is more exciting and has more potential than the positive made from it. If so, make the reversed tones the final image.

There are many different ways to get a negative image in slide or print form. The original image can be a positive slide, a negative or a print. The final image can also be a 35mm slide, enlarged film or a print. The following methods do not exhaust the possibilities for negative and positive manipulation. Because intermediate images can be altered, a final image can be distinctly different from the original in more than just tonal reversal.

Paper Printing—One interesting way to print negative images is with printing paper. A positive print contact printed with another piece of printing paper yields reversed tones. Take a print you've made and dried and contact print it onto an unexposed piece of paper. Make sure the paper's brand name is not on the back of the print because it will print through. If the emulsion sides are in contact, the image will be laterally reversed, but you will get the clearest image. Cover the sheets with a piece of glass on top of the positive print and make an exposure test strip. A long exposure is required, but by using a large lens aperture you'll minimize long-exposure reciprocity failure. A double-weight original needs a

longer print-through time than a single-weight original.

Process the negative print and observe the contrast. If the paper is the same contrast grade as the positive print, there will be a slight increase in contrast. You can change contrast by using another grade of paper.

If image orientation is important, you can make a laterally correct negative print three ways. Place the original print emulsion in contact with the back of the unexposed print or place the emulsion of the unexposed print against the back of the original. Then expose through the original. Because light must travel through the extra thickness of base, the image is slightly diffused or softened, but this can

Sandwiching a negative of the moon with a positive image of foliage created this ghostly photo.

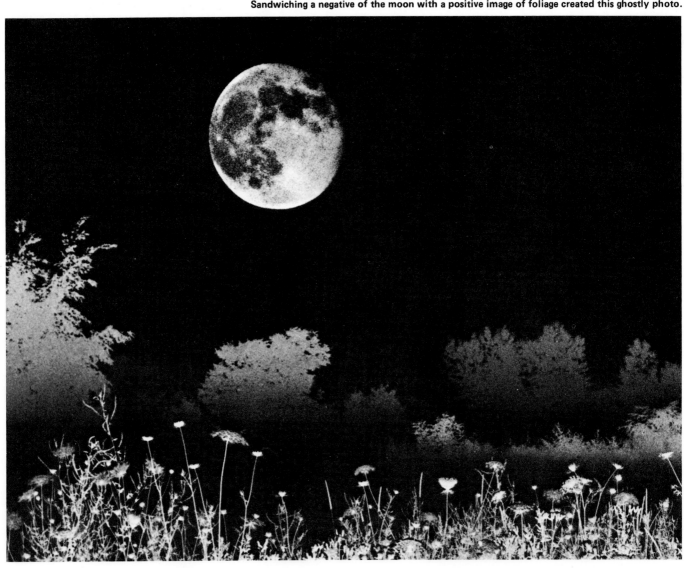

I contact printed this print with another piece of paper to get a negative print with lateral reversal.

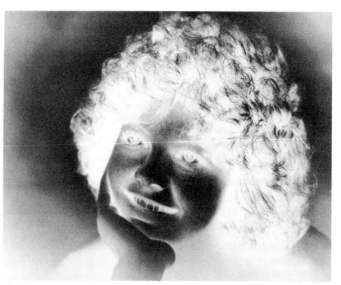

Then I shaded parts of the cheek and nose with a charcoal pencil.

When I contact printed the negative print, the image is again properly oriented, the contrast rose and my shadings dodged some freckles.

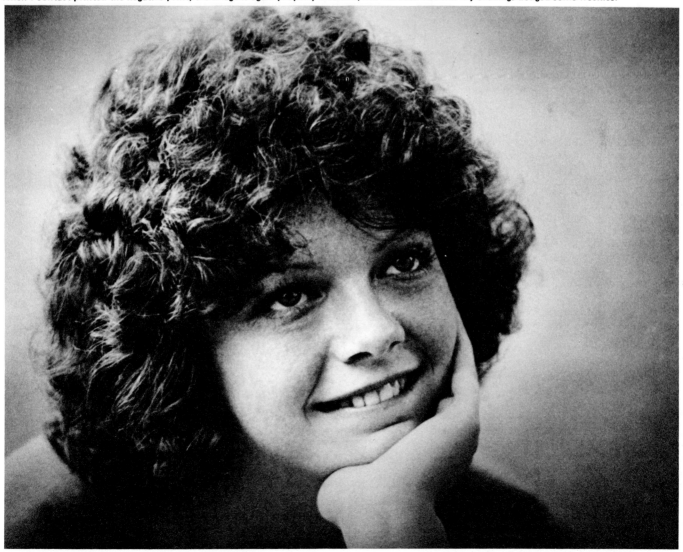

be a usable effect. The third way is to make a laterally reversed original positive print by printing the negative emulsion side up in the enlarger.

Dodging is easily done by shading the positive or negative print. Add density to the back or front of the print where you want lighter areas on the next print. With a soft pencil or charcoal pencil make smooth shadings that can be smeared to get a density gradation. To avoid permanently marking the original, a sheet of acetate laid over the print can be used as the dodging layer. Tape the acetate to the paper and apply the shadings.

Film Positive to Paper Negative—Some variations of paper printing use copy film. Contact print or enlarge a negative onto copy film such as Fine Grain Release Positive or litho film. This intermediate positive is then contact printed or enlarged onto printing paper to make the negative print. Exposure times are shorter and the image sharper than with a paper original. You can also make another positive from the negative print if you want more softness or manipulation. Dodged areas of the negative print will give lighter areas in the final positive than existed in the first positive. Try paper printing with photograms or some of the other images made with methods of this chapter.

Slide Originals—If your original image is a color or b&w slide, some interesting combinations can be done. If you project a positive onto regular copy film or print paper, you get a negative image directly. If you use a duplicating film, you get another positive image. Either of these secondary images can be manipulated with opaque or shadings to get the next image.

If the original is a color slide and the copy film or paper is orthochromatic, a distorted tonal balance results because red light does not expose the orthochromatic material. Sometimes this doesn't matter. If it does, copy the slide with a pan film and use the intermediate negative for contact printing with copy film to get the positive image back again. To save film costs, contact print several negatives and internegatives on a sheet of copy film to get a sheet of positive images for negative printing.

BAS-RELIEF PRINTING

A bas-relief image produces a sculptured three-dimensional effect emphasizing texture, bold designs and intricate patterns. A positive and its negative image are combined, registered and printed to create the effect.

One way to make a bas-relief print is to contact print a negative with a piece of copy film to get a positive. Develop the copy film and dry it. Register the two films so the positive areas block the negative areas. Now move the images slightly out of register and watch the lines appear along the borders between light and dark regions. The bas-relief effect is adjusted by controlling the width and relative position of these lines. Subjects with fine detail look best with a narrow bas-relief line. Simple shapes may require the graphic effect produced

From the original negative, Ted DiSante made a positive onto Fine Grain Release Positive and then printed the positive to get a negative print.

112

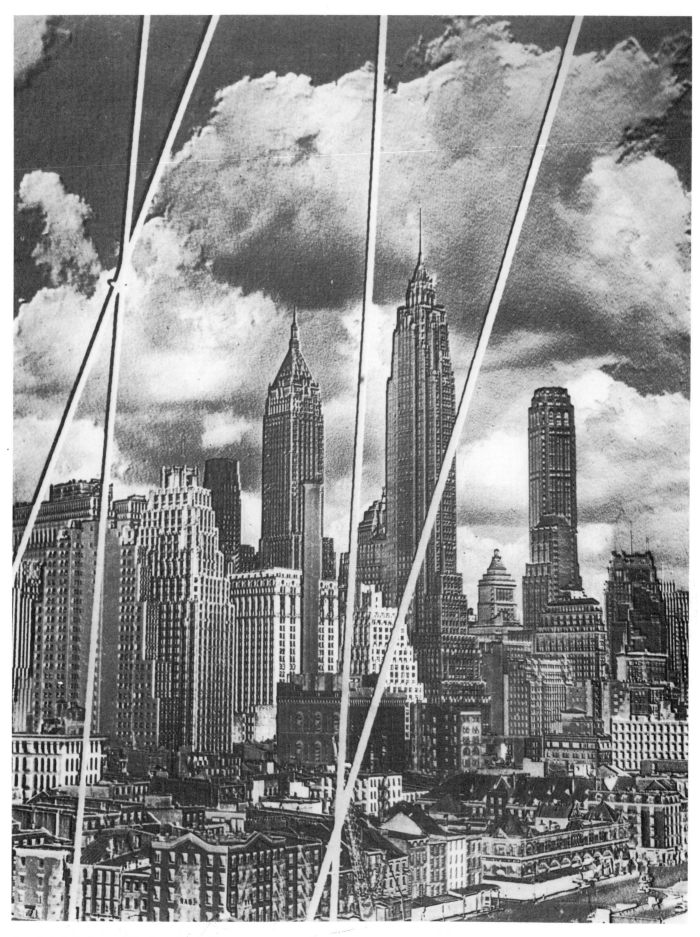

Bas-relief photos have a three-dimensional effect.

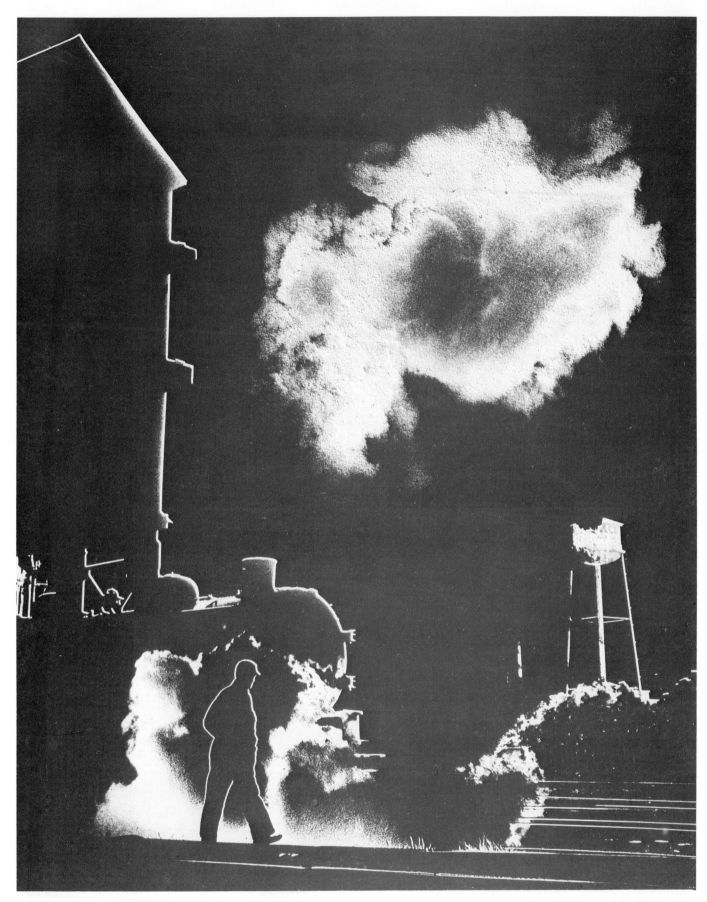

Bas-relief photo made with litho film.

by a wide line. Tape the edges of the sandwiched films together to hold the registration you want.

Put the sandwich into the negative carrier for enlarging. Some photographers prefer a glass negative carrier to hold the films flat, but if you don't have one, use a small lens aperture for maximum depth of focus. Use a contrasty printing paper such as number 4 or 5 to boost the contrast of the overlapping gray areas of the sandwiched images.

Some variations make the process more interesting: use a litho film as one or both of the images in the bas-relief sandwich; try enlarging the sandwich onto litho or copy film for a large master negative from which you can contact print; use the printed bas-relief image as a paper negative; or make copy negatives of manipulated prints and use these to make bas-relief sandwiches.

Color bas-relief images are made by contact printing a color slide onto panchromatic copy film and sandwiching the two images. Make a color print from this combination or copy it with a slide copier.

TONE-LINE PRINTS

A tone-line print is similar to a bas-relief print because it is made from a positive-negative sandwich. The basic difference is the registration of the films and the exposure through the sandwich. The end result is a high-contrast outline of the image in a field of white or black.

Make a high-contrast copy of a negative by enlarging the original onto litho film. Opaque where necessary and contact print this litho positive emulsion-to-emulsion with litho film to get a litho negative. I recommend litho film because the contrast and density of the two images should be nearly the same. It can be done with continuous-tone materials, but it is more difficult.

Place the processed positive and negative films *back to back* and register the images *exactly* so no light is transmitted as you look through it. Tape their edges to-gether to keep registration. Put the sandwich and an unexposed piece of litho film in a contact printer for an exposure-test series.

Light perpendicular to the contact printer is not transmitted because of the exact registration of the images, but light transmitted at a 45° angle travels through the gap between images created by sandwiching the films back to back. Light which gets through the gap exposes the film in an outline pattern around image areas.

A tone-line print is a high-contrast outline of the image areas. You can make one by tilting the sandwich as described in the text, or use the alternate method of putting the sandwich on a turntable and revolving it under light that is off center.

Make a test strip with the contact-printer frame held at a 45° angle to the enlarger. Process the test strip and determine the exposure time that gave the best tone-line in the exposed area. Use that time as a starting guide for a second test.

In the second test, use a piece of film or paper the same size as the sandwich. Expose each side of the sandwich for half the exposure time determined in the first test. After you process the second test you'll be able to adjust exposure accordingly to get a good tone-line image.

For instance, if the first test indicates a 20-second exposure, the fractional exposure is 10 seconds. Expose each side of the frame at a 45° angle for 10 seconds.

The tone-line negative can be contact printed with print paper to get a positive image of white outlines in a black field. By contact printing the negative with litho film, you get a tone-line positive from which you can make negative prints.

THE SABATTIER EFFECT

Prints or film re-exposed to light during processing undergo a change that creates some tonal reversal and a white line in the area of the reversal. The result is an image with positive and negative characteristics. Often erroneously called *solarization,* the correct name is Sabattier effect. True solarization is a reduction of developable density due to tremendous overexposure.

The physical mechanism of the Sabattier effect is complex and not completely understood. A combination of exposure and development phenomena create the boundary line and image reversal. The easiest way to use the effect is also the most difficult to control. Flash the darkroom white light with an exposed and partially processed print face up in the developer. Watch the light areas darken and a border line form between the dark black and white areas.

Better results are usually obtained by using orthochromatic copy films such as Kodak Fine Grain Release Positive or Kodak Commercial Film. Because of the experimental nature of the Sabattier effect, you should not use an original unprocessed negative for the process. Enlarge a

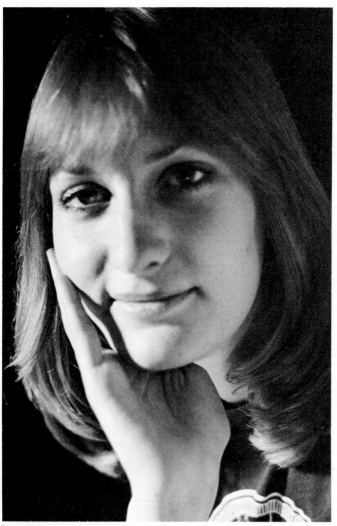

Photos made with strong side lighting best show the results of the Sabattier effect.

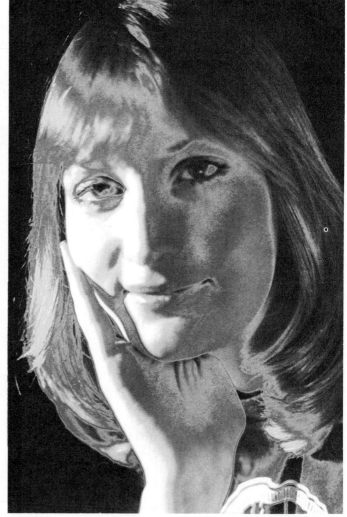

Partial-reversal print made by re-exposing the print while it was developing.

116

processed negative or slide onto copy film so you can preserve the original from disaster.

Method—Contact print the negative or enlarge it to fit a 4" x 5" area. Make a test strip to determine proper exposure and development times for the film or paper you use. The Sabattier effect works best with slight underexposure of the image. Expose for about 20% *less* than the normal exposure time indicated by the test strip.

Place the paper or film emulsion side up in the developer and let the image develop for about 1/3 the normal development time. Stop agitating several seconds before the re-exposure. Be alert for any sediment floating in the developer because it may settle on the print and be imaged during the re-exposure. Filter any sediment from the developer before using it.

For the re-exposure, use a small 10-watt bulb not less than four feet away from the developing tray, or use the enlarger with the negative removed, the head raised and the lens set at *f*-16 or *f*-22. Filter the light with ND filters for fine adjustments in illumination. With the tray under the light and the image emulsion up, make the re-exposure.

Re-exposure duration can be determined only through tests, but generally one or two seconds is sufficient. Finish developing the film or paper and complete the processing steps.

Variables—Several factors contribute to a successful image made with the Sabattier effect. The original image should portray a simple, strongly lit subject. A side-lit subject with deep shadows bordering light image areas creates the most distinct boundary line. The line is called a *Mackie line,* and it occurs on the heavily exposed side of the border between dark and light areas.

The technique has three main variables: the time during first development when re-exposure occurs; brightness and duration of the re-exposure light; and duration of final development.

Total development time for film or paper is the same as it would have received without manipulation. You can vary it for more or less contrast, but more experimentation

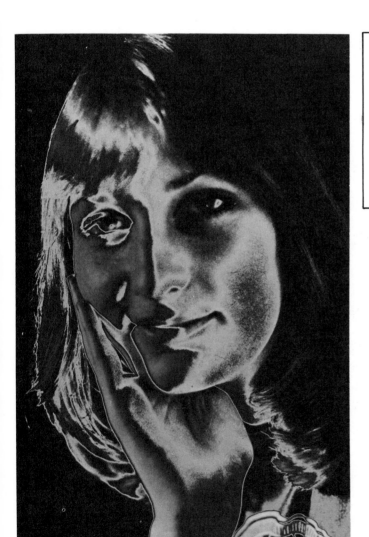

When I re-exposed another print for a slightly longer time, more reversal and a stronger Mackie line occured.

B&W PRINTING FROM A COLOR NEGATIVE

If you print a color negative onto regular b&w printing paper, tonal distortion results because the paper is orthochromatic and the negative has an orange mask. Kodak makes panchromatic b&w printing papers to avoid this problem. They are called *Panalure* and *Panalure Portrait.*

After exposure, both papers are processed like conventional b&w papers. Because both papers are panchromatic, they should only be used with a 10 amber safelight, and safelight exposure should be minimized.

will be necessary with this extra factor. As the first development time increases relative to total time, areas of tonal reversal in the final print will shift from the highlight areas to the shadow areas. See Figure 7-1. As re-exposure time is increased, tonal separation *decreases* and more reversal occurs. To prevent this, use the minimum re-exposure time which gives the Sabattier effect.

Many photographers give up on the Sabattier effect because of initial failures and unpredictable results. Most failures involve attempts to manipulate prints, which are far more difficult to control than film. If you want to use paper, use a high-contrast paper such as grade 5 or 6. Some photographers use an old and almost exhausted paper developer for Sabattier prints. They claim the brown, oxidized developer works slowly enough on the print to give you more control and to reduce some of the excess fog which occurs with prints. Save some old, used developer and try it. Make second-generation prints from paper prints that lack a wide tonal range by contact printing onto high-contrast paper.

Opposite page
This Sabattier image was made with litho film.

I enlarged a negative onto litho film and re-exposed it with a 15-watt light bulb for a couple of seconds while it was developing in paper developer. This is the resulting print from that negative.

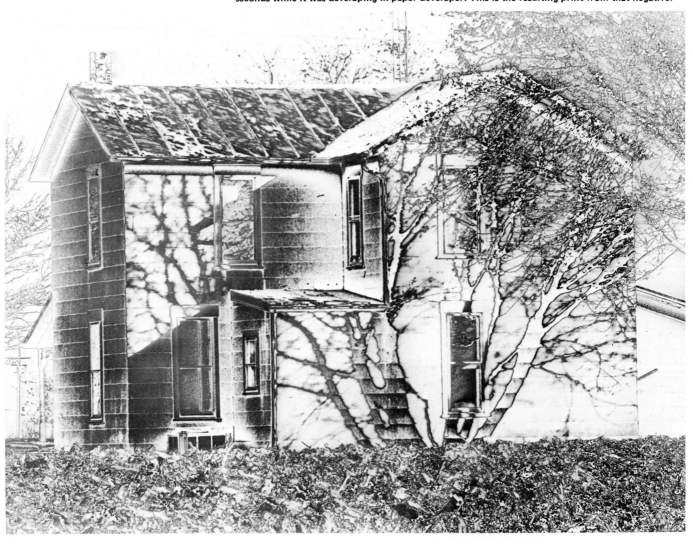

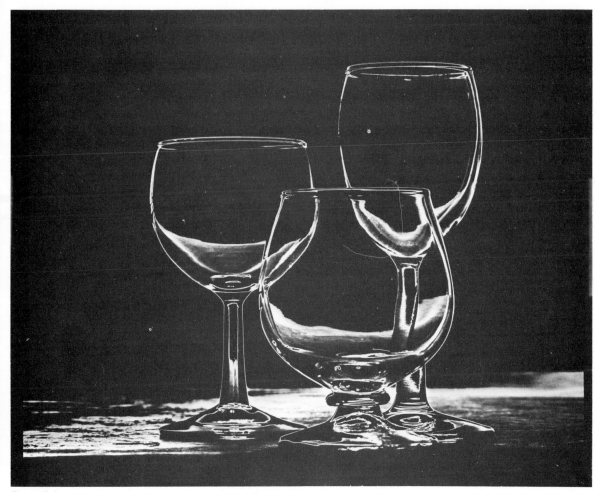

Figure 7-1

This combination of gray scales represents what the tonal reversal looks like in a positive image made from a negative that exhibits the Sabattier effect. The top row is a print from an unmanipulated negative. The rows below it represents negatives that received the same re-exposure and total development time. The only difference among the last five rows is the time of first development before re-exposure. You can find similar information for a specific film and developer combination in *Photographic Sensitometry* by Todd & Zakia, published by Morgan & Morgan, Inc., 1974.

Print from normally processed neg.						
Increasing time of first development before re-exposure						

Each image has its own best times for the three variables. The instructions of Figures 7-2 and 7-3 are guidelines for your own methodical testing. Figure 7-2 is a general method for films, and Figure 7-3 is a testing technique for papers. The latter shows the results of different times with the three variables. The same test procedure can be used with films.

LITHO FILM PRINTING

You can create bold, graphic imagery with high-contrast copies of negatives or slides. The solid blacks and whites demand attention, and when combined with a striking image, they possess visual power. Because of the versatility of litho films, they can be used with every technique in this chapter, but the simplest application is using them as negatives for printing.

Enlarge or contact print a negative onto copy film to get an intermediate positive. If you contact print, place the films emulsion-to-emulsion for best sharpness. You can also use a slide as the positive, but if it is a color slide, pan-litho film should be used for correct tonal rendition. With the intermediate positive, make an exposure test series onto litho film to determine which parts of the continuous tones should be made into the litho negative. Because the exposure range of litho film is narrow, only shadows, mid-

A GENERAL METHOD FOR THE SABATTIER EFFECT WITH FILMS

1 Contact print or enlarge the original for a test strip that determines a suitable exposure and processing time for the copy or litho film you are using. Process the film and examine it.

2 Contact print or enlarge the original onto the film with an exposure time slightly less than the one that gave best results in step 1. Try 20% less exposure for the first attempt.

3 Develop the film, with agitation, for 1/3 the total development time. Allow the film to settle in the tray during the last 15 seconds. The time of first development can vary, but this is a good starting point.

4 Re-expose the film. Use a 10-watt bulb at least four feet away for a second or two. For more precise variations, put the tray under an enlarger with the enlarger head fully raised, the negative removed and the lens set at f-16 or f-22. Re-expose for a second or two.

5 After re-exposure, continue development to completion. Litho films should not be agitated for the rest of the development because streaking may occur.

6 Finish processing the film and dry it.

7 If the original is a negative, the manipulated image is a Sabattier positive. For positive prints, contact print the Sabattier positive to get a master negative from which prints can be made. You might even want to make prints from the Sabattier positive. A master negative is obtained in one step if a positive transparency is the original.

8 Print the negative on different grades of paper to see which contrast works best. Local or overall density reduction of the negative may be necessary. See Chapter 8.

A TEST METHOD FOR THE SABATTIER EFFECT WITH PAPERS

1 Enlarge the negative and make a test strip to determine a suitable exposure and processing time for the high-contrast paper you are using. Grade 5 or 6 paper works best. Process it conventionally, examine it and choose the exposure time that gives the best looking image. Call this time *normal*.

2 Use a full sheet of the same paper for a Sabattier multiple-test print. Make three exposures lengthwise across the sheet. The first area is underexposed 30%, the middle is normal and the third is overexposed 30%. For example, if the normal exposure time is 10 seconds, make an overall exposure of 7 seconds. Cover 2/3 of the paper and expose for 3 seconds. Slide the cover to expose 1/3 of the paper and expose for three more seconds. This gives three areas exposed for 7, 10 and 13 seconds.

3 Remove the negative from the enlarger, raise the head and set the lens at f-22 or f-16.

4 Put the developer tray on the enlarger baseboard and insert the exposed print emulsion up. Agitate the print for 1/3 the total development time and allow the paper to settle in the tray during the last 15 seconds.

5 Re-expose the print with three different exposure times. Make three exposures at right angles to the first three exposures. For example, try a 1, 2 and 3-second exposure series.

6 If one of the exposures is correct, the paper should begin to darken within a few seconds. Agitate after the exposure for even results. Develop to completion and finish processing the print.

7 Examine the 9 blocks and evaluate the results. If one is good, make a complete print with those times which gave best results. The information is built into the print. If one is close to the desired effect, use the time data as a middle range for another test with finer increments so you can determine the exact times needed for that image.

8 If the original was a negative, the Sabattier print is a positive. It can be the final result, or you can shoot the positive with copy film to get a master negative. If the original was a slide, the manipulated print is a Sabattier negative which can be used as a paper negative to make more prints.

9 Some other variables you may want to alter in your tests are: re-exposure time, paper grade, and developer strength.

Figure 7-2

Figure 7-3

tones or highlights can be printed. This is called *tone separation.*

To expose for the highlights from a positive, use a shorter exposure time than exposing for the shadows. See pages 122, 123. The clear highlights of the positive let more light through than other areas, and the negative is black only in those areas. Decide which part of the image you want to emphasize and make the litho negative.

If defects such as pinholes, dust spots or distracting detail bother you, remove them with opaquing material. See the discussion about litho films and copy films in Chapter 4 for more useful information.

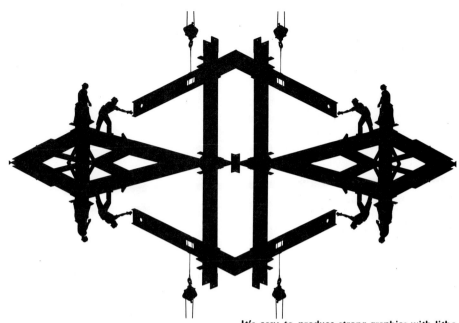

It's easy to produce strong graphics with litho images.

I printed the normal negative first and then the litho negative to make this print.

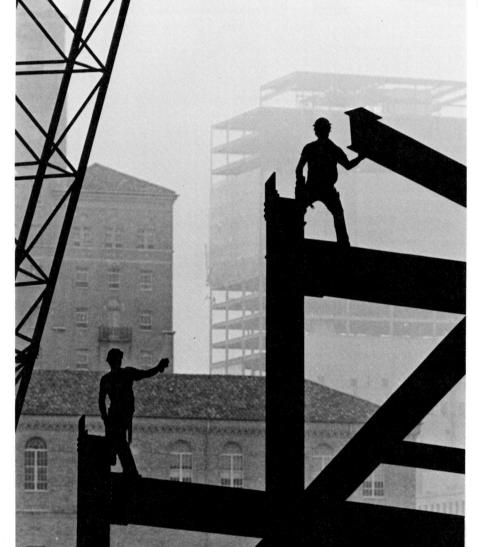

Whether you print from a negative or positive image, the high-contrast image is easily printed. A limited range of tones is desired, and this makes judging paper test strips easy. If you use a high-contrast paper such as a grade 5 or 6, maximum contrast results.

When printing with litho films, some extra effects can be used. Try printing the image to a softer gray instead of the densest black possible. Diffuse the image slightly with a sheet of tracing paper held in the image plane during part of the exposure. Print through texture screens to break up the pattern. Or combine a gray exposure of one negative with a black exposure from another negative—this is a good effect to stress foreground black against a gray background and reduce the amount of white space.

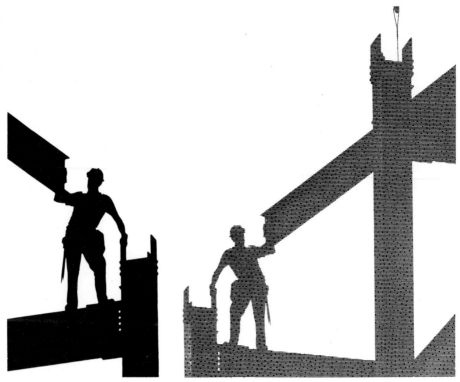

Textured litho images are made as described earlier in this chapter.

1/From the original negative that produced this print, I made three tone-separation positives onto litho film and contact printed each to get tone-separation negatives.

2/This is a record of the highlights of the print, and it was made from the most heavily exposed tone-separation positive.

122

POSTERIZATION

Posterization is multiple printing with tone-separation negatives which are parts of a continuous-tone original. Shadows, midtones and highlights are photographically extracted from the original with litho film by using different exposures for each. Each litho negative is then printed individually on the same sheet of paper to give a print with only three or four tones instead of the complete range of grays in continuous-tone images. The posterization is white highlights, black shadows, and only one or two gray tones in between.

I think it is easiest to make the tone separations from a continuous-tone positive. This saves making three or four positive litho separations from an original negative and then contact printing to get three negative separations. If your original is a negative, make an intermediate positive with copy film. If the original is a b&w slide, work directly

3/This is the midtone negative.

4/This shadow-detail negative was made from the lightest tone-separation positive.

5/When the three negatives are exposed separately, they create an image containing only three tones: a highlight, a midtone and a shadow tone.

123

from it. If it is a color slide, use a pan-litho film for correct tonal rendition in the separations.

With the intermediate positive, enlarge or contact print onto litho film and make an exposure test series to find the exposure times necessary for shadow, midtone and highlight records of the original. With this information, make three separations with three different exposure times. The highlight negative has the shortest exposure time, and the shadow negative has the longest time. If the separations are 4" x 5" or larger, image registration for multiple printing is easier than with 35mm film.

Image Registration—Because the three negatives must be printed consecutively, how the images are positioned in relation to each other, called *registration,* is important, and there are several ways to do it.

If the negatives are large and you wish to contact print them, the best way is with registration pins available from graphic arts suppliers. You hold the negatives in the relationship you want in the final print and punch two holes on the top border where there is no image detail. Tape two pins to the baseboard of the enlarger according to the spacing of the holes in the film. Punch two holes in the printing paper or tape it to the baseboard so it will not move between exposures. Then you expose each negative individually while it is set on the pins, thus keeping the image registered. A clean sheet of glass over the negative during printing will keep it flat on the paper.

A less precise method can be used with 35mm negatives. Tape a plain piece of white paper in the easel or contact frame. Enlarge and focus the mid-tone negative onto the paper. Outline some highlight and shadow detail with a black pen to serve as a guide for aligning the other negatives between exposures, and leave the white paper guide in the easel or frame throughout the printing.

Between exposures, remove the printing paper, change negatives, re-align the projected image with the tracing you made and replace the printing paper. Use one corner of the white paper as an alignment guide for the printing paper. Then make the next exposure.

Exposure—Because the negatives are exposed sequentially, the exposure is cumulative. Therefore, an exposure test strip must be made from the shadow negative. The clear areas of this negative are common to all three of the separations and transmit most of the exposure to create the black areas of the posterized image. They determine the total exposure time. Make a test strip with the shadow negative and choose the minimum exposure time which gives black shadows.

If you made three tone separations, divide this exposure time by three. For instance, if the test strip made from the shadow negative indicates a 15-second minimum exposure, expose each separation for five seconds. This gives a total exposure of 15 seconds in the shadow areas and creates maximum density in the print.

Expose the shadow negative first, the mid-tone negative second and the highlight negative third. If you use the pin-register method, make sure the printing paper does not move between exposures. If you

Registration pins make registration of large negatives easy.

Punch the holes in the negatives and printing paper outside of important image areas.

Another way to register images is to use an outlined guide sheet on the easel.

124

use the outlined-paper method, mark the back of the printing paper in the upper-right corner so it can be repositioned the same way on the white paper for each exposure.

Process the print and evaluate the contrast and tones. A typical posterization shows white and black areas intermingled with one or two gray tones. To adjust gray tone density, adjust the middle exposure time. *Do not change total exposure time.* Make the middle exposure either longer or shorter and compensate the exposure time of either the shadow or highlight negative to make the same total exposure you originally determined.

Color Posterization—By printing each separation through a different color filter onto color film, tones of the original are translated into color combinations. You can make color prints in a manner similar to the b&w method discussed or you can do it simply and more economically with multiple exposures on color slide film in a camera.

When I use color slide film, I usually use positive tone separations, but some color posterizations may work better as negative images. With large and small separations, the easiest way is to register and shoot them on a light box. Tape the shadow image to the light box along one edge. Register the midtone image and tape it along another edge. Do the same with the third image and others, if you have more, until each is taped along a different edge. This way they can be swung in and out of registration for individual exposures on the same frame. Make each exposure with a different color filter. Divide the metered exposure for each shot by the number of separations you have. If your camera does not exactly register multiple images, use the registration errors for extra effect.

The simplest color posterization is done with positive separations and diazo film. See Chapter 5 for the discussion of diazo film. You make different colored images from

the separations and sandwich them in a glass slide mount. A copy color slide or color print can then be made from this original.

MULTIPLE PRINTING

Making multiple images is one of the most creative photographic techniques. Multiple-imaging methods are discussed in Chapters 1, 2, 5 and 8. And posterization, bas-reliefs, tone lines and texture screens all use more than one image to create a final special effect. Other techniques let you combine images or use one negative several times for a final photo. All require experimentation, planning, patience and a vivid imagination. Doing it in the darkroom lets you work with old and new negatives. You can change ordinary photos into something visually unique and effective. Shift, sandwich, or montage negatives and positives as you explore and execute any visual idea.

Negative Shifting—One negative can be used to create multiple images on one print. Change the orienta-

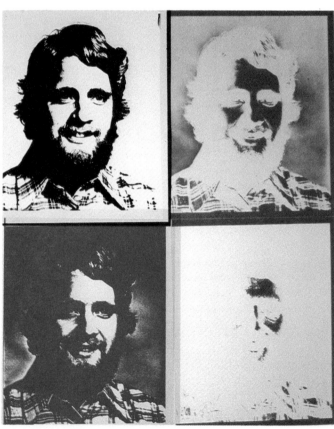

From the assortment of positive and negative tone separations, I made some diazo images for a color posterization.

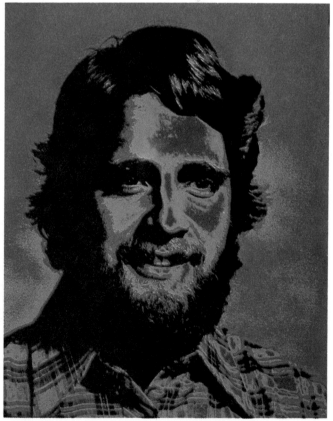

I sandwiched the four images and photographed them to get a master transparency.

125

tion, magnification or location of the negative between exposures for a variety of effects.

The simplest way is to make a double exposure. Choose an image with only one element and a simple background. Make a test strip to determine the total exposure time the print would need if it was to be made normally.

For the double exposure, make the first exposure for half the time just determined. Remove the negative from the enlarger, turn it upside down and put it back into the enlarger. You can shift the easel instead of laterally reversing the negative. Make the second exposure for the rest of the exposure time.

Process the print and evaluate the result. Some areas may need more or less exposure. The elements in the scene determine how well this technique works. Every negative is different, and you must experiment. The best time for each exposure depends on the background and amount of image overlap. Where dark areas of the negative overlap, the print will be light or white.

The area where the densest part of the negative overlaps the lightest part of the flipped image becomes gray in the print. If the original scene was shot with a white background such as with a light box or white wall, the dense black of the negative acts as a built-in mask for multiple printing. Where there is no image overlap you can give full exposure for each printing time.

One way to avoid the image-overlap problem is to mask areas of the printing paper during individual exposures from one negative. No fractional exposures are necessary.

For example, suppose you want to print a full-face portrait with this method. One interesting feature of the human face is that the two sides are different. If you print the left side of the face, flip the negative and print the reversed left side as the right side of the face, the portrait almost becomes that of a new person.

Enlarge the negative onto a piece of white paper taped on the easel.

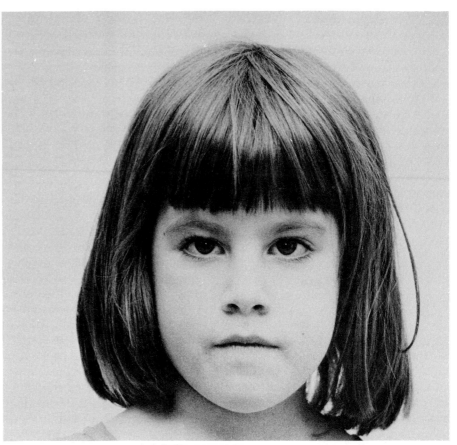

Portrait with no manipulation.

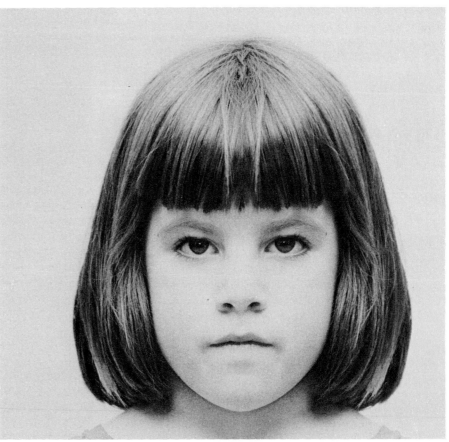

A new portrait results when the left side of the image is printed twice.

126

Arrange the centerline of the face in the center of the easel. Mark the exact location of the centerline of the face and one or two other points, such as lip edges or the tip of the nose. Make a test strip to determine the best contrast and exposure time for the print. Insert a piece of printing paper into the easel and align it with the white paper. Mark the upper right corner of the printing paper. Along the vertical centerline, cover exactly half of the face with a piece of cardboard. Make the first exposure with the full exposure time, and slightly shake the cardboard during half the exposure time so the border area of the the two exposures will be blended together.

Remove the paper, flip the negative, refocus and reposition it so the center of the image aligns with the centerline and other points already marked on the easel. Replace the printing paper in the same orientation and flip the cardboard so it masks the exposed side. Make the second exposure and blend the border area by jiggling the cardboard for half the exposure time.

The processed print does not show any manipulative effect if the blending is well done. Depending on the image, you can perform this technique two, three or four times with different orientations and magnifications of the negative. The difficulty lies in proper masking with the cardboard and blending the image borders. Some multiple images may be easier to make with the collage technique of Chapter 8.

Sandwiching—Some sandwich techniques are discussed in Chapters 5 and 8. These involve combining more than one image in a slide mount. In darkroom sandwiches you combine two or more negatives or positives in a negative carrier and print the sandwich.

View negatives in front of a light box or window. Handle them with thin, white, cotton gloves or by the edges to avoid fingerprints and scratches. Lay one strip over another and view the result with a magnifying glass or loupe. When searching for sandwichable negatives, remember densities add and a very dense sandwich needs a long exposure time for detail to print through. And the density range of two overlapping images may be greater than either one alone. The print may require extensive dodging or burning so all of the image can

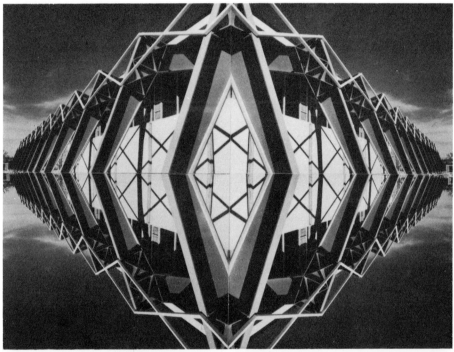

Photos like this can be made by masking or with a collage technique.

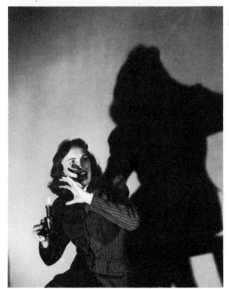

First I photographed the model with a dramatic lighting angle.

Then I shot the broken glass against a dark background.

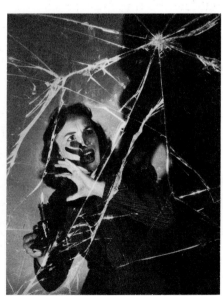

When I sandwiched the negatives, both negatives printed through and no important image areas were blocked.

be printed. Negatives with large thin areas work well because detail is not blocked by dense areas of other negatives, and the total density of the sandwich makes it less difficult to print.

You can reverse negatives so they are emulsion to emulsion, back to back, at right angles or skewed. Finding an exciting image is more important than negative orientation. Combine dark areas with light areas. Sandwich a slide with a negative to get a print with positive and negative image areas. The slide may be in color or b&w, but should be removed from the slide mount to make the sandwich.

As you look through many images, certain combinations seem to suggest themselves or even appear accidentally. One photographer I know discovered an interesting sandwich by noticing an image created by two strips of negatives inadvertently stuck together.

Ideas for shooting scenes to give sandwichable negatives may even occur to you. If so, use subjects that have dark backgrounds. This way, the background of the negatives will be practically clear, and image areas won't block each other.

The effort spent editing, sorting and combining is a slow discovery process that demands patience. Most of the creative part of producing a new image is at this stage. The darkroom work merely tests and fulfills your idea.

Once you have a sandwich to print, you must devise a way of using it in the enlarger. If the negatives lie flush together, you have no problem. They will stay flat in a regular negative carrier. If the negatives are skewed, you can do one of two things. They may fit in a large glass negative carrier or between two pieces of 2" x 2" cover glass taped together. But if this is impractical, you must make a negative carrier. Cut two pieces of thin stiff cardboard the same size.

Make them as large as the negative carrier for your enlarger. Tape the pieces together along one border so they are hinged. Measure the rectangular size of the sandwich image area and cut a slightly larger rectangle through both pieces of cardboard with a sharp razor knife. Put the sandwich between the pieces of cardboard—tape them in if necessary.

Enlarge and focus the sandwich. You may have to use *f*-16 or *f*-22 to get sufficient depth of focus for both negatives. If the sandwich is very dense and a small aperture must be used, a long exposure time is necessary for printing. With long printing times reciprocity failure in the print occurs; contrast and density of the paper decrease. You may have to print the negatives one at a time to avoid this problem. Make a full-size test strip so you can determine the extent of this effect and whether the print needs dodging or burning.

A double-image negative was used to make this print. The negative of the model was enlarged and duplicated, and the word negative was cut into its black background. Definition reprinted by permission of *The American Heritage Dictionary of the English Language* ©1978 by the Houghton Mifflin Co.

bal·let (bă-lā′, băl′ā′) *n.* **1.** An artistic dance form characterized by grace and precision of movement and an elaborate formal technique.

Montages—A montage is multiple printing from two or more different negatives. It can be as complex as printing parts from 4 negatives to make one print or as simple as the addition of detail to white areas of a print. Because each montage is different, the desired result defines the method. Sometimes image areas overlap and sometimes not. Masking can be done with blending masks, photographic masks or both. Three general methods are described here, but they are only guidelines for creating a montage. They can be used alone, combined or used with other darkroom techniques. With print-outs, blending masks, and photographic masks, patience and careful planning, you can find a technique to create any montage.

The print-out method is generally best for a two-negative montage. What you do is make the first exposure with any necessary dodging or masking in the areas of the second image. Partially process the print until a faint image appears, then wash, squeegee and reinsert it under the enlarger. The second negative is aligned with the print-out image and exposed. Then develop and process to completion. Be sure to dry any wet spots on the enlarger baseboard or easel to avoid rust or chemical contamination of the area.

Different negative combinations have different requirements and results with this method. Because it is a quick process, it is used as a proofing method for a montage. Make a print quickly so you can see if the elements work and if the image has enough potential to merit more careful work or a more complex montage technique. If there is minimal image overlap and one negative is being printed in the dense areas of another negative, dodging, burning or masking may not be necessary.

Test strips for each negative should be made. If a different magnification is required for each negative, mark or make note of each setting so the enlarger head can be reset precisely. Different image contrasts can also be obtained by using a variable-contrast paper and filtering each exposure with a different filter.

If there is much image overlap, the technique becomes more complicated. Determine the proper exposure times for each image with a large, right-angle test strip. With the first image, make four or five step exposures in one direction and record the exposure data. Partially develop the paper until the middle exposure is discernible. Then wash the print in water. During the wash, insert the other negative into the enlarger.

A safety filter is handy to use on the enlarger between exposures. The color of the filter should be the same as the safelight you are using for the print paper. Project

I fixed and washed a discarded piece of film and used this image for the print-out method.

First I exposed and partially processed the image. Then I projected the negative of the model into the clear center area while masking the surrounding print-out image.

the filtered image of the second negative onto the washed and squeegeed paper so you can focus and align the image without fogging the print. Then make the regular exposure without the filter. Safelight works well as long as it is not overused. An exposed print that gets too much safelight exposure loses contrast and becomes darker in the highlights, so safelight exposure should *always be minimized.*

After the second negative is aligned with the paper, remove the red safety filter and make step exposures at a right angle to the first exposures. Process the print to completion. The test strip has blocks of image area with different combinations of exposure. Use the times which gave best results and make a large print. After you make the print, judge the areas which need dodging, burning or masking.

The important aspect of processing the print is *consistency.* Process the print exactly like the test strip, or the test strip is not a valid test. Remove the paper from the developer as soon as enough image detail is present for you to work with. And *wash the print face down to minimize safelight exposure.* Use a running water bath of two to three minutes for excess developer to diffuse out the emulsion. If the print suffers from some safelight fog, it can usually be salvaged by reducing as described in Chapter 8.

A blending mask is well suited for adding large areas of image detail to a print. You must keep it moving so image border areas merge and show no seams. The complexity of the mask depends on how many negatives you'll be using, the image areas you select from them, and their relative location on the final print. The mask can be a rectangular piece of cardboard with or without holes cut in it, your hands, a double-weight print with image areas cut out, or pieces of cardboard that fit together like a jigsaw puzzle.

Adding clouds to a scene is a simple way to practice basic blending. Choose a landscape or other photo with a simple horizon line and select a negative of clouds. The background or white area of the sky is where the clouds are photographically placed.

Tape a white sheet of paper into the easel and use it to align the images between exposures. Enlarge the foreground negative onto the easel and, with a black pen, trace the border line between the background clouds and the foreground. Insert the cloud negative and position it onto the area where it will print. Adjust magnification, focus and mark the enlarger posts so the head can be relocated for the foreground exposure.

Make a test strip with the cloud negative and then the foreground negative. They may require different exposure times and have different image contrasts, so using variable-contrast paper is essential. Record all the exposure data so you can work efficiently and effectively, and make a short list of the steps you will do. These planning aids will make the process easier to control and repeat.

Focus and compose the foreground negative on the easel. If the cloud area of the foreground scene is a dense area of the negative, the blending is simplified because it masks itself. But usually some detail must be masked. To make a mask, start with a rectangular piece of thin cardboard or an

Rick Gayle got an interesting Sabattier effect in this print-out image.

130

old piece of double-weight print paper. Put the mask in the easel and align it with the white paper. Project the negative. With a pen, trace the border line on the mask. Cut the mask in two pieces along the line just drawn, and mark the pieces *top* and *bottom* if necessary.

Place a piece of printing paper in the easel and align it with the white sheet. As you make the exposure with the foreground negative, hold the cloud mask slightly above the easel with the borders of the negative image and the mask aligned. Slightly shake the mask so you produce a smooth border. Allow some of the image to print in the cloud area for at least half of the exposure.

Remove the negative and the printing paper. Mark the upper-right corner of the print so you can put

The clear area of the sky detracts from other elements of the scene.

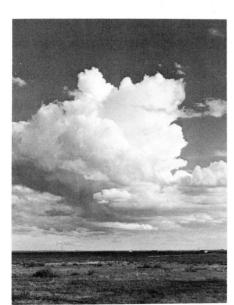

So I selected a cloud from my files and printed it in with a simple dodging technique.

it back in the easel the same way for the second exposure. Place the paper in a light-tight box or drawer so you won't fog it. Put the cloud negative in the enlarger and enlarge, focus and compose the image onto the background area. Turn off the enlarger and reinsert the printing paper in its original orientation.

For the cloud exposure, use the bottom mask in the same manner as the top mask. The most important part is blending the common border, and you may not get it just right the first time. Some adjustment for the first print's border may be necessary, but for a good starting point, blend for half the exposure time of each image.

Sometimes the border should be sharp and distinct, and sometimes a wide swath of border is needed for a gradual transition between areas. If so, make changes by adjusting exposure time and mask motion.

Process the print and evaluate the border, exposure and contrast for each image. An adjustment in image contrast or exposure may be necessary. Or sometimes the cloud negative needs to be reversed to align the direction of the sun and

shadows for each area. Record changes on the list of steps and data you made so it serves as a record of the process.

More complex blending involves three or more negatives and a different kind of mask. For instance, suppose you want to print from four negatives. Label these A, B, C and D.

Enlarge each negative onto the white alignment sheet and outline the area you'll print from the negative. Don't forget to mark the enlarger posts for the magnification of each negative. After each marking on the white sheet, insert a thin piece of cardboard masking material into the easel. Mark the negative's border area on it and label it appropriately. Then make a test strip for each negative and record the exposure data.

Cut out the four pieces of the mask. Print the A negative with a mask made of the B, C and D pieces taped together. Tape the mask pieces tightly together with black photographic tape, or some lines may print through.

Mark the printing paper in the corner, remove it, and put it in a light-tight box. Change to the B

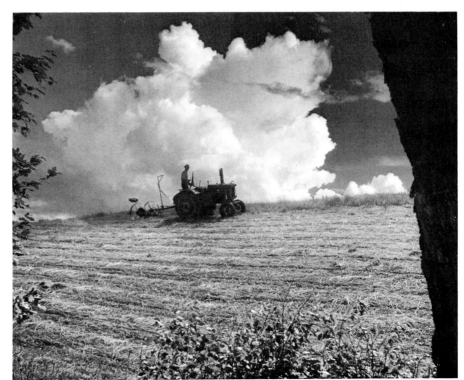

negative. Align the projected image with the B region of the easel sheet. Replace the printing paper and align it with the easel sheet. Then print the negative while masking with the A, C and D pieces. Continue until all four areas are printed.

A list of steps and a good labeling system makes the technical part of the process easier so you can give more attention to the esthetic aspects of the montage.

Photographic masks are used when image areas do not blend well or do not overlap. If fine image detail is in the border area, a blending mask is difficult to make and use. But masks made of litho film appropriately opaqued and registered let you drop in or exclude image areas precisely.

A mask must be made for each image that is part of the montage. The clear ares of the mask correspond to those areas that are printed in the montage. Usually the masks are all made from the negative that contains the major elements and detail of the scene. The negative is projected onto litho film the same size as the printing paper, and a positive mask is obtained. Opaquing of dust spots and unnecessary areas is then done so more masks can be made from the first one. Depending on the image and the areas of the montage, a number of intermediate masks containing opaqued areas must be made so each image area has its own mask.

When the masks are made, they are registered, punched and used with registration pins available from graphic-arts-supply stores. Make a test strip and mark the enlarger post for each negative's enlargement. Use the masks as guides to adjust magnification for each negative during printing.

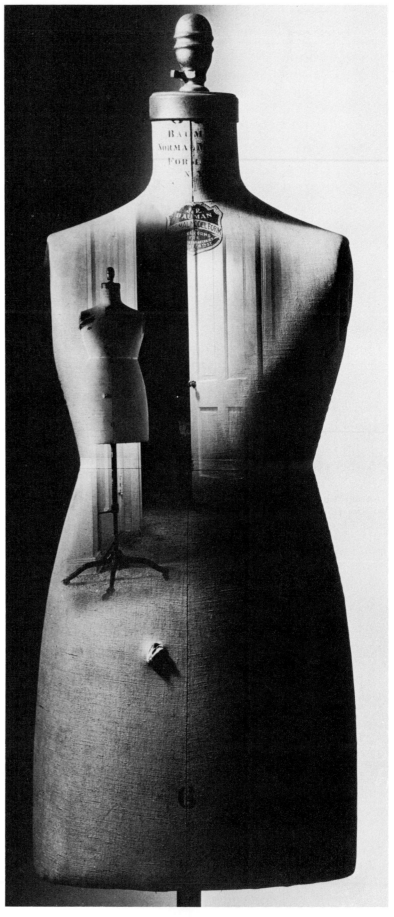

Rick Gayle used two dodging masks for this image.

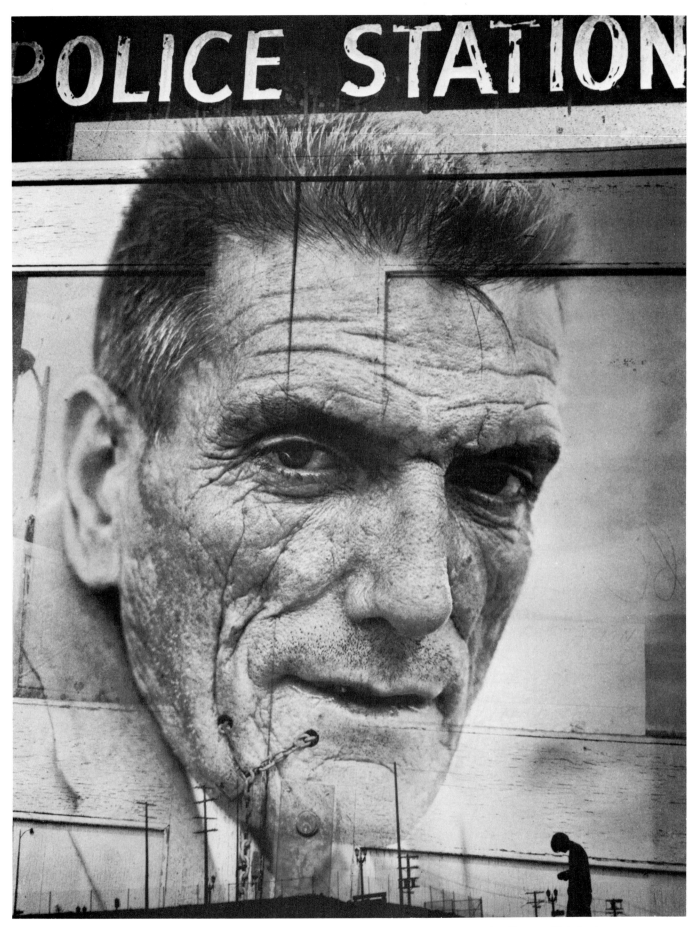

When three or more images are combined, complex masking is necessary to prevent extraneous image overlap. Photo by Rick Gayle.

8

IMAGE MANIPULATION

Manipulation of the final image can be planned before, during or after the actual shooting. It involves changing an image so it is distinctly different after it has been processed or printed. A slide or print can be changed completely or altered slightly. The diazo method of Chapter 5 is one way. A number of images can also be combined to make one unique final print or slide. With various copying techniques, chemical baths, color renderings and constructions, you can usually salvage a bad photo or make a good photo even better. You can apply these special-effect techniques to old slides and prints made with conventional methods.

SLIDE MANIPULATION

Photographers without darkrooms usually have a large collection of 35mm slides. They are ideal for manipulation by sandwiching and copying for special effect or subtle improvement. With these techniques, one slide can be made into many different images—each a different visual statement.

Slide Sandwiches—A simple and direct way to get a new image is with a slide sandwich. The diazo discussion in Chapter 5 contains some sandwiching technique, but there are more avenues to explore.

One requirement for sandwiching slides is picking transparencies of the right density. Two normally exposed slides mounted together may produce an image too dark for

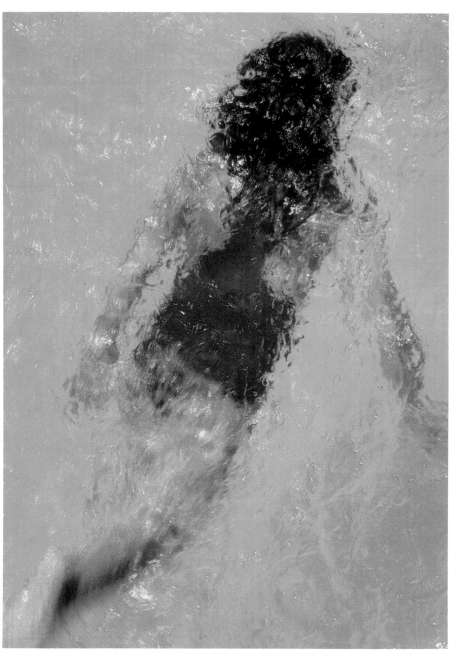

One of the simplest ways to manipulate an image is to use it in a different orientation. This slide was revolved 90° counter-clockwise to get the strongest image.

Opposite page
I made this photo by sandwiching a litho transparency with a diazo image. See Chapter 5 to learn how to make diazo slides.

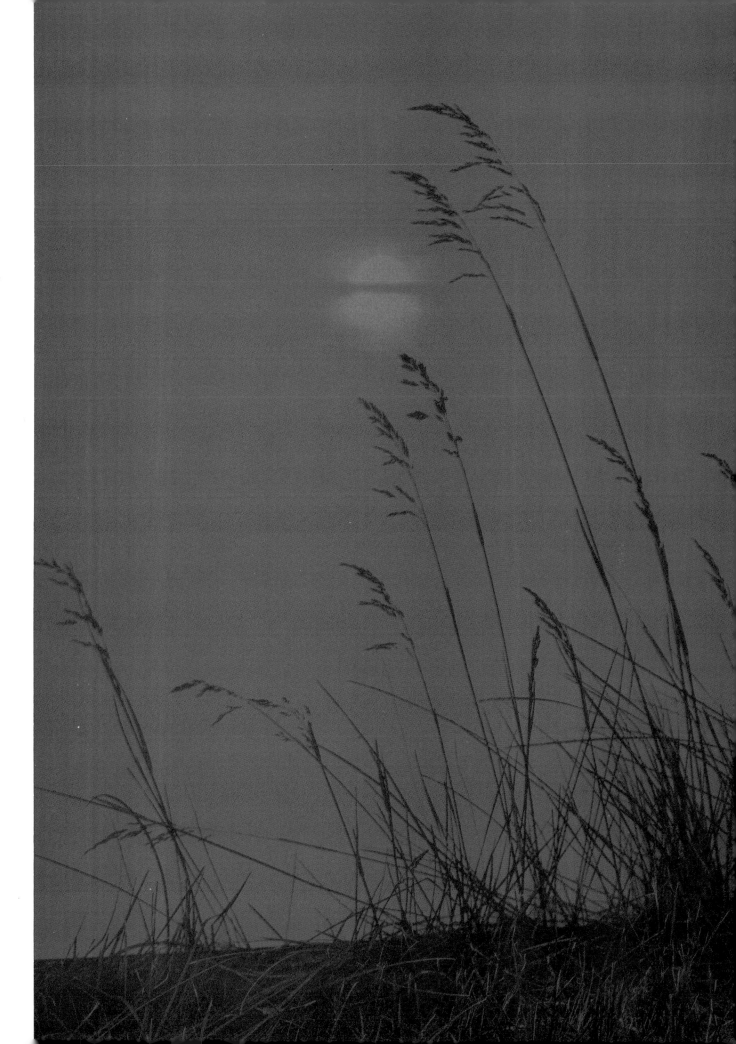

viewing. Slides lighter than normal due to overexposure work well in sandwiches, and this is a good reason to save overexposed slides. Some people even overexpose scenes deliberately with this goal in mind.

Cut off the corners of the cardboard mounts holding the transparencies and separate the layers, thus freeing the film. Sometimes the best arrangement for the two images occurs when the films do not completely overlap. This reduces the picture area to the part that is common to both films, so you may want to bind in a mask with an opening smaller than the standard size.

Place the transparencies together between two pieces of clean 2-inch-square cover glass. Unroll a strip of 3/8-inch binding tape and lay it on the work table, adhesive side up. Place one edge of the glass sandwich

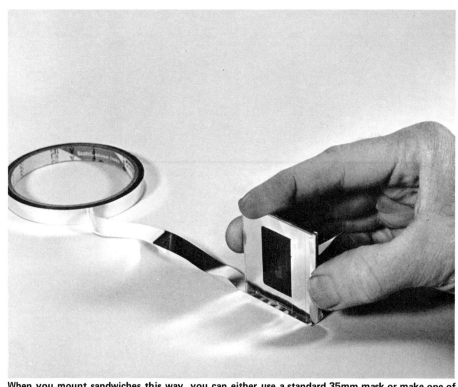

When you mount sandwiches this way, you can either use a standard 35mm mask or make one of your own to fit.

Slides that are underexposed or unexciting may become part of a slide sandwich. Always consider sandwiching as you edit slides.

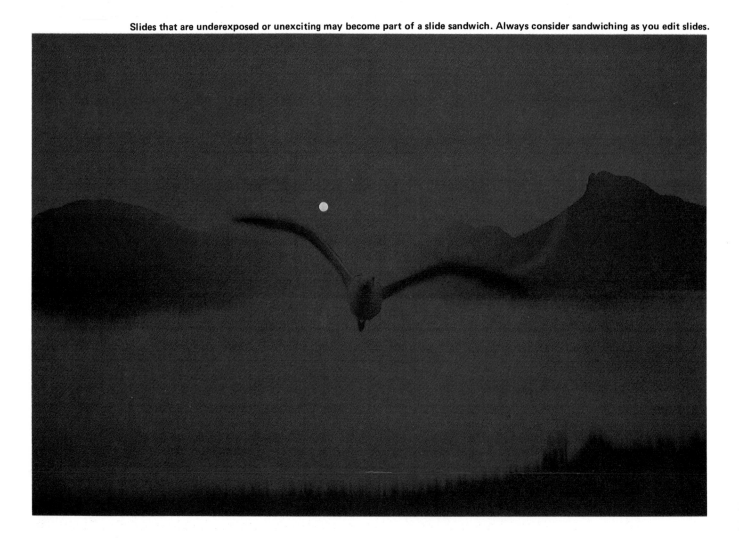

The Multiblitz Slide Duplicator is a specialized tool for making copies of transparencies. You can also get good results with a bellows and slide-copier unit that fits your camera. Photo courtesy of H.P. Marketing Corp.

on the tape and rotate the slide onto the adjacent edge. You can then press the tape down on the sides of the glass along the first edge. Continue until the slide is bound on all four edges. If you would rather not make your own mounts, buy Gepe Super-Thin Glass Binders or Perrot-Color Ultra-Thin Mounts from a camera store. They are expensive, but the mount is reusable and well designed for this purpose.

The sandwich need not be permanent. You can copy it and then try another combination with those images. Gather your old slides and mix and match them by sandwiching. This will make you more aware of the method's potential during shooting sessions. When shooting with sandwiches in mind, make a normal exposure and then deliberately overexpose by a half step. See if you can improve on the original by sandwiching the second photo with another slide.

When sandwiching, you must decide if colors and image areas are compatible. Some combinations to consider are silhouettes of people, places or things used with abstract or natural scenes. Try title slides made of litho film sandwiched with a background image or color. Try texture screen images, colored gels, polarized-crystal slides or other effect images as the sandwich background.

Slide Copying—The most versatile slide copying equipment is a professional duplicator such as the Bowens Illumitran or the Multiblitz Slide Duplicator. You can also get good results using a 35mm camera with bellows, slide-copier unit and a macro lens. Not only can you make duplicates of your best slides, but

Kevin Marks made this photo, after Heinecken, by taping a large litho photogram to a TV screen. He waited for an appropriate scene and then photographed the combined images. Use a shutter speed of 1/30 second or slower when photographing a TV screen.

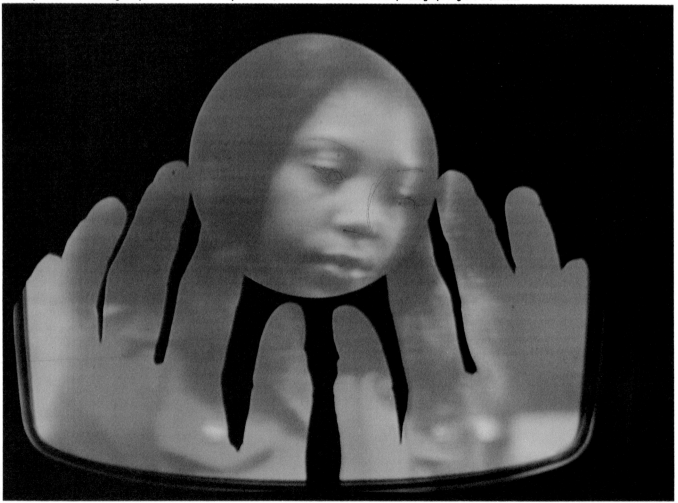

you can also create new photos from old slides.

A good slide copier lets you enlarge and crop the image. Sometimes you can't get close enough to shoot a scene the way you want to. Enlarging and cropping the slide eliminates unneeded elements of the scene to give it more visual impact. The main subject in the scene can be relocated by adjusting the slide horizontally or vertically in the copier.

If you are using regular color film to copy slides, you'll get increased contrast in the copy. Sometimes this is acceptable, but if you want to make more exact duplicates, I recommend a special film. Kodak Ektachrome Slide Duplicating Film minimizes this contrast

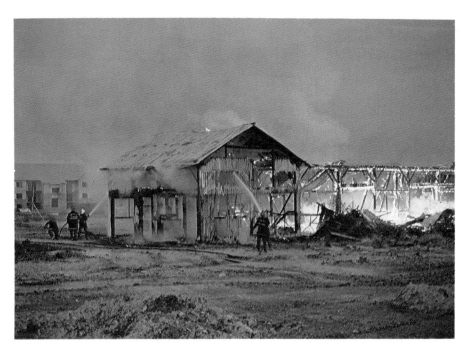

To increase the impact of this scene shot with a 50mm lens, I copied it with 1.5 magnification. Notice the rise in contrast and slight shift in color balance in the result, shown below.

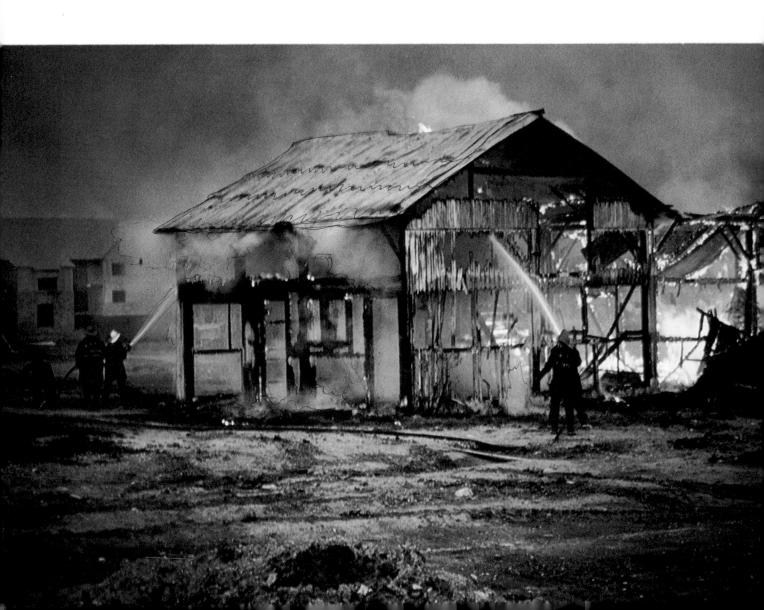

increase and gives a photo with nearly the same colors and contrast as the original.

Some films mentioned in Chapter 4 give fascinating copy images. The high-contrast, fast and grainy, and b&w infrared films are on a clear base. You can copy b&w negatives with these special negative films to get a positive transparency. Try compounding grain by copying a grainy negative with grainy film. Copy a color slide to get a bizarre negative transparency. Raise contrast of an original by copying it with high-contrast film. Contrast control of these films is possible by adjusting development time and temperature.

The color films of Chapter 4 also extend the special-effect possibilities of copying. Color infrared film is easy to use for copying because after initial tests, less bracketing is needed than with original scenes. The dyes in color slides transmit infrared radiation, and weird and vibrant false-color scenes are still possible after the scene is photographed conventionally. Copies made with push-processed slide film tend to show a large rise in contrast because it has even more contrast than a normal film. The grainy image, splashy colors and high contrast may be effective for copying. To get maximum contrast in a color image, use Photomicrography film to copy slides. Flat or underexposed slides may benefit from the increased contrast.

Sometimes you won't want to experiment when first shooting a scene. Creative hindsight lets you change your mind about an image and the way it works best. Some effects can be added during copying. Use the filter or lens attachment you could have used when shooting the original. I've used multi-image prisms, spot filters, colored filters or gels, and soft-focus attachments with a copy unit to improve certain photos. Some color correction can even by done in this step if the original was exposed with improper illumination, but don't expect total correction.

The potential of multiple exposures while copying partly depends on your camera's multiple-image registration. Some cameras do not completely align all shots.

This false-color scene was made with color infrared film.

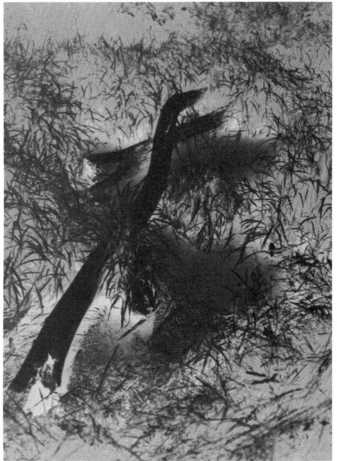

When it was copied with color negative film, another false-color photo resulted.

Even if there is some misalignment, the camera can be used, but you need to know its limitations.

Exposure for multiple images depends on image overlap. Where there is significant overlap, each individual exposure should receive a fraction of the normal exposure. This fraction depends on the number of exposures. For a double exposure, each shot gets 1/2 the total exposure—underexpose each by one step. For a triple exposure, each shot gets 1/3 the normal exposure, and so forth. These guidelines work for most situations in which much of the images overlap.

If there is no image overlap, and the backgrounds are dark, give each shot full exposure. The background in the copy becomes lighter as more exposures are made, and it is possible to give it so much background exposure that it washes out the main subjects.

You can shift one slide between exposures to give a sense of motion to the photo or change magnification of the image for a multiple-size effect.

Title Slides by Copying—Title slides with white letters against a color or image background are always effective in slide shows. Dark numbers, letters or symbols of the title must be photographed against a light background. Use rub-on letters, typewritten copy, drawings or stenciled letters on light paper. Load your camera with a high-contrast b&w film and shoot the composition. Careful exposure, processing and opaquing of the film is necessary for best results. The result is a negative image with the title in white on a field of black.

The negative is then copied with a slide copier as the first part of a double exposure. Overexpose it about a half step so the clear areas will be clear in the final slide. Expose the background image on the same frame, but make the second exposure as indicated by the meter. Underexposure will give a more intense color, and overexposure gives a less saturated color.

If you want colored letters against a colored background, filter the first exposure of the title slide. The second exposure uses a filter of a different color. For example, shoot the title image with a red filter.

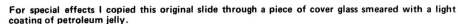
For special effects I copied this original slide through a piece of cover glass smeared with a light coating of petroleum jelly.

You can make title slides like the one shown in Chapter 1 or photograph white letters against a dark background with slide film. Either way, you then make a double exposure with the background image to get the white letters to print through.

The litho negative has a black background with white letters. For a colorful title slide, it was first copied through a green filter. Then the litho negative was removed and the light box was photographed through a red filter. The green and red exposures added photographically to make yellow.

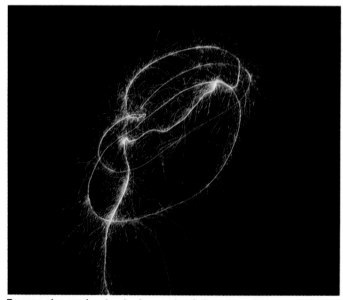

Because the overlapping backgrounds of these two slides are dark, Ted DiSante gave full exposure for each when he combined them.

Then make the second exposure of just a blue filter. The resulting color slide has a blue background with magenta letters less dense than the background. The red and blue exposures add photographically to make magenta. The accompanying table shows other possible color combinations you can try. Bracket the exposures a half step the first time you do this to see what settings give best results with your filters.

TITLE-SLIDE COLOR COMBINATIONS			
ORIGINALS		FINAL IMAGE	
Title Color	Background	Title Color	Background
R	G	Y	G
G	R	Y	R
B	G	C	G
G	B	C	B
B	R	M	R
R	B	M	B
Y*	M	R	M
M	Y	R	Y
C	Y	G	Y
Y	C	G	C
M	C	B	C
C	M	B	M

*When using Y, C and M filters, decrease exposure a half step or more.

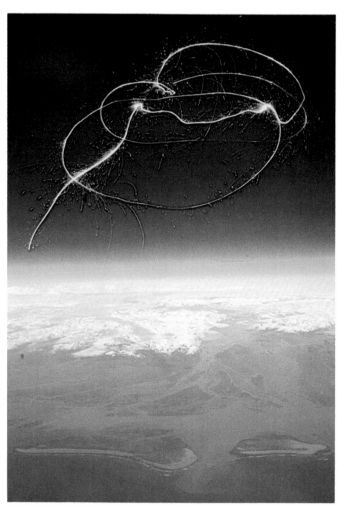

Multiple Masking—A more advanced technique for altering backgrounds in color transparencies uses multiple exposures and multiple masks. To do this, you need a backlit piece of ground glass to hold the materials being copied. A light table is best, but you can improvise if necessary. You also need a rigid tripod or copy stand and a camera that gives good registration during multiple exposures. If your camera doesn't give good registration, use the black-card method for multiple exposures described in Chapter 1.

The technique is to tape images and masks by one of their edges onto the backlit ground glass surface. The taped edges then serve as hinges so you can fold the materials on top of each other while preserving registration.

Suppose you have a slide of a person in light-colored clothing posed in front of a plain, dark

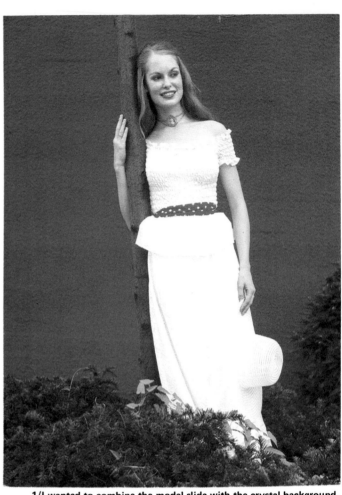

1/I wanted to combine the model slide with the crystal background.

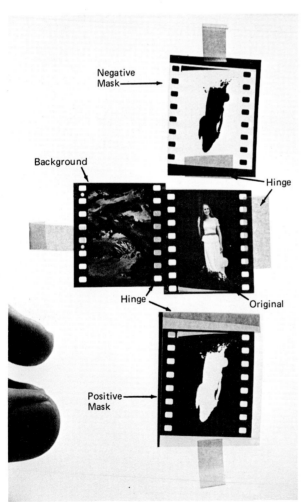

2/So I made a negative and positive mask with litho film and taped all the images on a light box where they could be swung in and out of registration.

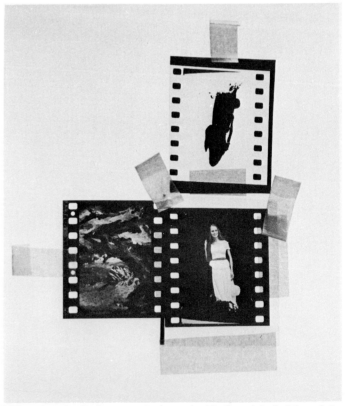

3/First, I made the foreground exposure with the original slide and the positive mask registered.

142

background, and you want to substitute a more interesting background. This requires a set of masks obtained by contact printing the original with high-contrast film—litho film works best. These masks are then used to hold back image areas during the double exposure.

Contact print the original slide of the person onto litho film. Use litho film slightly larger than the original to make handling easier. The processed film is the *negative mask.* The dark background of the original should be nearly transparent in the negative mask. Clear spots in the black area that you don't want can be opaqued, and black spots in a clear area are removed later, so don't worry about them now.

Contact print the negative mask with litho film to get the *positive mask.* This gives a black background that can be opaqued to remove clear spots. Contact print the positive

mask to get a clean final negative mask. When you have a good positive and negative mask, you are ready to make the double exposure.

Tape the original transparency to the ground glass or light box. Tape it along the right side of the image. Place the positive mask on top, register it carefully and tape the top side to the glass. Fold it back below the original and secure it with tape.

Next, place the background slide you want to use on top of the transparency and tape it along its left side. Then fold it to the left and secure it too. Position the negative mask over the original transparency and tape its bottom side.

Make sure the film plane in the camera is parallel to the subject plane to minimize distortion. Fold the original and positive mask into place and secure them with a bit of tape on the mask. Make the first exposure; then fold the positive

mask and the slide of the person out of the way. Don't remove them from the glass if you want to bracket exposures. Fold the background slide and negative mask into place and secure them for the second part of the double exposure. Be careful not to move anything because image registration is important.

Posterization—If you make tone separations of an original with litho film and copy the separations through filters, easy and direct posterization is possible. Use the registration method just described and see Chapter 7 for a discussion of posterization.

TONING B&W PRINTS

Toning is done for two reasons: to add a color or tone to a b&w print or to make the print more permanent. Toning involves additional chemical processing of the silver-based b&w print. It can be

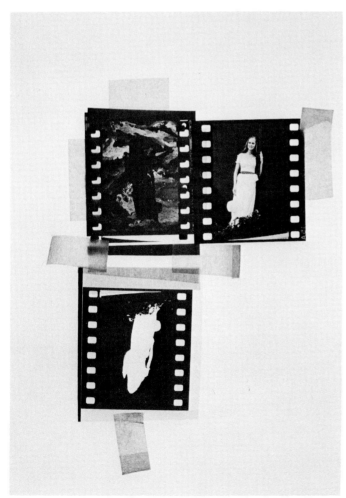

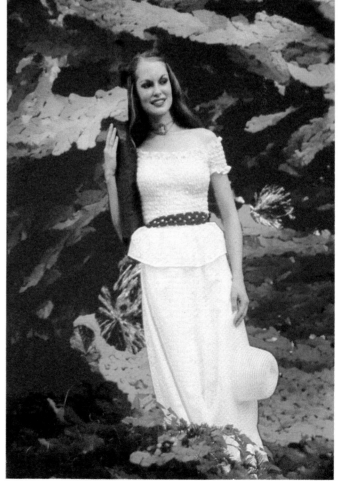

4/For the second exposure I swung the crystal image and the negative mask in place. 5/The final slide made by multiple masking.

These are two useful products to make b&w images withstand the effects of time and last years longer than color film.

By holding a lit match under a scrap piece of color slide film for an instant, Kevin Marks made this interesting bubble abstraction.

You can also use a solution of Rapid Selenium Toner to give reddish-brown hues to warm-tone prints.

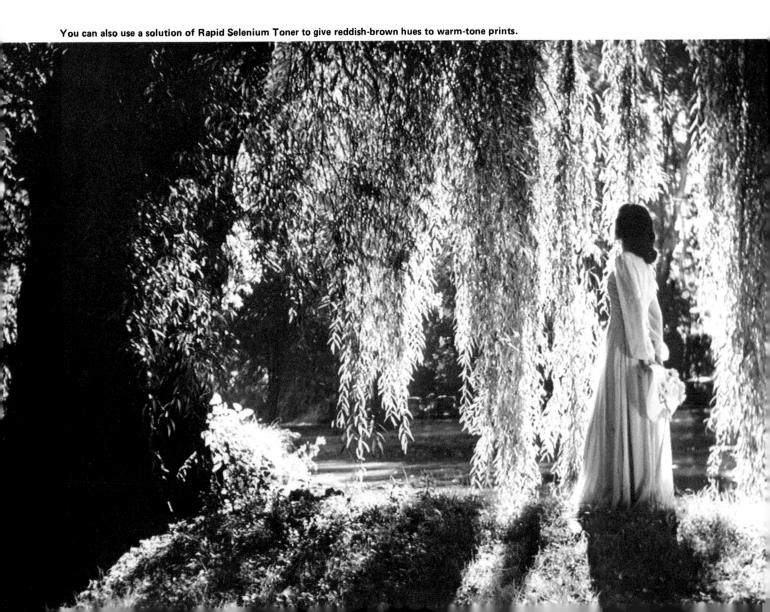

done before or after the print is dried, but many photographers save prints for a toning session. The procedures can all be done under roomlight so you don't need a darkroom. Trays, tongs, and the toning chemicals are all you need to change the color and life expectancy of new or old b&w prints. Even b&w transparencies can be toned because they are also silver-based.

ARCHIVAL TONING

The chemical action of certain toners is an essential part of an archival process to preserve photographs from the effects of chemical deterioration and airborne pollution. Gold and selenium toners combine with the silver image to withstand the effects of time. Archivally processed prints have estimated lifespans of over 300 years. Usually, minimal color change of the image occurs with these toners.

Gold Toning—One gold toner is made by Berg Color-Tone. The gold solution combines with the silver image to make a less reactive compound. It tones the print a slight blue-black. One quart of working solution treats eight 8" x 10" prints and must be used within a few hours of mixing. For old prints you want to preserve or new works of your own, first wash the prints well to remove residual processing chemicals. Then immerse the prints for 15 minutes in the gold solution. Washing and drying completes the process.

Selenium Toning—A less expensive and less permanent way to tone prints archivally is with a diluted solution of Kodak Rapid Selenium Toner and a hypo-remover solution. Add 1-1/2 ounces of undiluted Kodak Rapid Selenium Toner to a gallon of hypo remover at working strength.

You can tone the print in this solution immediately after it has been rinsed and fixed. If you wish to archivally tone a print—one which has already been processed and dried—you still can. First soak the print in plain water for a few minutes before transferring it to the toner/hypo-remover tray.

Agitate the print in the toner/hypo-remover solution for three to five minutes. Rinse it for one minute in plain water and wash for the recommended time for that hypo remover.

TONING FOR COLOR

Most photographers use toners to improve the appearance of prints. Toning can adjust the mood in some photographs. Snow, water and rainy scenes have a heightened sense of realism when toned blue because we are used to seeing these subjects in cool atmospheric conditions, and blue is a cold tone. The color need not be so strong as to detract from the subject, and usually a slight blue tint is sufficient.

Warm tones are brown and reddish-brown colors which enhance the flesh tones of a person or accentuate the warmth of a natural scene.

Although toning improves certain photos, it is not a cure-all for a poor print. A flat and uninteresting print can look just as bad or worse after toning. Choose interesting photos with good contrast and tonal range. Some toners change the maximum density and contrast of a print. When these kinds of toners are used, compensate for the expected change during printing and processing of the print. You'll have to do some testing to see how much extra density the print needs.

Make a duplicate untoned print to compare with the toned print.

A slight blue tone makes this print of coral seem more realistic.

Decide if the toning is effective in making the image better.

Papers for Toning—Because some toning processes convert the silver image into a different compound, the kind of print paper you use affects the result. Prime consideration is given to the normal image tone of the paper. This depends on the silver halide used in manufacturing and the kind of developer used to process the print. Some photographic papers and their image tones are listed in Table 8-1.

Warm-tone papers give significantly warmer tones in a brown toner than cold-tone papers. They also give richer blues in a blue toner than cold-tone papers. The intensity of the toned color is also greater if a warm-tone developer, such as Kodak Selectol, is used.

One Toning Method—Many different toners and techniques exist. One popular technique using Kodak Sepia Toner is given in detail here, and much of the process is common to other toning methods. Kodak Sepia Toner is available in a packaged form to make one quart each of bleach and toner solutions.

1. Prepare the bleach and toner solutions and use them at room temperature in separate trays. Do not use trays with any exposed iron because a chemical reaction occurs and stains the print. When you are ready to tone a print, soak it in a separate tray of water.

2. Agitate a water-soaked print in the bleach bath for about a minute or until a faint image remains. In this step the silver is converted to silver bromide. It is soluble in fixer, which is the reason no residual fixer should be in the print. Rinse the print for two minutes in a running water bath.

3. Place the print in the toning bath until the original image detail returns with a warm tone. The faint silver-bromide image is converted to brown silver-sulfide, and this usually takes about 30 seconds. Controlling the degree of toning is not done in this step—it depends on the density of the orignal. Ton-

ing causes some loss in density because of the bleaching step, but you can compensate by increasing the exposure time of the print during enlarging. This increase can be up to 20%, but it depends on the type and grade of paper being used and the subsequent tone which fits your needs. Tone a normal print and some extra-exposure prints during the same toning session and compare the toning results.

4. If you toned a print that was fixed in a non-hardening fixer, you may want to treat the toned print for two to five minutes in a hardening bath made from Kodak Liquid Hardener. This makes the print emulsion more durable. Some change toward a colder tone can occur if the print is heat dried without hardening first.

5. Wash for 30 minutes in running water; then dry.

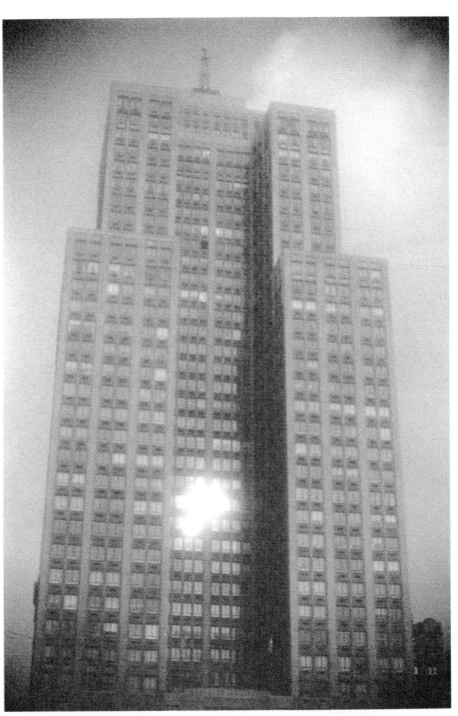

Toning a print brown can sometimes photographically "age" a print and make it seem older than it really is. Photo by Greg Rohall.

146

SOME PHOTOGRAPHIC PAPERS

Paper	Tone	Type
AGFA		
Brovira	cold black	enlarging
Portriga-Rapid	warm black	enlarging
ILFORD		
Ilfobrom	neutral	enlarging
Ilfospeed	neutral	enlarging
CS Ilfoprint	neutral	contact
LR Ilfoprint	neutral	enlarging
EASTMAN KODAK		
Azo	neutral	contact
Ektalure	brown	enlarging
Ektamatic SC	warm black	enlarging
Kodabrome RC	neutral	enlarging
Kodabromide	neutral	enlarging
Medalist	neutral	enlarging
Mural	warm black	enlarging
Panalure	warm black	enlarging
Panalure Portrait	brown	enlarging
Polycontrast	warm black	enlarging
Velox	blue black	contact

Table 8-1

Table 8-2

TONING CHART FOR SOME KODAK PAPERS

Kodak Paper	Sepia Toner	Brown Toner	Rapid Selenium Toner	Poly-Toner (1:24)	Blue Toner
Azo	X	R	X	R	NR
Ektalure	X	X	R	R	X
Ektamatic SC*	R	R	X	X	X
Kodabromide	R	NR	NR	NR	NR
Medalist	R	R	X	R	X
Mural	R	R	X	R	X
Panalure	R	R	X	X	X
Panalure Portrait	X	X	R	R	X
Polycontrast	R	R	X	X	X
Polycontrast Rapid	R	R	X	X	X
Polycontrast Rapid RC	R	R	X	X	X
Portralure	R	R	R	R	X
Portrait Proof	X	X	R	R	X
Velox	R	X	NR	NR	X
Velox Premier	X	X	NR	NR	X
Velox Premier RC	X	X	NR	NR	X

R—Recommended Toner
NR—Not Recommended
X—Toner is not ideally suited for this paper, but it may produce a tone that has special-purpose applications.
*Prints must be fixed and washed before toning.

Other Toners—Table 8-2 shows various Kodak papers and some packaged Kodak toners which work well with them. Sepia Toner is inexpensive and compatible with most papers. Brown Toner is another sulfide toner, but it works as a single-step process to yield warm tones with cold- or warm-tone papers.

Rapid Selenium Toner is also a single-solution toner, but it gives reddish-brown hues. The intensity of the tone depends on the dilution of the toner. It works best with warm-tone papers.

Poly-Toner can give a range of tones similar to those of the Rapid Selenium and Brown toners. Dilution and time variations give the photographer the widest choice of tones possible with a single toner. It is best used with Portralure, Ektalure and other warm-tone papers. For cold tones, use the Blue Toner for most papers.

A set of one-step toners made by Berg Color-Tone has special features for interesting effects. The original b&w tones of a print toned with the Brown/Copper Toner can be restored partially or fully by putting the print in paper developer followed by stop bath, fixing and washing. You can also brush on the developer locally to eliminate the brown tone from specific areas of the print.

Strange effects are obtained by redeveloping a heavily toned print in a highly diluted solution of paper developer. First soak the print in a stock solution of Brown/Copper Toner for 10 minutes or longer until it takes on a metallic-copper sheen. Redevelopment then gives an imitation Sabattier effect combined with blacks and a deep reddish-copper color. Remove the print from the developer when the desired effect is obtained. Transfer to a stop bath, fix and wash.

You can tone a print a combination of colors by using both toning solutions with the same print. A print toned first in the Brown/Copper Toner then with the

Brilliant Blue Toner gives a combination copper and blue-green print.

You can also use the Brilliant Blue Toner and the Brown/Copper Toner like other toners previously mentioned. For instance, the Brown/Copper Toner also lowers the maximum density of the print. Prints must also be well-washed prior to toning. All silver-based images tone with these products, but quicker results occur with warm-tone papers. Standard procedure is to soak the print in the toner until the desired shade is reached and then wash the print.

Berg also makes a kit of dye toners containing five or ten colors. With it you can produce tinted b&w papers. And the colors in the kit can be mixed for even more color versatility.

Precautions—Careful handling is always necessary with chemical solutions, and toners are no exception. A sulfide toner emits hydrogen-sulfide fumes, and good ventilation of the work area is required. The fumes, which smell like rotten eggs, can fog light-sensitive materials. So keep film and paper away from the toning area. Do not discard these toners along with acid solutions, such as stop baths or fixer, because more fumes will form. Discard them separately and flush the drain with water after each dump.

Tongs or rubber gloves should always be used when handling prints in chemicals. Avoid skin contact and splattering. Sulfur, bleach and selenium solutions are all poisonous, so carefully wash all equipment that comes in contact with them and avoid contaminating your work area.

Print Preparation for Toning—Processing steps prior to toning seriously affect the quality of the toning. The most frequent causes of staining and uneven toning are incorrect fixing and washing. Failure to maintain a fresh fixing bath causes stains and chemical retention which can't be removed by washing. A fixing bath without a hardener should be used before some toning processes because an unhardened

print tones easier and faster than a hardened print, and the hardening step can be done after the print is toned.

Non-hardening fixers you can buy are Edwal Hi-Speed Liquid Fix and Kodak Rapid Fixer. Both are liquid concentrates that must be diluted before use. Kodak Rapid Fixer contains two concentrated solutions. One is hardener and the other is fixing agent. To make a non-hardening fixer, do not include the hardener in the diluted fixer solution. Edwal Hi-Speed Liquid Fixer contains no hardener at all.

Fixing prints too long may lighten highlight areas and impregnate the base with chemicals. The bleach step for some toners converts the silver image to a compound soluble in fixer, and any retained fixer lowers the density of the print by dissolving some of the transformed image. To avoid this problem, use a two-bath fixing procedure with

paper-base prints. Fix prints for three to five minutes in each bath. After 200 8" x 10" single-weight prints per gallon, or the equivalent, have been fixed, discard the first bath and replace it with the second bath. Make and use a new second bath.

Wash paper-base prints for one hour in a tank that allows free circulation around the prints and completely changes the wash water every five minutes. Wash time can be significantly shortened by using hypo-removing chemicals such as Hypo-Clearing Agent, Perma Wash or Orbit Bath. Resin-coated papers are sufficiently washed after four minutes and don't need hypo-remover treatment. The prints to be toned can be dried and saved for a toning session.

Selective Toning—With selective toning you can make a print with different colors to accentuate different areas of the image. The

With the Berg Color-Toning System, you can tone or tint papers many different colors.

148

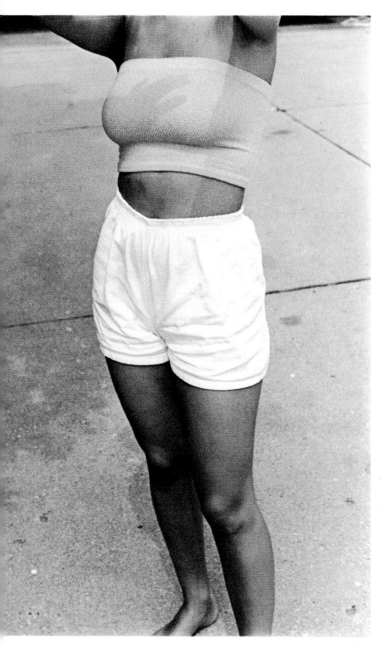

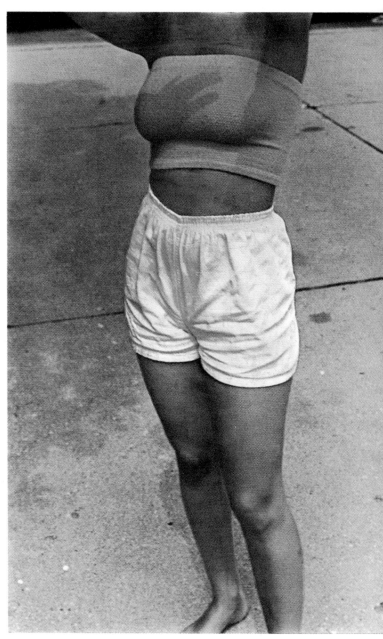

When you want multiple tones, choose a print with simple shapes.

First, the model's shorts and the background were masked with thinned rubber cement and the print toned in Kodak Brown Toner. After the print was washed, the shorts were unmasked and the skin masked. Application of Berg Blue Toner toned the shorts blue and created a blue-green tint in the brown-toned top. The background remains untoned. Photo by Ted DiSante.

usual procedure is to tone part of a masked print in brown toner, remask it and then tone it in a blue toner. This requires several steps.

Cover part of the image with thinned rubber cement or liquid masking material from an art-supply store. Use a brush to outline the area and then fill it in. The liquid mask has a red color which lets you see where it has been applied, but rubber cement is virtually clear and hard to see when you use it for masking. It should be diluted with an equal amount of rubber-cement thinner. Two coats are necessary to minimize bleeding of the toner into the masked area.

Once the coating is dry, do the first toning. After the unmasked areas are toned, wash the print. Remove the mask from the print and let it dry. A rubber-cement mask can be gently rubbed off, and the dried, red mask can be removed with tape. Cover the toned area with masking material and tone the rest of the print.

For simple compositions it may be possible to dip the image area to be toned into the solution and agitate it while keeping the protected area out of the toner to prevent it bleeding under the mask.

Various color combinations are possible. You may select just one area of a print to be toned, and this requires masking all areas but the one to be toned.

Two or three colors are possible with either Kodak or Berg toners. A combination of red, brown and blue tones can be obtained by using Kodak Blue Toner with either the Sepia or Brown Toner. First use the warm toner, then the Blue Toner. The second toning is for 15 to 30 minutes at 90°F (32°C). Areas toned by both solutions show a red or orange color. Cold-tone papers become red and warm-tone papers have an orange tint. With the control of masking, you can get untoned, brown, blue, and red or orange areas. A similar procedure with Berg toners yields untoned, brown, blues and blue-green colors.

MORE PRINT MANIPULATION

In addition to toning a print you can revise an image in other ways for creative purpose. A b&w or color print can be changed to alter the original mood, composition or impact. By using copy techniques, chemicals and colored media, you can create a printed image that is more a product of your imagination than of your camera.

Copying Prints—Copying b&w or color prints demands correct lighting and camera placement. Two lights should be positioned at 45° angles to the copy. One should be on each side and each equidistant from the print to be copied. Uniform illumination eliminates glare and reflections. The print can be in a horizontal plane on a copy stand or in a vertical plane on a wall. The film plane must be parallel to the subject plane to minimize distortion, and you can use a bubble level to check both camera and print.

Hold the print flat with a clean sheet of glass, tape or pins. Glass is best, and it won't show glare if properly illuminated. Meter from an 18% gray card held in the subject plane and bracket in half steps.

Add special effects during the copy process: use some of the camera tricks in Chapter 1; use the zoom effect, filters and attachments from Chapter 2; copy color prints onto b&w film or vice versa with the special films in Chapter 4; or copy manipulated prints from Chapter 7 to get a master negative.

Make a Collage—The collage is a powerful technique. The effect is similar to multiple printing, but it is often easier to do. Cut out different parts of various prints, darken the cut edges to prevent them from showing and recombine them in any possible arrangement. You can glue them with rubber cement or mounting tissue onto a background print or simply hold them flat under a sheet of glass. Investigate the surreal; go abstract; illustrate your dreams; make repeated images; improve straight photographs; make three-dimensional collages or combine b&w and color. Make an interesting image which is more than just an effect, or the interest value will quickly fade. A properly made master negative or transparency will disguise technique and allow the visual statement to be made. You control and shape the image, so let creative sense be your guide.

The best way to copy prints is with a copy stand and two lights angled at 45° to the copy board.

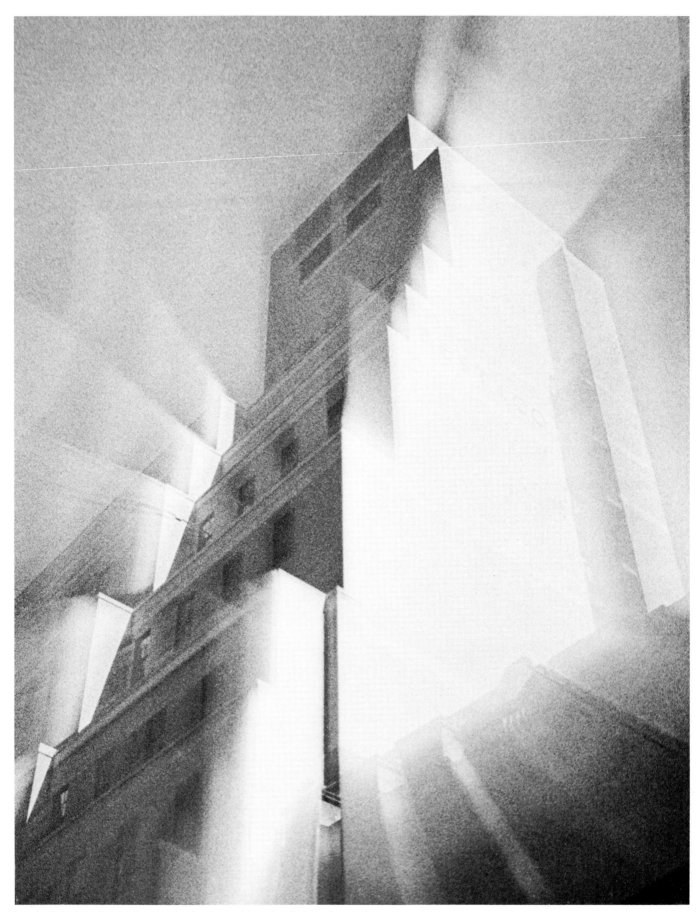

I made this ethereal photo by zooming in on a straight print during a 1 second exposure.

Altering B&W Density—The silver-based image offers many opportunities for creative control. Two products exist that do not use color to change the image. They are for b&w prints, negatives or transparencies only. One removes density and the other adds density.

If you *spot*, or increase the density of a negative, the print lightens in that area. The result is similar to *reducing*, or bleaching, parts of the print. Reducing a negative increases the density of the print. Spotting or reducing is best done on large image areas, so if you must manipulate the negative, do it on an enlarged copy negative. Kodak High Speed Duplicating Film is useful for making large copies in one step. This allows you to do a better job and preserve the original from disaster. Reducing prints should be done prior to toning them, and spotting with water-based dyes should be done after toning.

Silver Bleaching—A bleach solution etches the black silver image and allows you to make whiter highlights, decrease fog, remove unnecessary dark spots or open up shadows in a print. You can even paint in an additional image such as stars, halos, abstract shapes or clouds with the bleach. It comes in packaged form from Eastman Kodak and is known as Farmer's Reducer. You can buy the main chemical agent of the reducer, potassium ferricyanide, and make your own solution, but unless you can weigh small amounts accurately or are willing to experiment with different dilutions, I don't recommend it. The packaged product makes two solutions—bleach and fixing agent. Bleach turns the silver into a chemical which is then dissolved by the fixing agent—a procedure called *reducing*.

Different combinations of the two solutions are recommended by the manufacturer, depending on whether local or overall reduction is needed. Before working on an original negative, make the best print possible or make a copy negative because there is a chance of ruining the original by removing too much silver. Then practice on the print or copy negative before reducing the original. Brushes or trays with exposed metal must not be used with these chemicals because stains will occur on the paper.

Brush a dilute solution of the two chemicals onto the image. Use small brushes or cotton swabs to control agitation and the flow of

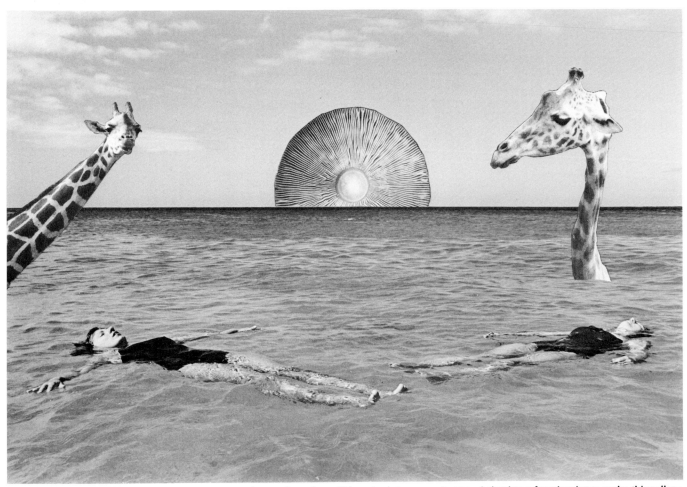

Images from three different prints were cut out and glued to a fourth print to make this collage.

solution in the area being reduced. Work over a light box with a negative and under bright lights with a print. A dilute solution exhausts quickly, so rinse the area with water and apply fresh reducer. When the area reaches the desired density, rinse the image well with water, fix and wash as you would during ordinary processing. If reducer is left in the image, it will continue working, causing a bit more density loss. Work slowly and follow the manufacturer's instructions and safety procedures.

Adding Density—To increase density locally in the silver image, I use spotting dyes. They are normally used to darken dust spots on a print or negative, but they can also be used to darken areas and to make abstract shapes. Spotting dyes are available at camera stores. They are sold in concentrated form in kits of various shades. The colors are intended to match tones obtainable in a b&w print. Blue-black, neutral-black and olive-black come in the Spotone Kit. Instructions give mixing recommendations using the three colors to match the image tones of most b&w papers.

The color combination is diluted

To remove some excess shadows and lines, use a solution of Farmer's Reducer to locally reduce density. Photo by Ted DiSante.

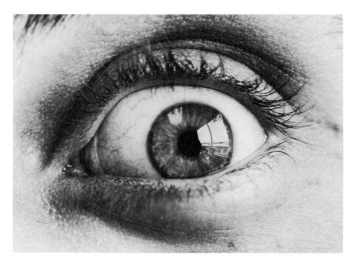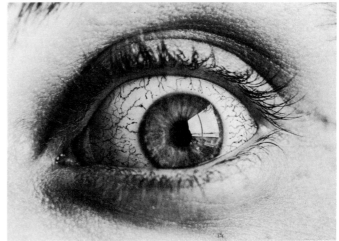

One way to add density to a b&w print is to apply spotting dyes with a fine-tipped brush.

according to directions and applied with a fine-tipped brush. The dye soaks into the print and is permanent as long as the print is not washed again. They are water-based dyes and will wash out if the print is soaked such as in the first stage of toning. Spot *after* toning for best results.

The density of the dyed area is increased by adding more dye, but the area darkens slightly when dry. Test on scrap prints before tack-ling an important job. An un-hardened print absorbs spotting dye easier than a hardened print.

ADDING COLOR

Some of the tools for color addition are the same as used by professional retouchers. What differs is the intent of the artist. Before color photography was common, many photo studios did hand coloring or tinting of b&w portraits so they would appear more lifelike. The rarity of this method today makes it special just as a color photograph was then special.

Water-based color spotting dyes are similar to the mentioned b&w variety, are made by the same manufacturers, and are used in the same manner. They are effective in adding subtle tints to both b&w and color prints. The mixture or dilution of the concentrates depend on your need, but most manufacturers recommend building the density of the color with successive applications. The colors work best when light pastel shades are needed in a print.

One way to add bold color to b&w slides is to use the dyes full strength. Title slides made with litho film can be made having clear symbols on a black background. Add color with a brush or cotton swab by applying dye to the clear areas on the emulsion side. Full strength watercolor dyes available from art-supply stores can also be used this way. Allow the dye to be absorbed and dry before applying more. If you are careful, you can add color selectively to emphasize certain elements.

A large litho transparency can also be dyed for special effect. Mat it on a white background, copy it with color film or even contact print it with color print paper.

Adding water-based dyes to an emulsion is a slow process if large areas need color. A quicker method for coloring large areas of a print uses oil-based materials. Special colored pencils and oil paints can be purchased in a broad range of colors and densities. The pencils are easiest and least messy. You apply color locally and slightly smudge it to fill the area. You can use your finger or a soft fiber tool to smear the color. Different colors can be mixed easily in this way.

Oil paints are applied with a brush. Some brands need a liquid "tooth" applied to the print prior to painting. It allows the color to stick to the surface. Usually it is sprayed on. After an oil-based material or anything else which may smudge is applied to a print,

If you soak or tint a print with water-based color dyes, you can remove all or part of the color by washing the print. This print was soaked in a solution of Dr. Ph. Martin's Concentrated Watercolor.

Apply color dyes full strength on litho transparencies.

Cindy Sirko combined different effects to make this print. She pushed Tri-X to a speed of 1200, toned the print in Sepia Toner, and then hand-colored the print with Marshall's Photo Painting Pencils.

In this manipulated image is a partially colored b&w print and a pencil. They were combined and then photographed with slide film.

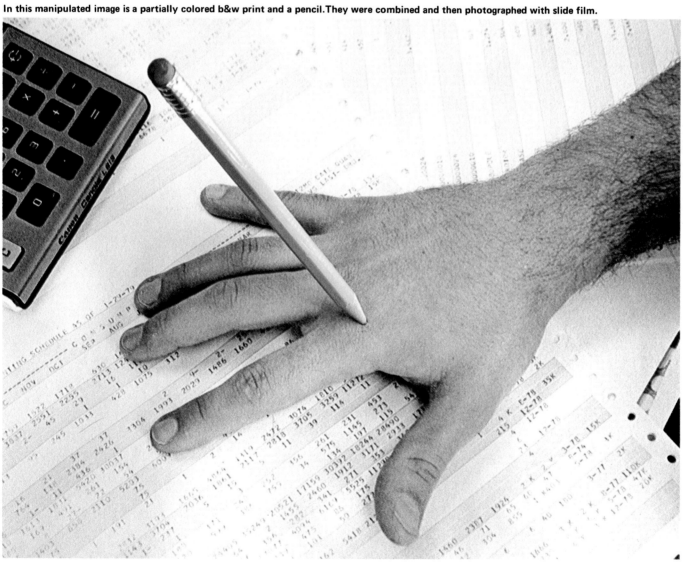

a protective coating should be applied to the new surface. Usually these coatings are available in spray form, but most liquid fixatives will work. Some manufacturers of the coloring media recommend or supply a fixative.

You can add bold and graphic color to prints by using indelible-ink pens. You can buy them in different colors and tip sizes. Some manufacturers put the ink in small bottles for use in drawing pens.

The ink is permanent, so avoid making mistakes. Shadings are not possible, but outlining or coloring large areas of the print with vivid colors make this technique useful.

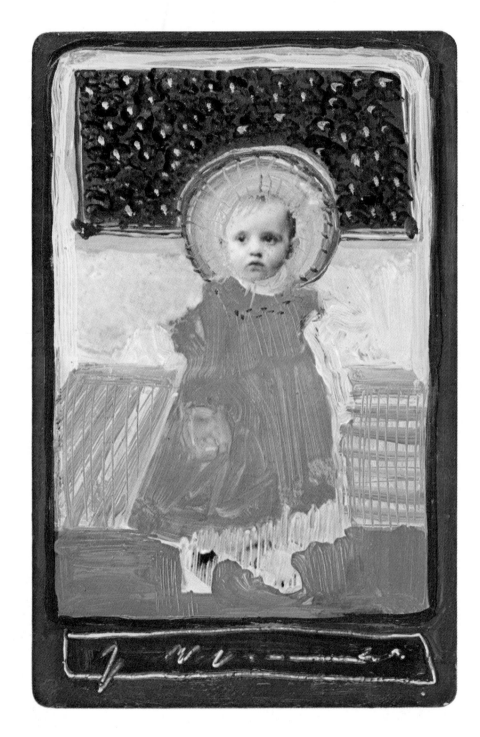

Artist Alice Kreit painted this carte de visite with oil paints and radically altered the original image.

Photo by Forest McMullin.

Use color and density to emphasize areas, moods or relationships. Consider the interplay between background and foreground. Color may work best only in a foreground subject of main interest. If only the background is colored, the foreground will still be distinct, but with a different emphasis. The relative intensity of background and foreground colors imply their importance. Try realistic or abstract colorings. Mix different color media or add color to images made with other special-effect techniques.

Index

Front Cover Photos:
Upper left made with the Hollo Spectralstar Andromeda diffraction grating.
Lower left is a pendulum pattern.
Lower right is a slide sandwich made by Dorothy Richards.
Back Cover Photo:
Napthalene crystal made with the melt method.